P9-DEC-450

K·I·S·S

The Only Guides You'll Ever Need!

THIS SERIES IS YOUR TRUSTED GUIDE through all of life's stages and situations. Want to learn how to surf the Internet or care for your new dog? Or maybe you'd like to become a wine connoisseur or an expert gardener? The solution is simple: Just pick up a K.I.S.S. Guide and turn to the first page.

Expert authors will walk you through the subject from start to finish, using simple blocks of knowledge to build your skills one step at a time. Build upon these learning blocks and by the end of the book, you'll be an expert yourself! Or, if you are familiar with the topic but want to learn more, it's easy to dive in and pick up where you left off.

The K.I.S.S. Guides deliver what they promise: simple access to all the information you'll need on one subject. Other titles you might want to check out include: Playing Guitar, Cat Care, Living With a Dog, Astrology, Sex, Weight Loss, and many more to come.

GUIDE TO

Photography

JOHN GARRETT

Foreword by **Martin Sandler**
Acclaimed Author and Photohistorian

A Dorling Kindersley Book

LONDON, NEW YORK,
MUNICH, MELBOURNE, DELHI

DK Publishing, Inc.
Senior Editor Jennifer Williams
US Consultant Jennifer Quasha
Category Publisher LaVonne Carlson

Dorling Kindersley Limited
Managing Editor Maxine Lewis
Managing Art Editor Heather M^cCarry
Production Heather Hughes
Category Publisher Mary Thompson

Produced for Dorling Kindersley by **Sands Publishing Solutions**
4 Jenner Way, Eccles, Aylesford, Kent ME20 7SQ, United Kingdom

Project Editors David & Sylvia Tombesi-Walton
Project Art Editor Simon Murrell

DK Publishing, Inc. offers special discounts for bulk purchases for sales promotions or premiums.
Specific, large-quantity needs can be met with special editions, including personalized covers, excerpts
of existing guides, and corporate imprints. For more information, contact Special Markets Department,
DK Publishing, Inc., 95 Madison Avenue, New York, NY 10016. Fax: 800-600-9098.

Library of Congress Cataloging-in-Publication Data

Garrett, John, 1941-
 KISS guide to photography / John Garrett.
 -- (Keep it simple series)
 Includes index.
 ISBN 0-7894-8069-7 (alk. paper)
 1. Photography. I. Title. II. Series.
TR149 .G37 2001
771--dc21

 2001002876

Color reproduction by ColourScan, Singapore
Printed and bound by Printer Industria Grafica, S.A., Barcelona, Spain

For our complete catalog visit

www.dk.com

Contents at a Glance

PART ONE

Before You Shoot

The History of Photography
How the Camera Works
Which Camera to Choose?
Film

PART TWO

The Point-and-Shoot Camera

What You Get for Your Money
Things You Need to Know
Flash
Framing
Troubleshooting

PART THREE

The Arty Stuff

Natural Light
Artificial Light
Lenses, Aperture, and Shutter
Learning to See
Space and Composition

PART FOUR

Photographic Themes

Portraits
Landscapes
Still Life
Children
Action
Travel

PART FIVE

Taking Things More Seriously

Medium and Large Formats
Seeing in Black and White
Working with Your Photofinisher
Digital Photography
The Digital Darkroom

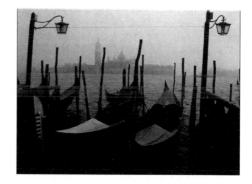

CONTENTS

PART ONE *Before You Shoot*

CHAPTER 1 *The History of Photography* 22

CHAPTER 2 *How the Camera Works* 34

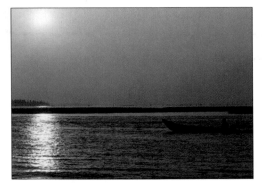

PART THREE The Arty Stuff

APPENDICES

Foreword

"I HAVE SEIZED THE LIGHT." With that proud exclamation, in 1839, Louis Jacques Mandé Daguerre announced that he had succeeded in producing the world's first successful photograph. Less than 50 years later, George Eastman would invent the Kodak™ camera, making just about everyone a photographer and a picture-maker. Within a remarkably short period of time thereafter, photography would become such an important part of our lives that critic Thomas Lawson could proclaim in truth that "photography is the modern world."

Put simply, photography has become the most democratic form of art the world has ever known. It has established itself as the universal language, understood by everyone, arguably surpassing even the written word as a form of communication.

Almost all of us take pictures. We use our photographs as memories – memories of the rituals and passages in our lives, reminders of ourselves and our loved ones in earlier times, records of places we have lived or visited. Photography also provides us personally with even more. In our hands, the camera gives us nothing less than one of our most powerful means of self-expression.

Yes, most of us are picture-takers, and almost all of us wish we were better at it. Now, thanks to John Garrett and what he has given us in this book, we can be. Here I would add a word of caution. Don't be misled by how easy this book is to read or how enjoyable it is to look at its compelling photographs.

This is the most solid and helpful book of its type I have
encountered. It will not only make you a better photographer,
it will also help you understand what it is about certain
photographs that makes them so highly regarded.

Garrett touches all the bases. He explains the many technical
aspects of picture-taking in easy-to-understand, practical terms.
He identifies the special challenges of taking specific types of
pictures – portraits, landscapes, still lifes, snapshots, action, and
travel photographs – and provides us with achievable strategies
and tips for most effectively capturing each type of image.
Throughout the book he offers particularly valuable advice on
how to master what successful photographers have long known to
be the three most basic elements that lead to great photographs –
light, composition, and capturing the decisive moment.

It was that giant of the medium Edward Weston who reminded us
that photography is the most pure and direct means of expression
yet discovered, and that the person behind the camera is limited
only by his or her capacity to create. This book will help you
increase that capacity. Along with taking better pictures, you will
also receive an invaluable bonus. Through the content and approach
of this book, John Garrett has helped us better understand one of
the greatest gifts that photography has to offer – its ability to
expand our vision and see the world in a whole new way.

Martin Wandler

MARTIN SANDLER

Introduction

WELCOME TO the K.I.S.S. Guide to Photography. I have written this book with the intention of simplifying the seemingly complicated and technical process of photography – to demystify the whole thing.

I've been a professional photographer for nearly 40 years, but I don't believe in technique for the sake of it. Neither do I drool at the sight of a new camera. I am interested in producing good images, and strive constantly to improve my photography so that I can achieve personal satisfaction by taking a beautiful picture that was previously beyond my expertise.

The photographic principles discussed in this book apply equally to the point-and-shoot photographers as they do to the SLR users, and although there are some chapters that seem, on the surface, to be devoted specifically to one or the other, I believe you will benefit from reading everything in the book.

I hope that this guide will provide the perfect starting point for all the newcomers among you and kick start a thirst for photographic knowledge wherever you can find it. To help you with that, I've included a recommended reading list and a whole bunch of web sites in the appendices. But don't stop there; check out photography classes, too.

Even if you're not a newcomer there's still plenty here for you. I think you'll find the sections on light and composition to be creatively stimulating, for example, and I am passing on tips for all the great themes of photography. These are nuggets of knowledge and advice that have come from hard-earned experience . . . not to mention costly mistakes.

On the subject of mistakes In writing this book I tried to bear in mind several goals, one of which was to help you reduce your number of errors. But even so, don't be too discouraged when you get something wrong. We've all been there.

To me, one of the joys of photography is that we are all lifelong students:
I aspire to be a better photographer next month than I am now.

In this early part of the 21st century, digital photography is very much here and
I've included two chapters on that subject. However, if you are into this sort of
photography, you should note that the shooting method is similar enough to
conventional photography for the whole book to be applicable to you too.

There's something for everyone in this book. Regardless of what sort of camera
you are using or your level of expertise, if you are interested in photography and
improving your photographic skills, you've come to the right place.

Have fun, folks – that's the whole point!

JOHN GARRETT

A NOTE ON MEASUREMENT CONVENTIONS IN PHOTOGRAPHY

Measurements are used for many different reasons in photography, and photographic
convention decrees that some measurements are always given in metric and some in
imperial. In the great majority of cases in this book I have not converted one into the
other: If something is always given one way, it serves no purpose to learn it another way.
However, where I have felt that confusion may be caused by *not* giving a conversion –
when talking about medium format cameras, for example – I have included one, at
least in the first occasion of its use.

What's Inside?

THE INFORMATION *in the* K.I.S.S. Guide to Photography *is arranged from the simple to the more advanced, making it most effective if you start from the beginning and slowly work your way through to the more involved chapters.*

PART ONE

I thought it would be a good idea to give you some background information on photography before we get into the nitty-gritty of how to take pictures. In Part One, I'll tell you a little about the history of photography and then move onto how cameras work and the wide choice in the stores today, in addition to the complicated issue of film types.

PART TWO

Compact cameras are serious machines, far more sophisticated than the cameras used to shoot many of our favorite images from the past. However, they can't take beautiful pictures by themselves. In this part we'll look at the different types of point-and-shoot cameras available and how to make them do what you want them to.

PART THREE

I've called Part Three The Arty Stuff, and I mean it in a good way. Arty is inspirational and is at the core of the best of us, both as people and as communities. I believe that you will produce more interesting pictures than you do now if you get into the arty stuff, and you'll get a lot more satisfaction from your work.

PART FOUR

In Part Four, I have grouped classic photography subjects into themes. This section is mostly about how you learn to see the world as a photographer. It's about becoming more visually aware, and it's also about simplifying photography. I want you to be able to take great pictures . . . and to learn from my experience.

PART FIVE

This last section of the book is intended to inspire you to go on further than you first thought you would. We'll look at the equipment professional photographers use, black-and-white photography, what happens after your roll of film is all finished – the important behind-the-scenes action – and I'll shed some light on digital photography.

The Extras

THROUGHOUT THE BOOK you will notice a number of boxes and symbols. They are there to emphasize certain points I want you to pay special attention to because they are important to your understanding and improvement. You'll find:

Very Important Point

This symbol points out a topic I believe deserves careful attention. You really need to know this information before continuing.

Complete No-No

This is a warning, something I want to advise you not to do or to be aware of.

Getting Technical

When the information is about to get a bit technical, I'll let you know so that you can read carefully.

Inside Scoop

These are special suggestions that come from my own personal experience. I want to share them with you because they helped me when I was learning the game.

You'll also find some little boxes that include information I think is important, useful, or just plain fun.

Trivia...

These are simply fun facts or anecdotes that will give you an extra appreciation and understanding of photography.

DEFINITION

Here I'll define words and terms for you in an easy-to-understand style. You'll also find a glossary at the back of the book packed with photography lingo.

INTERNET

www.dk.com

I think the Internet is a great resource for photographers, so I've scouted out some web sites that I think will add to your enjoyment and understanding of the subject.

PART ONE

WE'RE GOING ON A PHOTOGRAPHIC JOURNEY . . .

BEFORE YOU SHOOT

I THOUGHT IT WOULD BE a good idea to give you some background information on photography before we get into the nitty-gritty of taking pictures. Some of you will already know more than others, but it's important to learn a little about the *history* of photography before we move onto the camera itself.

The advances that have been made in photography since the first pictures in the mid-19th century are *mind-blowing*. However, it's nice to feel connected to those old pioneers who had to work so hard to pave the way for the simplicity we have today. This part is also about how cameras work and the options we have when we choose what to buy next, in addition to the complicated issue of *film types*. This is all information that you need to know in order to get the most out of photography.

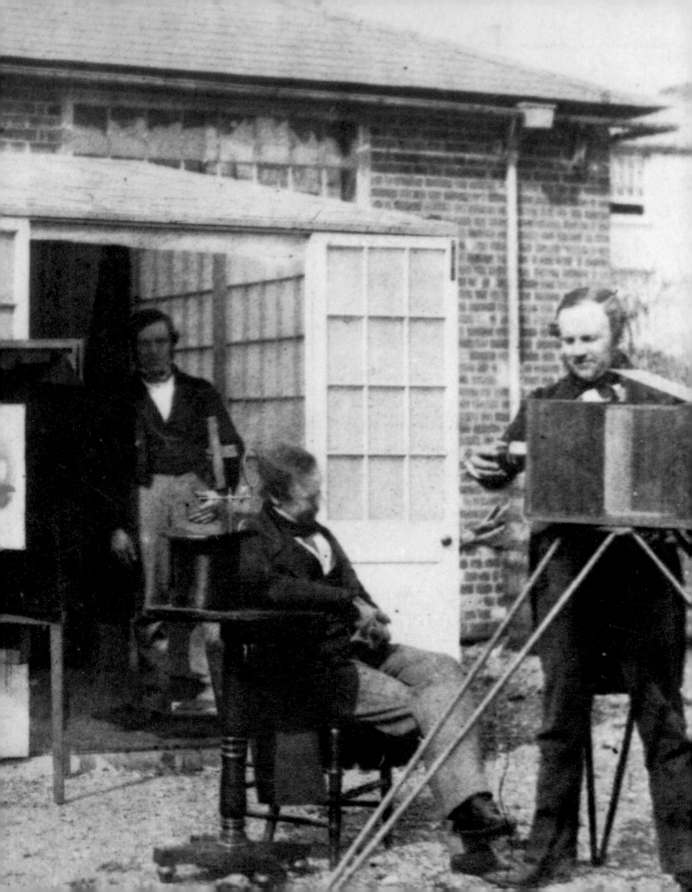

Chapter 1

The History of Photography

THE FIRST THING I WANT TO DO in this book is briefly run through a history of photography so far. It will hopefully give you an understanding of some of the extraordinary progress that has been made in such a short time. I am in awe when I study some of the fantastic photographs that have been taken in the past, often with very rudimentary equipment. When I read about 19th-century photographers it spurs me to make more of an effort to improve my own work. I hope this chapter will inspire you in the same way.

In this chapter...

✓ The birth of photography

✓ The photography explosion

✓ Photography for the masses

✓ Keeping things simple

✓ The modern compact

The birth of photography

PHOTOGRAPHY WAS OFFICIALLY INVENTED in 1839. I say "officially" because that is when the existence of a photographic image was made public. However, amazingly the first reference to cameras is recorded by Aristotle in the 4th century BC.

The *camera obscura* was originally a completely enclosed, dark room with a hole in one wall, which, by the effect of light diffraction, projected an image of the outside world onto the opposite wall. It was not until 1568, around 2,000 years later, that Italian Daniello Barbaro added a lens to the hole, greatly improving the sharpness of the image. In the mid-17th century the camera obscura became portable when it was miniaturized down to a box about 12 inches (30 cm) square. When a piece of paper was placed opposite the lens it was possible to display landscape pictures on it. Everything was in place for photography, except the chemistry.

PORTABLE CAMERA OBSCURA

> **DEFINITION**
>
> Camera obscura *is a Latin term literally meaning "dark room," or "dark chamber."*

The first pictures

It was known in the late 18th century that an image (from a stencil) could be formed on material soaked in silver nitrate, but there was no means of fixing that image until Sir John Herschel discovered sodium hyposulphite as a fixing agent in 1819 . . . and we were all set.

By 1819 we had a camera, photographic-sensitive materials, and a fixing agent, and in the summer of 1826 a Frenchman named Joseph Niepce made the first photograph. He cut a hole in a wooden box and into the hole he fitted a lens. Opposite the lens he placed a glass plate coated with a bitumen compound. He placed the box on his workshop's windowsill and left it for 8 hours.

When he finally removed the box from the windowsill he washed the plate in lavender oil. Where the plate had been exposed to the light, the bitumen had hardened. The unexposed areas of the plate dissolved in the oil, leaving behind a crude photographic image of the rooftops in his village.

In 1829, Niepce went into collaboration with another Frenchman named Louis Daguerre. Together, through further experimentation, they developed the daguerreotype method of photography, which was announced to the world by the Institut de France in 1839. Daguerre excitedly said, "I have seized the fleeting light and imprisoned it I have forced the sun to paint pictures for me."

Fox Talbot

At the same time as Niepce and Daguerre were developing the daguerreotype, Englishman William Fox Talbot was working on his own experiments in photographic imaging. Each party was totally unaware of the work being done by the other. Fox Talbot was horrified by the Institut de France's announcement in 1839. He thought he had invented photography. He had certainly succeeded in making photographic images, but unfortunately they weren't permanent.

In 1841 Fox Talbot developed the first negative-to-positive process, a process that was repeatable, meaning that black-and-white prints were now possible.

He soaked high-grade writing paper in a salt solution, and, after it had dried, he brushed the paper with a silver-nitrate solution, forming a light-sensitive silver chloride. Once that had dried, he placed the paper in his camera and removed the lens cap to expose it. He was left with a negative image that he was able to stabilize with a strong salt solution. To make a positive print of that image, he put the negative in contact with another sheet and exposed it to light again. This was an incredible step forward – a leap is probably more accurate – because it was now possible to reproduce as many prints from a single negative as required. Photography took off . . . big time! I'll let the historians decide who invented photography, but I believe that Fox Talbot was the father of modern photography.

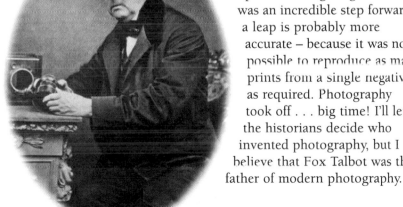

WILLIAM FOX TALBOT

INTERNET

www.rleggat.com/ photohistory

If you want more information about some of photography's pioneers, this is a great place to start. Not only has Dr. Robert Leggat put together a history of the art form up until the 1920s, but he has also cross-referenced all the key names: Just click on a name in the text to jump to the relevant biography.

The photography explosion

THE VICTORIANS BECAME OBSESSED *with photography, and by 1853 there were 80 professional studios in New York alone. London and Paris were also photo crazy.*

Frederick Scott Archer made a big contribution to the photography explosion by giving us the collodion plate, which basically enabled the making of negatives on glass plates. Unfortunately, though, the process worked best when the silver nitrate was wet. This meant photographers had to travel with a light-tight tent darkroom, a camera, a tripod, water, and a heavy load of glass plates and liquid silver solution.

They set up the camera, went into the tent and coated the glass plate, exposed it in the camera, and then went back into the darkroom to develop the plate. Give a thought to those guys when you next take your APS camera out of your pocket and snap away!

> **DEFINITION**
>
> APS *stands for Advanced Photo System, which was launched in the mid-1990s.*

You can still buy bottles of liquid photographic emulsion and coat your own glass plates, but this method is mainly used by arty printmakers who are looking for unusual effects.

Recording the world

Those wet-plate photographers traveled all over the world and documented the Civil War and the Crimean War carrying hundreds of pounds of equipment on their backs. They were heroic in their devotion to recording the world around them. For the first time in history the public could see what celebrities looked like. The great migration west in America was now being photographed, as were the great industrial and architectural projects. Photojournalism was alive and kicking, and the world was about to become smaller.

■ **Images such as this** *gave the general public a chance to see sights that they had only ever read or heard about before.*

Photography for the masses

IN THE EARLY 1880s, the revolutionary gelatine dry plate was invented and put on the market. This was important because it meant that photographers no longer had to lug around a portable darkroom and all the other equipment I've mentioned in the last couple of pages.

The dry plates were much more sensitive to light, so instantaneous pictures were now possible. Instead of covering and uncovering the lens to make an exposure, the *shutter* was added to the camera. It was this advancement that changed the look of photography dramatically. You could now photograph movement: No longer would a horse and cart walking down the road be blurry. People didn't suddenly become happier in the 1880s, but they were finally allowed to smile when photographed, and they were no longer required to sit with their heads still for a 15- to 30-second exposure. Exposures (depending on the light quality) were now around ¹⁄₂₅ of a second. On a sunny day, it was even possible to take hand-held pictures.

DEFINITION

The shutter is the mechanism used to control when and for how long the film inside the camera is exposed to light. It is activated by pressing the button that "takes the picture." The button is correctly called the shutter button or shutter-release button.

Don't throw away your grandfather's old camera. Those machines are now very collectable.

■ **Family portraits** *were hugely popular in the early years of photography – just as they were in paintings before photography existed – and still are today.*

Kodak gets us taking photographs!

In 1885 an American named George Eastman made another very important invention. He coated a light-sensitive silver solution onto rolls of paper to make the first photographic film.

Three years later, in 1888, Eastman created the famous *Kodak*™ trademark and was totally responsible for popularizing photography by launching a camera already loaded with film, with the potential for 100 photos. The camera had a fixed focus and fixed shutter speed. There was nothing to do but point and shoot. The famous Kodak slogan "You press the button, we do the rest" kicked off photography as a pastime for the masses.

> ### DEFINITION
>
> *The trademark **Kodak** is a word George Eastman made up – he just liked the sound of it. He also thought the visual appearance of it would look good and be remembered. It doesn't mean anything!*

Once the photographer had finished all of the film, he returned the camera to Kodak. The company processed and printed the pictures, reloaded the camera with a new film, and returned it all to the photographer. These days, well over 100 years later, we still buy single-use cameras – is nothing new?

Trivia...

My first camera was a Kodak Box Brownie. I thought it took great pictures. In fact, the quality was far inferior to the single-use compact cameras that are so cheap today.

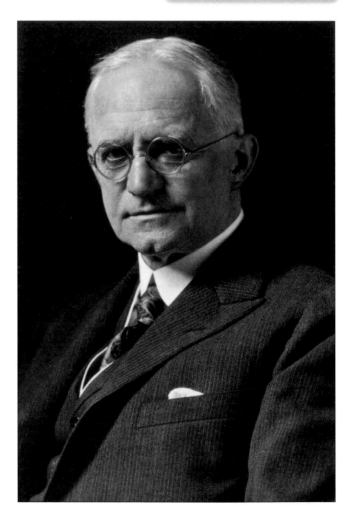

■ **George Eastman**, *the man behind the Kodak company, was responsible for making photography affordable for the population at large.*

Slow times

Over the next 30 years there were no major revolutions in photography. Great developments were made, but in stages rather than in leaps and bounds. Amateurs were snapping away with their box cameras and bellows roll-film cameras while the professionals stuck to their serious, large format machines. Although there was some wonderful reportage work being done in that period by the likes of Alfred Stieglitz, the main thrust was to try to establish photography as a major art form. As a result this was a rich period for images: Check out the work of Edward Steichen, Paul Strand, and other Pictorialist photographers.

The movies were where the biggest breakthroughs were being made, and it was the great success of 35mm film in cinema photography that gave birth to the 35mm rangefinder camera.

EARLY KODAK CAMERA

Enter Leica

The first 35mm stills camera was launched in 1925, when the German company Leica introduced the Leica 1, developed by Oskar Barnack. This camera revolutionized the hand-held camera market. It was the first serious "miniature" camera (a term coined by the trade at the time) that enabled photographers to capture reality spontaneously and to observe life as it was going on around them.

The Leica 1 was a fraction of the size and weight of the large format press cameras, which used glass plates and sheet film. It had a high-definition lens and a rudimentary manual-focusing system. The aperture and shutter speed were also manual and, since there were no light meters on the market at that time, exposure times had to be judged from experience.

These early 35mm cameras were the great-grandparents of our modern compacts, and for us happy photographers of the 21st century, the ***point-and-shoot*** camera was in the pipeline from the day the idea for the Leica 1 was born.

DEFINITION

Point-and-shoot *is the name often given to compact cameras, simply because it more or less defines the actions needed to take a photograph with those machines. The trade and professional photographers tend to use the term compact camera instead.*

Photojournalism

The photographers using these new lightweight machines started to show people images that previously they had to imagine from the written word. Photojournalism had arrived.

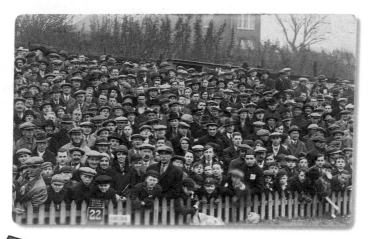

■ **Photojournalists** *recorded not only the major news stories of the day, but also documented more everyday subjects like sporting events. People all around the world were even able to see what their contemporaries in other countries wore to watch their national sports.*

The invention of the first 35mm camera by Leica gave rise to a new breed of photographer, the photojournalists, now free to take their cameras anywhere. With a few rolls of 36-exposure film in their pocket, they photographed the world with a spontaneity never seen before.

Popularizing 35mm

The Leica 1, however, was expensive, and in the early 1930s Kodak mass-produced a much cheaper 35mm camera. It was this move that made 35mm the universally popular format that it is today. Despite what some people may have thought at the time, the large format cameras managed to survive this miniature revolution since, although the photojournalists opted for the smaller machines, professionals stuck to the larger negatives to reproduce nature and man-made objects as perfectly as possible. It was in the 1920s, 30s, and 40s that most of the great landscape pictures of America's West were made by photographic heroes like Edward Weston and Ansel Adams.

INTERNET

www.masters-of-photography.com/

This is a great web site for anybody who wants to see a small selection of works by some of the best photographers of all time. It includes pictures by Ansel Adams, Alfred Stieglitz, and Edward Weston, to name a few.

Keeping things simple

THE MOST VERSATILE *and popular 35mm camera type available, the SLR, was launched in 1960. Its popularity has been largely due to the range of lenses and accessories available for it in addition to its built-in electronic programming.*

DEFINITION

SLR stands for single lens reflex and is a camera design in which the scene in the viewfinder is exactly the same as that "seen" by the lens. This is achieved by the use of an angled mirror and a series of silver surfaces.

INSIDE AN SLR

The basic features – and the layout of those features – are the same in all 35mm SLRs, regardless of how different the cameras look.

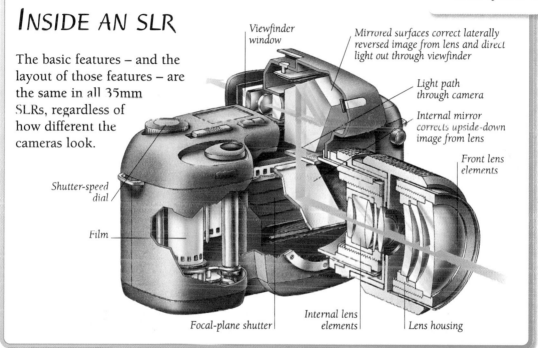

Viewfinder window

Mirrored surfaces correct laterally reversed image from lens and direct light out through viewfinder

Light path through camera

Internal mirror corrects upside-down image from lens

Front lens elements

Shutter-speed dial

Film

Focal-plane shutter

Internal lens elements

Lens housing

While the SLR was being launched and well received, however, the photographic industry was aware that millions of "ordinary people" wanted to take pictures without learning the comparatively complex techniques needed to use the SLR successfully.

Kodak, of course, was the first to offer the simple solution. The company introduced a 126 cartridge camera in 1963, the 110 cartridge in 1972, and, in 1982, they launched a disc camera. All these camera types were grouped together under the umbrella term "instamatics." The electronics were developing and these cameras were producing better exposed pictures in daylight and, with the introduction of an auto-flash unit, at nighttime too. However, the quality was ultimately limited by the negative sizes, which were smaller than those from a 35mm film.

The modern compact

THE COMPACT CAMERA *as we know it today was launched in 1976 by Konica. This 35mm point-and-shoot camera was marketed with automatic focusing and exposure, in addition to a built-in flash. Like all compacts for the next 4 years, this camera had a* **fixed-focal-length lens** *of 35mm. However, in 1980 that all changed, when Minolta brought out the first compact with a zoom lens, offering a choice of two focal lengths, 38mm and 60mm. Today, these cameras are called twin lens compacts.*

> **DEFINITION**
>
> A **fixed-focal-length lens** is *a non-zoom lens.*

From that point on, the development of zoom lenses has exploded and compacts are now available with a variety of continuous zooms, such as 28–80mm, 35–70mm, and 35–105mm. Alongside the zoom boom came autoexposure and autofocus programming, fill-in automatic flash, remote shutter buttons, and many other functions designed to make the nontechnical photographer's life easier. The compact had come of age, making it possible to take excellent pictures without having to go to night school or carrying around a huge load of equipment.

■ **Compact cameras with zoom lenses** *were launched in 1980; zooms are now commonplace on even modestly priced point-and-shoot cameras.*

The digital age

We're now experiencing the latest photography revolution. Although digital photography has been in use since the mid-1980s, it's only in the last couple of years that it has really been taken seriously.

Digital photography is the big leap; we've moved from recording images on light-sensitive emulsions to recording electronic images.

It's a logical progression out of the electronic technology that dominates every aspect of our lives. The general consensus in the industry is that traditional and electronic imaging will continue to coexist for the next 30 years or so.

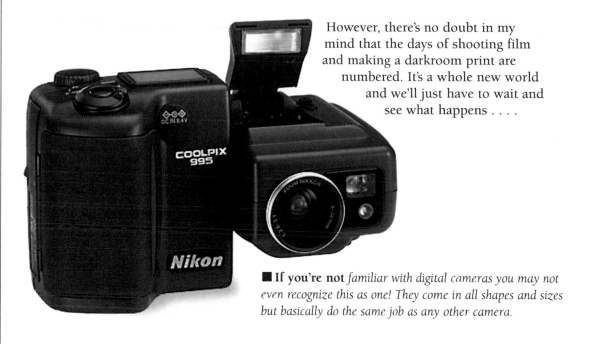

However, there's no doubt in my mind that the days of shooting film and making a darkroom print are numbered. It's a whole new world and we'll just have to wait and see what happens

■ **If you're not** *familiar with digital cameras you may not even recognize this as one! They come in all shapes and sizes but basically do the same job as any other camera.*

A simple summary

✓ The first photograph was made in 1826 by Joseph Niepce.

✓ The negative-to-positive process was invented by William Fox Talbot in 1841.

✓ Early photography was an arduous process, but pioneering photographers were devoted to taking pictures of their world.

✓ By the early 1880s, instant exposures were available, leading to the invention of the shutter.

✓ In 1888, George Eastman founded the company Kodak.

✓ The first 35mm stills camera, the Leica 1, was unveiled in 1925.

✓ The SLR was launched in 1960. Within 3 years Kodak produced a simpler alternative.

✓ Konica produced the first 35mm compact camera in 1976.

✓ Digital photography's popularity has grown in the last few years.

Chapter 2

How the Camera Works

I LOVE THE FACT THAT NO MATTER HOW you look at a camera or how expensive it is, it's still basically a light-tight box with a film holder on one side and a lens on the other side. Everything else is extra. Imagine what a photographer 100 years ago would make of our high-tech, multifunctional cameras of the early 21st century. This chapter is all about what we have added to make our cameras more accurate, lighter, sharper, and more convenient to use. It's about how these sophisticated machines work and how we stay in control of all that technology.

In this chapter...

✓ What is a camera?

✓ Camera basics

✓ The aperture—shutter marriage

✓ Exposing with the SLR system

LET'S FIND OUT WHY THE FOREGROUND IS SHARP AND THE BACKGROUND IS BLURRY

What is a camera?

THE BASIC CAMERA – *and by that I mean every camera, from the cheapest point-and-shoot cameras to the newest and most complicated digital models – is a pinhole camera with other mechanical devices added to it.*

You may have made a pinhole camera in science class at school. The pinhole camera is the most basic machine that can produce a photographic image. You remember the camera obscura that we discussed in the last chapter?

The pinhole camera is just a small version of the ancient camera obscura with, now that we have the chemistry, a sheet of film opposite the pinhole.

The image through the pinhole is projected onto the film upside down and back to front. Because there's no lens, there's no way to focus the image, so it's not very sharp. However, the pinhole camera does produce a recognizable photographic picture of the subject.

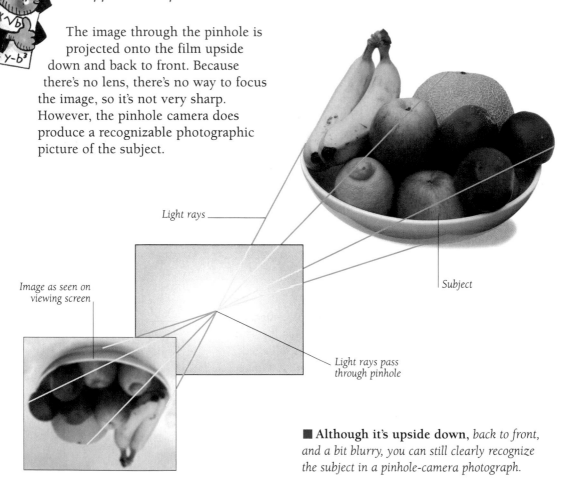

Light rays

Image as seen on viewing screen

Subject

Light rays pass through pinhole

■ **Although it's upside down,** *back to front, and a bit blurry, you can still clearly recognize the subject in a pinhole-camera photograph.*

Camera basics

ON A "REAL" CAMERA, *instead of a pinhole, you have a lens, and a film holder keeps the film in place. The film is held a set distance from the lens to obtain a sharp image. There is also a film-transport system if the camera takes roll film, or a mechanism into which sheet-film magazines are inserted.*

The lens must have a focus mechanism that moves it closer to or further from the film to ensure subjects that are, in turn, close or far from the lens, are kept sharp. The *aperture* of the lens is adjustable and is controlled by an *iris diaphragm*. The diaphragm controls the amount of light to which the film is exposed through the lens. A shutter is required to control the length of time the film is exposed to the light. There is also a viewfinder so that you, the photographer, can see what the camera "sees" through the lens.

■ As with a pinhole camera, *the image that is captured on film in a conventional camera is still upside down and back to front. However, the lens enables you to focus, the diaphragm controls the amount of light exposing the film, and the shutter allows you to control how long the film is exposed to the light. All this adds up to give you creative control.*

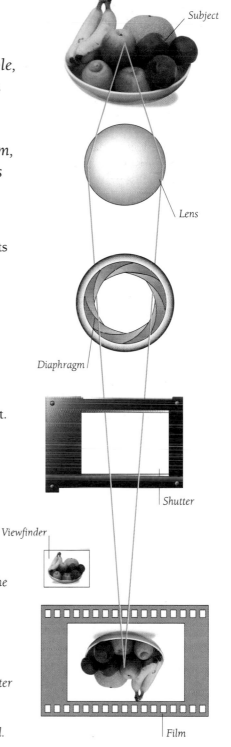

Subject

Lens

Diaphragm

Shutter

Viewfinder

Film

Aperture

The design of the aperture is based on the iris of the eye. You will have noticed that the iris of the eye opens when light is low and closes to a smaller diameter in bright light. Your lens aperture operates in the same way. The lens aperture is calculated on a

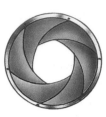

■ **This is how** *the iris diaphragm works. The smaller the hole, or aperture, the less light is allowed through to expose the film.*

scale of f-stops, or f-numbers, which are fractions of the focal length of the lens. So if you read on the front of your lens that it is a 50mm f2 lens, it means that the maximum aperture is *half* the focal length of the lens; in this case, 25 mm (50÷2). Because f-stops are fractions, the larger the f-number, the smaller the aperture, and vice versa.

The term "to stop down" is universally used to mean the closing down of the aperture to a smaller diameter. To open up means to increase the aperture to a larger diameter.

Increasing the aperture by 1 stop (this is achieved on SLR cameras by the use of an "aperture ring") doubles the volume of light entering through the lens. Decreasing by 1 stop halves the light allowed to enter. So, for example, if you stop down from f5.6 to f8 (this is 1 stop), you halve the volume of light entering through the lens, and if you open up 1 stop from f5.6 to f4, you double the volume of light entering through the lens. This can be confusing, but once you get to grips with the fact that f-stops are fractions then it will start to make sense and be easier to remember.

Many aperture rings also have half-stop positions – for example, an aperture position halfway between f5.6 and f8.

The aperture controls the depth of focus of a lens.

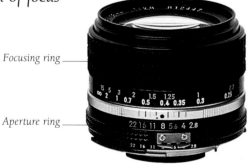

Focusing ring

Aperture ring

DEFINITION

*The **depth of focus** is the distance in front and behind your picture's main subject that is also kept sharply focused. It's also sometimes called depth of field.*

■ **Adjustments to focusing** *and aperture are made through the use of rings around the lens.*

Don't just snap away at your subject without considering the depth of focus.

Your lens has a depth-of-focus scale that tells you how much depth of focus you get at each f-stop. Further to this, many SLR cameras have a stop-down button. This allows you to see the amount of depth you get as you stop down.

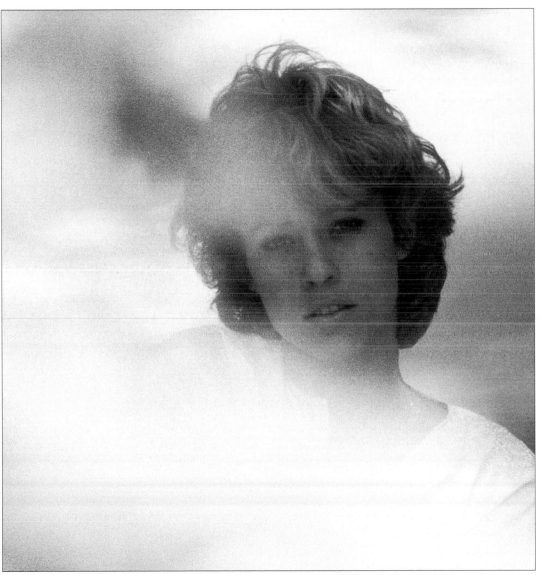

■ **I shot this picture** *at f2.8 with a shutter speed of ¹⁄₂₅₀ of a second in order to keep the girl sharp but blur both the foreground and background.*

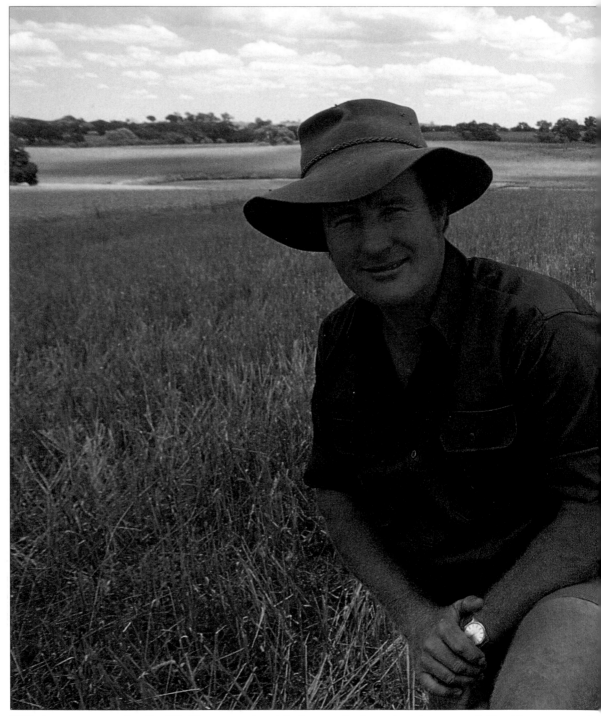

■ **To increase your depth of field,** *try stopping right down and using a slow shutter speed. For this picture I set the aperture to f16 and the shutter to ¹⁄₃₀ of a second.*

Shutter

As I mentioned in Chapter 1, the shutter is the camera mechanism that controls the length of time for which light is allowed to expose the film. There are basically two different designs of shutter mechanisms: the leaf shutter and the focal-plane shutter.

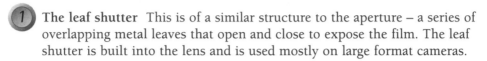

1 **The leaf shutter** This is of a similar structure to the aperture – a series of overlapping metal leaves that open and close to expose the film. The leaf shutter is built into the lens and is used mostly on large format cameras.

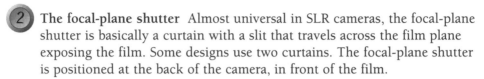

2 **The focal-plane shutter** Almost universal in SLR cameras, the focal-plane shutter is basically a curtain with a slit that travels across the film plane exposing the film. Some designs use two curtains. The focal-plane shutter is positioned at the back of the camera, in front of the film.

TYPICAL SLR SHUTTER-SPEED SEQUENCE

Shutter speeds are in fractions of a second. In all SLR models, electronic shutters now provide speeds from an incredible $\frac{1}{8000}$ of a second up to 30 seconds. When setting shutter speeds manually, every change up to a faster speed or change down to the next slow speed has the same exposure consequence as opening up or stopping down the aperture by 1 stop. Changing from $\frac{1}{250}$ of a second to $\frac{1}{125}$ of a second doubles the length of time for which the light exposes the film, and, of course, when you change from $\frac{1}{250}$ of a second to $\frac{1}{500}$ of a second you halve the length of time that the light exposes the film.

- 1 second
- $\frac{1}{2}$ second
- $\frac{1}{4}$ of a second
- $\frac{1}{8}$ of a second
- $\frac{1}{15}$ of a second
- $\frac{1}{30}$ of a second
- $\frac{1}{60}$ of a second
- $\frac{1}{125}$ of a second
- $\frac{1}{250}$ of a second
- $\frac{1}{500}$ of a second
- $\frac{1}{1000}$ of a second
- $\frac{1}{2000}$ of a second
- $\frac{1}{4000}$ of a second

■ **The range of shutter speeds** *varies between cameras. Yours may have fewer or more options than this example.*

RELEASING THE SHUTTER

When the shutter is in its closed position, not only does the film remain hidden from light but also a mirror reflects the light up to the viewfinder. When you press the shutter-release button, the shutter opens and the mirror lifts out of the way.

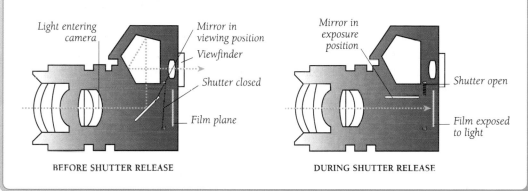

Light entering camera *Mirror in viewing position* *Viewfinder* *Shutter closed* *Film plane*

Mirror in exposure position *Shutter open* *Film exposed to light*

BEFORE SHUTTER RELEASE DURING SHUTTER RELEASE

The aperture–shutter marriage

LET'S SUM UP THE BASICS. *The aperture is the diameter of the lens through which light exposes the film. By increasing and decreasing the size of the aperture (making a bigger or smaller hole), you control the volume of light entering the camera. The shutter is the mechanism that opens and closes to control the length of time the light is exposing the film. The aperture and the shutter are totally wedded together, and one cannot be altered without the other being altered also.*

I will explain this because it's important that you understand the relationship between the two. However, in practical terms most of the rest of this chapter is only relevant to SLR users. Compact, or point-and-shoot, cameras are automated – the camera does all the calculations – and their users are not able to control their cameras to the same degree as SLR users. However, it is worth knowing the theory so I urge you to continue reading this chapter. (We will look at the point-and-shoot camera in detail in Part Two.)

Reading your light meter

When you take a light reading, using either the *TTL metering* on your SLR camera or a separate hand-held light meter, the meter gives you a range of alternative settings, each of which is an average "correct" exposure. That means that each alternative lets in the same amount of light. Point-and-shoot cameras also make exposure readings but the user doesn't know what combination of shutter speed and aperture the camera has chosen. (However, the expensive, top-of-the-line point-and-shoot cameras – called super-compacts – do give you a choice of aperture combinations.)

The light meter (whether built-in or separate) takes a reading of the amount of light reflecting off your subject. However, to get the correct exposure combination you also have to tell the meter what speed (ISO rating) of film you have in the camera.

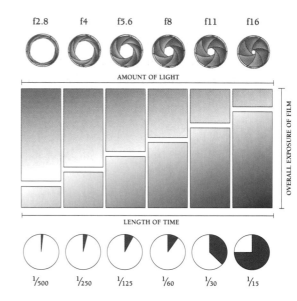

■ **This diagram** *shows a series of six aperture–shutter settings. Each aperture setting is wedded to the shutter speed beneath it. Every one of these six combinations lets in the same volume of light.*

DEFINITION

TTL metering *is through-the-lens light metering.*

How do I choose my shutter speed?

Each aperture–shutter speed combination in the list below is a correct exposure according to the sample meter reading alongside.

Aperture	Shutter speed
f2.8	$\frac{1}{1000}$ of a second
f4	$\frac{1}{500}$ of a second
f5.6	$\frac{1}{250}$ of a second
f8	$\frac{1}{125}$ of a second
f11	$\frac{1}{60}$ of a second
f16	$\frac{1}{30}$ of a second

SAMPLE METER READING

So . . . which combination to use? Does it matter? You bet it does! But in order to make this choice you need to know what other properties the aperture and shutter possess.

You already know that the aperture controls the depth of focus of the lens. The smaller the aperture, the greater the depth of focus; the larger the aperture, the smaller the depth of focus.

Well, the shutter controls movement in the photograph, or in other words, it controls the degree of sharpness or blur that a moving object makes across the frame of your picture. A fast shutter speed – like $\frac{1}{1000}$ of a second – will freeze a cyclist whizzing past the camera, while on $\frac{1}{30}$ of second, the cyclist will appear blurry.

Most unintentionally out-of-focus pictures are caused by camera shake. Shutter speeds must be fast enough to prevent camera shake.

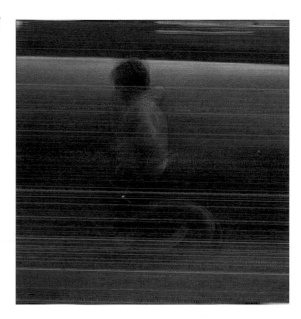

■ **By selecting** *a slow shutter speed when action is moving quickly past you, the effect in the resulting picture will be a blurry image.*

COMBATING CAMERA SHAKE

The longer the lens you have on your camera, the more camera shake you will experience. To reduce the effect of camera shake, your shutter speed needs to increase in line with the focal length of your lens. Use this guide to cut down your blur.

Focal length	Shutter speed
● 24–35mm	$\frac{1}{30}$ of a second
● 50mm	$\frac{1}{60}$ of a second
● 105mm	$\frac{1}{125}$ of a second
● 200mm	$\frac{1}{250}$ of a second
● 500mm	$\frac{1}{500}$ of a second

Exposing with the SLR system

THE EXPOSURE-METERING SYSTEM *of the modern SLR camera is incredibly sophisticated. Most SLRs work either on automatic or manual. Although the metering systems can solve most problems, they are useless unless you know how they do what they do, and you have to know what result you want. As with a computer, cameras can only do the job well if you give them the right instructions.*

I cannot emphasize enough how important it is to study your instruction book thoroughly. Each camera has slightly different systems and I can only talk here in general terms. Always keep your instruction book in your camera bag.

The exposure-metering systems

There are three different metering methods and many SLR cameras incorporate all three. Let's look at each of them.

Center-weighted metering

Center-weighted metering is fairly self-explanatory. The reading is taken from the control area of the viewfinder (usually a 12-mm diameter area). This is the first system used by SLR cameras and is an excellent all-around metering system. You can move the camera around the picture area, make a decision about which area is most important, and set the exposure accordingly.

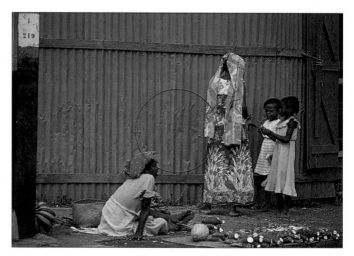

CENTER-WEIGHTED METERING

Matrix metering

This is a sophisticated computer meter. The meter's computer has been fed the exposure values of about 100,000 sample photographs. Each photograph is of a different subject in differing light conditions. With this knowledge at its disposal, the meter can make an accurate exposure calculation on any subject and lighting conditions put before it. The exposure reading is taken from the whole of the picture area. The viewfinder is divided up into

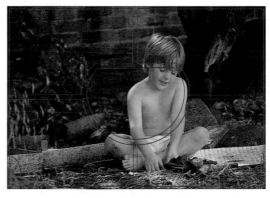

MATRIX METERING

segments, each of which is metered before the computer evaluates the results and makes a decision. Matrix is an ideal system to use before you are confident of your technique. Theoretically, because of its 100,000-picture memory, it can read and solve all the traditional exposure problems such as backlighting. However, in my experience, the matrix system is not infallible and I prefer using spot metering for tricky situations.

Spot metering

Not all SLR cameras have a spot meter, but most of the latest mid- to top-of-the-line models do. The spot meter takes a reading from a circular area of (depending on the camera) 3–5mm in diameter in the middle of the viewfinder. (It uses approximately 2–2½ percent of the viewfinder's area.) By pointing the spot at any area of the picture you can take a precise reading of an area that you consider critical, like the focal point perhaps. Spot metering is perfect for difficult situations like a small (in the frame), brightly lit face in front of a dark

SPOT METERING

background, or the reverse, with a small, dark object against a very light background. You'll find that you use spot metering more and more as you get more experienced.

Many professionals use spot metering for landscapes. They take a series of highlight and shadow readings before making a decision on which is more important. Or they may decide an average is more desirable. They then set the aperture and shutter combination manually.

Aperture priority and shutter priority

Some SLRs set the exposure by the aperture priority method – that is, you set the aperture and the camera automatically sets the correct shutter speed – and some use shutter priority, in which you select the shutter speed and the camera chooses the correct aperture. Most of the top-of-the-line cameras have both methods.

I don't believe both are required because by altering the shutter speed you get the aperture you require for your considered depth of focus. Alternatively, by changing your aperture you can find the shutter speed you want if movement control (not forgetting camera shake) is a critical factor. Each system is as good as the other.

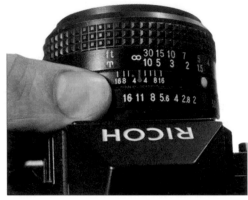

■ **You can alter** *the aperture setting on your SLR camera simply by turning the aperture ring that you'll find on the lens.*

Exposure compensation

An SLR camera has another method for fine-tuning exposure called exposure compensation. Many top-of-the-line point-and-shoot cameras – and not just super-compacts – also incorporate exposure compensation. Some cameras have a dial at the top of the camera body with a scale reading -2 -1 0 +1 +2, while fully electronic cameras display this scale in the LCD when you push the appropriate button (see your instruction book for more in-depth information). Exposure compensation allows the photographer to override the autoexposure and over- or underexpose the film by up to 2 stops in steps of ⅓ of a stop.

INTERNET

www.betterphoto.com/
exploring/groenhout
Exposure.asp

This web page is well worth visiting: it contains an interesting article called "Obtaining Correct Exposure."

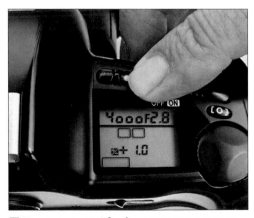

■ **You can override** *the automatic exposure on your SLR and over- or underexpose your film by using the exposure compensation.*

If you have been using exposure compensation, never pack away the camera without first making sure the control is set back to 0. Otherwise you could pull the camera out and accidentally over- or underexpose your next picture.

Exposure compensation is useful when you want creative control of your exposure – when you want to give a different exposure to the one that the auto setting has come up with. Some cameras (including some point-and-shoot models) have a backlight button that increases the exposure by 1½ stops to compensate for the fact that the light pouring straight into the meter through the lens has fooled the lens into underexposing the foreground. The exposure-compensation function does the same thing. I use it for backlighting: at +1½ stops it does the same as a backlight button. I also use exposure compensation when filtering black-and-white film. I go +1 or +1½ stops to make sure that the increased contrast produced by the filter does not leave the shadows underexposed.

When in their fully automated modes, most point-and-shoot cameras will automatically balance the backlight by using a flash fill.

■ **Strong backlight in a scene** *fools the camera's light meter into underexposing the film. I used +1 exposure compensation for this picture to prevent the backlight from ruining the shot.*

SLR programs

Yet another exposure system built into most SLR cameras is called programming. With programmed exposure control, the computer automatically adjusts the aperture and shutter speed to the correct exposure.

To describe programming, I will use the system on my Nikon 90X as an example. Your camera will vary in its programming but the principle is the same.

There are two main programs: the fully automatic Auto Multi Program (P on the LCD screen), which is designed to select shutter and aperture settings for "average" subjects and is high enough to avoid camera shake, and the Vari Program (PS on LCD), which is more flexible and has the following subprograms.

PO Portrait program

Sets the largest aperture for the available exposure value to enable the subject to stand out against a blurry (out-of-focus) background.

HF Hyperfocal program

Stops down the aperture to keep both the foreground and background sharp.

LP Landscape program

Stops down the aperture for maximum foreground-to-infinity depth of focus.

SL Silhouette program

Underexposes a foreground subject against a brightly lit background – for example, a sunset – to make it into a silhouette.

SP Sports program

Selects the fastest possible shutter speed for the lighting conditions in order to freeze the movement.

CU Closeup program

Exposes for closeup shots and ignores the background.

These programs may sound great, but in my opinion they only complicate one's photographic life – and all of them are compromises. I recommend that you use the other systems and learn to make your own decisions. You take the pictures – don't let the manufacturers control your creative decisions.

A simple summary

✔ Every camera available to buy is basically a glorified version of a pinhole camera. However, instead of a pinhole there is a lens, and the viewed image is recorded onto a piece of film.

✔ The diameter of a lens is called its aperture. Lens aperture is adjusted by the use of an iris diaphragm to let more or less light into the camera.

✔ Aperture is measured as an f-stop, or f number, which is a fraction of the lens's focal length. The larger the f-number, the smaller the aperture.

✔ The shutter controls the length of time for which the film inside the camera is exposed to light.

✔ Aperture and shutter work together. If one is altered, the other must be too.

✔ A light meter will give you several aperture–shutter choices, but to make a correct exposure you must also tell the meter what speed film you are using.

✔ The same amount of light will expose the film in any one of several aperture–shutter combinations.

✔ There are three different SLR exposure-metering systems: center-weighted, matrix, and spot metering.

✔ Your camera may expose by aperture priority or by shutter priority. In each case, you select one setting and the camera automatically adjusts the other.

✔ Exposure compensation is useful when you want a different exposure setting to that which the camera has selected.

✔ Many SLRs also have an exposure program system that contains appropriate settings for certain types of photography.

Chapter 3

Which Camera to Choose?

CHOOSING WHICH CAMERA to buy can feel like walking through a minefield. The advertising hype confuses the issue considerably. We can defuse the problem by asking ourselves a few simple questions. This chapter suggests what those questions might be for you and helps you formulate a sensible and cost-effective answer.

In this chapter...

✓ What camera should I buy?

✓ But I like my current camera . . .

✓ In simple terms

A GOOD SUBJECT SHOT WELL WILL MAKE A GOOD PICTURE REGARDLESS OF THE CAMERA YOU USE

What camera should I buy?

THIS IS A VERY DIFFICULT *question to answer. Over the years I have had hundreds of friends and acquaintances ask me that very thing. I would guess that almost all of you who have bought this book probably have at least one camera at home, so what we're really talking about is what camera to buy next.*

I think I can be most helpful by asking you a few questions first. The first, and probably the most important, one is "What's your budget?" I need to jump in here and say that cameras have never been as cheap as they are now. When you consider salaries and inflation, cameras cost about half what they did in the early 1970s. Even a fairly small budget can get you a surprisingly good camera.

■ **It can seem** *pretty complicated out there in the camera stores. Even after you've decided which type to buy, there is still a huge range to choose from.*

What are my needs?

Once you've decided how much you want (or can afford) to spend, you need to consider what you'll be using your camera for. Ask yourself the following questions:

1 **What do I want to photograph?** This is an important question. For example, if you are about to go on a safari and are hoping to take some great pictures of the African wildlife, you should immediately discount a point-and-shoot camera. You just can't get the sort of intimate, closeup shots that you would undoubtedly want to capture in such a phenomenal setting. For photography such as this, only a 35mm SLR camera with a long lens (or two) will suffice. If you want to take some pictures of your newborn child and continue to do so as he or she grows up, however, an APS camera might provide the perfect solution.

2 **Will I be the only person using it?** The reason you need to ask yourself this is because, if the answer is no, you will need to bear in mind the needs of the other users in terms of both camera capabilities and simplicity of use. You may be the world's biggest technophile, but maybe the others users are not. Most point-and-shoot cameras offer a choice between total automation and the user having some degree of control, so this might be a good choice for multiple users.

(3) **Am I more interested in technique or creativity?** The basics of photographic technique are applicable to all cameras and even a cheap compact will offer some practice opportunities. Regarding creativity, you can, of course, be creative with a point-and-shoot camera through your choice of subjects, but if you want to maximize your creative control over the images you produce you need to consider a fully manual 35mm SLR. However, if your creative input is going to come at a later stage, using a computer after the picture has been taken, you might want to consider going digital from the beginning.

(4) **What will I do with the images I produce?** There are many different options here: You may want to e-mail them to friends and family, make huge prints to decorate the inside walls of your home, or document your daily life, for example. I would suggest digital, 35mm SLR, and either APS or point-and-shoot cameras respectively.

But I like my current camera . . .

IF YOU ALREADY HAVE A CAMERA that you love and you are happy with the results it gives you, don't be bullied into buying a new high-tech model. Knowing your camera is a vitally important part of producing creative work.

■ **Buying a new camera** *doesn't mean you have to throw away your old one. Why not keep it as a backup?*

On the other hand, though, you might want to take advantage of some of the new technologies, like autofocus and improved zoom lenses. There are some great budget models available now that are aimed at the keen amateur – many are even of suitable specification for professionals. Or, if you have a point-and-shoot camera, you may feel that you would like a little (or a lot) more creative freedom, in which case why not get an SLR, and keep your much-loved compact as a second camera?

There are some real brand-new camera bargains out there, but you could also consider buying secondhand from a camera store that you trust.

In simple terms

OKAY, LET'S GET DOWN to the nitty-gritty. I'm going to give you a brief, simple breakdown of which cameras are best for which people. Of course, this list can only be in general terms: You might feel you don't quite fit into any of these categories, or that you fit into more than one. Please use this list as a guideline; only you know what you want from your new camera.

Computer minded

If you are a computer expert, you may enjoy manipulating your pictures using some photography software on your computer before printing them out. Or you might want to e-mail images to your family and friends. If that sounds like you, I would be inclined to say, "Go digital." The prices of digital equipment are higher than those of conventional gear but they're coming down fast . . . and you won't have to pay for developing ever again.

No hassle required

If you are looking for the simplest, most hassle-free camera, go for an APS point-and-shoot camera. Although they are tiny, the quality of image is pretty good (but not as good as on a 35mm point-and-shoot camera because the negative is half the size). If you follow my tips on composition and light, you will be able to use your creative eye to produce some exciting photographs. I also think an APS is worth considering as a second camera if you already have an SLR you are happy with.

Don't fall for the APS as a fashion accessory. They may look good but is that what you really need photographically?

■ **APS cameras** *offer a no-hassle option. It's possible to take some great pictures, and if you want a reprint, you select it from your index print – no more trawling through negatives!*

Quality and convenience

If you want better quality than APS offers, go for a 35mm compact with either a fixed or zoom lens. A fixed-lens compact usually has a wide-angle lens of 28mm, 32mm, or 35mm. These cameras are nearly as small as APS cameras and can produce good pictures. The quality of the lens and the strength of the flash improve as the price goes up. If you are going for a zoom-lens compact, don't buy one that is too telephoto; the maximum aperture at the 135mm end of a point-and-shoot zoom is about f11 to f16, which is pretty useless, so don't go over 105mm. Play around with the camera for a while. The feel and balance is very important. Choose a camera that feels comfortable in your hands. I would strongly advise you not to buy loads of modes that you don't need – they will cost extra. There are also some super-compacts available that have superb lenses, both manual and auto. They are made as snap cameras for professionals and can set you back a lot of money.

Getting serious

If you want to get serious about your photography there is no doubt in my mind that you need a 35mm SLR camera. The 35mm is incredibly versatile and, in the right hands, can produce images of a stunning quality. SLRs have an enormous range of lenses and accessories that will allow a photographer to shoot almost anything at all. My lenses range from 15mm to 1000mm.

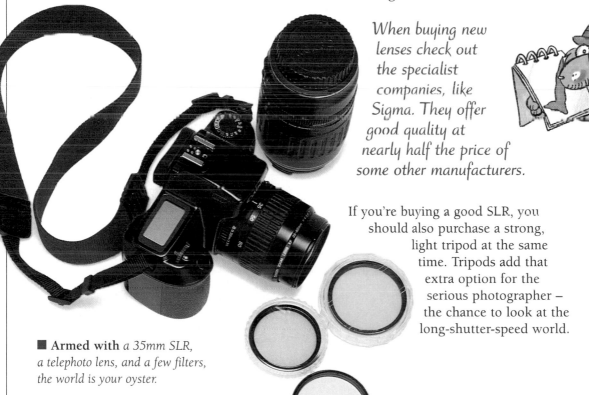

When buying new lenses check out the specialist companies, like Sigma. They offer good quality at nearly half the price of some other manufacturers.

If you're buying a good SLR, you should also purchase a strong, light tripod at the same time. Tripods add that extra option for the serious photographer – the chance to look at the long-shutter-speed world.

■ **Armed with** *a 35mm SLR, a telephoto lens, and a few filters, the world is your oyster.*

BUILDING UP YOUR EQUIPMENT

For those of you who are thinking about going SLR, here is a list of recommended equipment that you can build up in stages.

Stage 1

- Camera body
- Waterproof camera bag
- 28–70mm zoom
- Polarizing filter
- Orange filter
- Red filter (for black-and-white work)
- Tripod

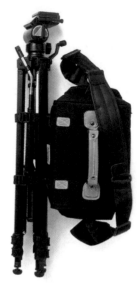

Stage 2

- 80–200mm zoom
- Flashgun with extension cord

CAMERA BAG AND TRIPOD

Stage 3

- 20mm wide-angle lens
- Large aperture 50mm f1.4 lens, for photography where flash isn't possible
- Underwater compact for beach vacations

UNDERWATER COMPACT CAMERA

If you can't afford an underwater compact, buy a handful of underwater single-use cameras whenever you go on a beach vacation. They are literally point-and-shoot cameras, but the results are often great!

Stage 4

- A good point-and-shoot camera, for those occasions when you don't want to take all your equipment but a good picture opportunity may come up

When you are looking to buy a brand-new camera it's important to keep an eye on the product reviews in photography magazines. The reviewers are experienced photographers, so take advantage of their advice.

Do haggle when you are buying a new camera. The salesperson might throw in a bag of filters or some other useful accessories to secure your business.

INTERNET

www.camerareview.com

This is a great place to start if you're not sure which SLR camera to buy. You can even type in what features you're looking for, and they'll come back with a list of cameras that fit the bill.

A simple summary

✓ The first thing to consider when buying a camera is your budget.

✓ Cameras are less expensive now than they have ever been.

✓ Once your budget is decided, four other points need to be considered: what you'll use the camera for, whether you'll be the sole user, how creative you want to be, and what you'll do with your resulting images.

✓ If your old camera works just fine and you know how to get the best out of it, keep it, even if you do buy a new one.

✓ Going digital is worth considering if you want to manipulate your images or e-mail them to people.

✓ If you want a hassle-free life, an APS is a good choice.

✓ A 35mm compact offers better print quality than APS, and it's not that much bigger.

✓ If you really want to maximize your creative-photography potential, get a 35mm SLR.

✓ Camera reviews in photography magazines are invaluable sources of advice for buyers.

Chapter 4

Film

SELECTING FILM is almost as confusing as choosing a camera. Advertisements tell us that this brand of film is better than that one, and if we really listened we might believe that we couldn't take a good picture without their product. The truth is that all the films on the market are good. Let's see what they are all about.

In this chapter...

✓ Film choices

✓ Film speed

✓ Color print film

✓ Color slide film

✓ Black-and-white film

✓ Special films

Film choices

BRAND NAME isn't the most important consideration in choosing film – so what is? Before you can make a choice you need to know what's available. The three main groups of film are **color negative** (or print film), color positive (or slide film), and black-and-white film. (When talking about black and white we are almost always referring to negative film.)

ROLL OF 35MM FILM

> **DEFINITION**
>
> **Color negative** *film produces a negative, or reverse, image, from which your print is made. You will hear people refer to color negative film as print film.*

Don't buy old film even if it's on special offer – it's simply not worth the risk. As with everything else in the supermarket, check the sell-by date on the packet.

To help you decide which group of films to choose from, we will look at each of them in detail, but first of all I'm going to teach you about film speed.

Film speed

FILM SPEED is one of the most used terms of photographic jargon, and it refers to a film's sensitivity to light: the faster the film the more sensitive it is to light. A fast film, therefore, requires less light than a slow film to produce a photographic image.

Film speed is calculated in ISO ratings, and you can buy film from as slow as 25 ISO to as fast as 3200 ISO, which can in turn be *pushed* up to 25000 ISO – I'll move onto that in a minute.

> **DEFINITION**
>
> *ISO is simply an abbreviation for International Standards Organization. Some of your older cameras and books will have an ASA rating. ASA ratings are exactly the same as ISO ratings. The term **pushing** means to expose a film to less light than its ISO rating dictates. You need to tell your lab if you do this because they will have to develop the film differently. Pushing is sometimes also known as uprating.*

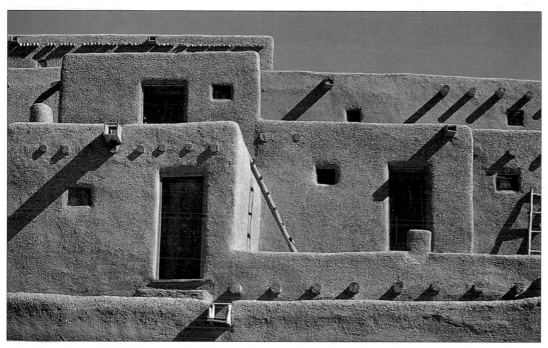

■ **A slow film (100 ISO) was ideal** *for the detail in Adobe House, New Mexico. It's hard to see here, but the 35mm negative enlarges to 16 x 20 inches (40 x 50 cm), pin sharp and almost grain-free.*

As a general rule of thumb, the slower the film, the smaller the grain and the sharper the image. Contrast is also related to film speed – the slower the film, the higher the contrast. Also, when specifically discussing color, the slower the film, the more saturated the color will be. It follows, then, that the faster the film, the grainier it is, and the softer its contrast, color, and sharpness.

Films have their ISO ratings on the box, and they usually start at 100 ISO with 200 ISO, 400 ISO, 800 ISO, and 1600 ISO following. ISO ratings are in logical relative steps, so a 200 ISO film is twice as sensitive to light as a 100 ISO and requires half the volume of light to produce a satisfactory image.

■ **Here I used a fast slide film** *pushed even faster (1600 ISO pushed to 3200 ISO) for a soft, grainy effect. I was trying to get the feel of an Impressionist painting.*

Everyday choice

Before we go into any great depth, I'll strongly advise you to buy 400 ISO film regardless of which type of film you are using. I recommend this because it's fast enough to cope with most light situations and the grain structure has become much finer recently. Another benefit of 400 ISO as standard is that it's fast enough to reduce the effects of camera shake, which is the most common cause of out-of-focus pictures.

If you are using telephoto lenses, use a fast film – 400 ISO or faster – because camera shake is magnified by telephoto lenses. Fast films allow for faster shutter speeds, which in turn overcome camera shake. Or you could use a tripod.

Pushing and pulling

To push film you need to increase the film speed at which the camera is operating. This is usually done either with a dial, which you will probably find on the top of your camera, or via a menu system. Ordinarily, this setting should correlate to the ISO rating of the film you are using. Check your camera's instruction manual if you can't find the control. Often, unfortunately, this is not possible on a compact, or point-and-shoot, camera.

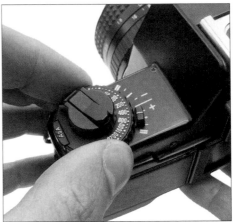

MANUAL SLR DIAL

Just to complicate things, film speed is also related to development. Increasing the development time from normal has the same effect as increasing the ISO rating, and both methods are known as pushing.

Never change your camera's ISO setting in the middle of the film. Some of the film will be well exposed and some won't.

Professional photographers have been pushing their films for years. There are two reasons for this:

1. To obtain a satisfactory image when the lighting is too low for the film being used

2. To take advantage of the increased grain size to produce a painterly effect

Pushing film also results in increased contrast. Recently, new chemical technology has resulted in a breed of special push films. These films have an ISO rating as normal but are designed to be processed at an extra 2–2½ stops, so an 800 ISO film could be developed as though it were a 4800 ISO film. This greatly increases the contrast and grain size.

Before you buy push film, make sure that your photolab does a push service. If not, find a local professional lab.

It's important to grasp the point that the pushing of a film from 400 ISO to 600 ISO is the equivalent of opening up the aperture half a stop, and pushing from 400 ISO to 800 ISO is equal to opening up 1 stop.

Try to use the correct terminology when talking to your lab — they will take you more seriously. If you want your 400 ISO pushed to 800 ISO tell them you want it pushed 1 stop.

Pulling film down from the rated speed to a slower ISO rating is also possible but, unless you have mistakenly shot a 400 ISO film at 200 ISO and need to compensate in development, I don't think there's any point in pulling film. You may as well use a slower film and cash in on its properties – the finer grain and increased color saturation.

Keep a permanent marker in your bag so that you can immediately write down the ISO rating to which you pushed the film on the canister or the film itself as soon as you remove it.

Experiment with pushing and pulling films, but I highly recommend that you use the special push films. Don't miss out if your supermarket (or wherever you buy your film) doesn't stock them, find a professional camera store in the nearest big city and buy some. The quality is even better than the general range.

Never throw an exposed film into your bag thinking you will mark it later — you will forget and ruin a great film.

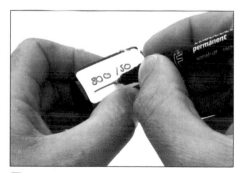

■ **It's important** *to mark a pushed film as soon as you remove it from the camera. If you pushed a 400 ISO by 1 stop – for example – mark it 800 ISO.*

Grain

The light-sensitive photographic emulsion on film is formed by silver crystals, and it's these crystals that give a grainy texture to your images. In order for a fast film to catch more light quicker than a slow film, the silver crystals (and therefore the grains on the photographs) are larger. A slow film is coated with smaller crystals. The slow film's small grain size makes for a less grainy effect and also allows for a higher resolution because the image is not being broken up by the larger grain structure of fast film. Some photographers hate grain and others love it.

Most professionals don't agree with the film speeds quoted by the manufacturers. For maximum quality at normal development I would rate 400 ISO at 320 on my meter and 200 ISO at 125.

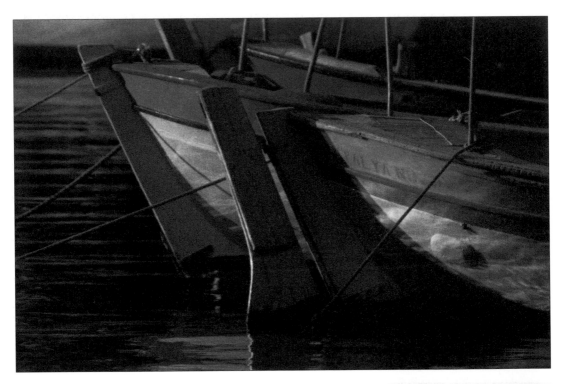

■ **Although I didn't need** *a fast film to obtain a satisfactory exposure, I used a 1000 ISO pushed to 2500 (2¼ stops). It was a creative decision. I visualized soft, merging colors, rather than the clean, hard-edged colors that a 100 or 200 ISO film would have given me. My romantic period . . . or something! Note the large grain structure in the detail.*

In real life, however, unless you are making an *enlargement* larger than 10 x 8 inches (25 x 20 cm), you will notice very little difference in grain size between 100 ISO and 800 ISO film on your prints.

DEFINITION

*An **enlargement** is simply a large print.*

If you want to experiment with grainy pictures you need to find a custom lab — one used by professionals — and discuss technique with them. Severe push development of fast film is the usual method.

Very grainy color can have a romantic atmosphere similar to an Impressionist painting. Grainy black and white looks like an old etching.

■ **This still life required** *a different film than the one I used opposite. My wife Michelle used a very slow (50 ISO) transparency film to get the ultimate in color saturation, fine grain, and sharpness. This time in the detail, note how fine the grain structure is.*

Color print film

THE MAJORITY *of newcomers to photography will be used to using color print film, and it's for this reason that I'll discuss it first.*

Color print films have improved greatly over the last 10 years. They're sharper, have a finer grain, and are capable of better color rendition. In fact, it's the improvement in print film that has made the APS possible.

The APS negative is almost half the size of a full 35mm negative, so it needs the new high-quality films in order to produce a good print.

> **DEFINITION**
>
> **Exposure latitude** *is the amount a film can be under- or overexposed and still produce a satisfactory print.*

The advantage of print film over slide film is its *exposure latitude*. Print film can be under- or overexposed by 2 stops and still produce a reasonable print. This means that the camera's metering system doesn't need to be very accurate, which is why you can achieve remarkably good results with cheap point-and-shoot cameras. It's this latitude that has led to sports and press photographers turning to color print film recently.

The color print film processing system is called the C41 process.

Print film is far more tolerant to tungsten and other artificial light than slide film. It's even possible to correct at the printing stage a color cast that has been recorded on the negative. Also, there are warm- and cool-tone films on the market, so you can choose whether to go for natural subtle colors or very saturated colors.

■ **I have chosen** *a negative with a full range of colors so that you can see, by comparing it to the print, how colors look in negative form. You'll see that they are the opposites of each other: the greens of the negative print as reds, for example.*

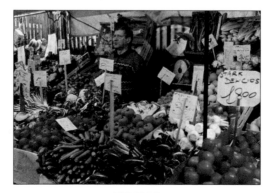

THE PRINT

THE NEGATIVE

Color slide film

MOST PROFESSIONAL PHOTOGRAPHERS *still use* **transparency** *film for their color work. The reason is that you can control the result in the camera. You are not reliant on a printer or an automatic printing machine for your results. Transparencies are the ultimate in color quality. If you are a point-and-shoot user, the next couple of pages will be only of academic interest to you, because the compact camera's exposure system is built with print film in mind. The metering is not sufficiently accurate to deal with the lack of exposure latitude that slide film offers.*

DEFINITION

The word **transparency** is simply the professional term for a slide.

SLIDE

MOUNTED SLIDE

Exposure is subjective and relative to your visualization of a subject. One person's "correct" exposure may look overexposed to somebody else.

If you are after a dark, moody image you can underexpose the transparency film without worrying that a printing machine will compensate for the underexposure and try to produce a "correctly exposed" print. You have much more creative control.

If you used a color-correction filter to change the color balance of a scene, you would know that what you see in the viewfinder is how the transparency is going to look – without the interference of a printing machine.

An automatic printing machine is designed to produce an average, or normal, print, which may not be what you want creatively.

Trivia...

Slide film is distinguished by the word "chrome" at the end of the trade name – for example, Kodachrome, Ektachrome, Fujichrome, Agfachrome. Color print film has the word "color" at the end.

Bracketing

When shooting on slide film, most professionals *bracket* their exposures. The reasons are twofold:

1. If you are being paid lots of money to take a picture, you can't afford to risk an exposure mistake

2. A shot that is under- or overexposed (by the meter's calculation) can sometimes have a great look to it that the photographer didn't visualize through the viewfinder

I strongly advise you to bracket your exposures whenever it's practical – when shooting landscapes and still lifes, for example.

Never bracket exposures on unrepeatable subjects like sports or children playing because the best shot could be the one that is over- or underexposed.

DEFINITION

*To **bracket** exposures means to take a series of exposures both under and over the meter reading. With your SLR you will most probably have an exposure compensation facility that allows you to go up or down 2 stops in ⅓-of-a-stop increments.*

The clip test

Another safety procedure is to have your lab process a *clip test*. If the test is light or dark you can ask them to adjust the remaining film and development of it accordingly. You need to find a good custom lab for this sort of service.

DEFINITION

*A **clip test** is a short piece of film – about three frames – cut off the start of the film and developed, to check that your exposures are perfect.*

Film manufacturers produce both a professional line and an amateur line of slide film. Check out the pro films, they are superior. A recent development has been the introduction of warm-tone and cool-tone emulsions. The cool tones are more suitable for skin tones and the warm tones are more suitable for producing saturated, vibrant colors.

Don't use warm-tone films for portrait work. The skin tones can have a magenta cast.

When using slide film in tungsten light, it's important to remember that you need to use tungsten-balanced slide film. Daylight slide film will go reddish in tungsten light. You can, however, shoot with daylight film and correct it with an *80B filter*. Or filter your tungsten lights with 80B filters!

DEFINITION

*An **80B filter** is a blue filter that restores the color temperature of tungsten light back to daylight.*

Trivia...

Many pros are obsessive about clip testing and will have their films pushed or pulled about ¼ of a stop after inspecting the clip. Too small a margin for the average amateur to notice.

The slide show

Call me an old romantic, but you haven't really seen color photography if you've never seen a slide show. Slides projected onto a big screen look fantastic; I still project mine and add some background music. Slides can be made into great prints, too. Although it's more expensive to make prints from color slides versus using color print film, you do have the slide as a guide for your print quality.

Color transparency film is called color reversal film by the manufacturers because it is first processed as a negative and is then reexposed halfway through the process. The reexposure reverses the image to a transparency, which is a positive image.

Black-and-white film

I WILL DISCUSS *the visualization of our colorful world in tones of black and white in Chapter 22; in this section I'll simply tell you about the black-and-white films available and suggest which films work best in which circumstances. To get the most out of black-and-white photography, ideally you need to develop and print your own work – the great joy of black and white is watching that printed image magically appear in the developing dish. However, if you're new to photography that's all in the future . . . or you may decide to leave it to somebody else.*

THE NEGATIVE

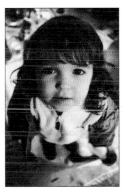

THE PRINT

Black-and-white photography has had a big revival lately and the manufacturers have responded by producing what are called **chromogenic** black-and-white films. These films can be processed by photolabs using the C41 (color print film) chemistry rather than the conventional black-and-white processing that needs more individual attention.

Most major film manufacturers, including Kodak and Konica, produce chromogenic black-and-white films.

Chromogenic films are great to experiment with to see if you like black and white.

Chromogenic films have a dye image rather than the silver crystal image of conventional black-and-white film.

Conventional black-and-white films have a huge range of ISO ratings from 25 ISO to 3200 ISO, which can be processed up to 25000 ISO. I strongly recommend that you find a good custom lab specializing in black-and-white printing before you start experimenting with conventional black-and-white films. Otherwise the prints might be disappointing and turn you off.

INTERNET

www.apogeephoto.com/
buyguide/index1.htm

Click on "Film" for a selection of film manufacturers; for each one there's a detailed product guide.

■ **The rain** *was coming down and the light was murky, but I love this Scottish castle and I didn't have time to wait for the perfect light. By pushing 3200 ISO film to 6400, I made a picture that I feel works pretty well. The grainy texture is sympathetic with the rugged scenery and wintry weather.*

When choosing black-and-white film we have the complication of too much choice, mainly between the traditional and the chromogenic chemistry. As with slide and color print film, the basic black-and-white workhorse is the 400 ISO. It's extremely versatile, the grain structure is smooth, and it can be pushed by 2 stops, if necessary, without the quality suffering too much. Also, it can reproduce a very large range of tones.

Special films

THIS CHAPTER MAY HAVE BEEN *a bit technical if you're new to photography, but now you are aware of the main film types. In these last couple of pages I will tell you about two different and more unusual types of film.*

Polaroid

Although Polaroid™ instant photography is more expensive than using other films and you can't easily make cheap prints from the original, it is still popular because you get instant images. Also, Polaroid is a much relied-upon tool of the professional. Most advertising and studio photographers take Polaroids as a test of their lighting and exposure before making the final shoot on conventional film.

POLAROID PICTURES

Polaroid is popular with art photographers too, who manipulate the processing to produce some extraordinary effects. You can also buy Polaroid transparency films. These are very interesting and worth experimenting with.

To process instant Polaroid transparencies you need a processing machine. It's small and inexpensive.

Polaroid makes a black-and-white print film that has a permanent negative from which you can make an instant print in the conventional way. I like the tonal range of the 100 ISO black-and-white Polaroid slide film, and the 400 ISO is good, too, but contrasty. The color transparencies have an unusual, almost painterly, quality. The emulsion is very fragile, however, and you need to mount the transparencies in glass slides or protective sheets as soon as possible to avoid scratches.

I have often used Polaroid black-and-white transparency film when giving lectures. I do a series of demonstration portraits and project them up on a huge screen.

Infrared film

Infrared film uses the invisible light at the infrared end of the spectrum. The film is sensitive to reflected light – the light bouncing off leaves, for example. The ISO ratings are only to be used as a guide, and the results, although unpredictable, can be spectacular: blue skies come out black and green foliage goes a ghostly white. I recommend you use a deep red filter with infrared film.

Infrared black-and-white film is useful for cutting through haze and giving detail to infinity when little is visible to the eye. Color infrared was trendy in the late 60s and early 70s. The wild colors it reproduces – greenish faces, magenta grass – fit in with the psychedelic scene at the time. If you decide to experiment with infrared – and why not? – you'll need to use a professional lab. Remember you must be very careful to load and unload the film in the dark.

A simple summary

✔ Brand name is not necessarily important when buying film.

✔ There are three main types of film: color negative, color positive, and black and white.

✔ The term film speed refers to a film's sensitivity to light: the faster the film, the more sensitive it is to light.

✔ Film speed is shown in ISO ratings. The higher the ISO number, the faster the film.

✔ A 200 ISO film is twice as sensitive to light – it needs half as much light – as a 100 ISO film.

✔ Your standard film purchase for everyday use should be 400 ISO.

✔ The ISO setting on your camera should match the film inside it.

✔ Pushing a film means to expose it to less light than dictated by the ISO rating; it will increase the grain size on the print.

✔ Most professionals use color slide film rather than print film. This gives them more creative control over the final image.

✔ It's worth experimenting with some of the chromogenic black-and-white films now available.

PART TWO

BIGGER ISN'T NECESSARILY BETTER

THE POINT-AND-SHOOT CAMERA

PEOPLE OFTEN ASK MY ADVICE and start with, "I only have a point-and-shoot camera but" You should never apologize for your compact camera. Compacts are serious cameras, far *more sophisticated* than those used to shoot many of our favorite images from the past.

However, contrary to what the advertisements tell you, they can't take beautiful pictures by themselves. We take the pictures – cameras are *just machines* with no taste, no design sense, and no color sense: That's where we come in, folks; that's our job. In this section we'll look at the different types of point-and-shoot cameras available and how to control all their *automatic features*. I want you to be able to make the camera do what you want it to do rather than what it has been programmed to do. So if you care how your pictures turn out, read on

What You Get for Your Money

THE TECHNOLOGY built into our point-and-shoot cameras has galloped ahead in recent years. These days, compacts employ little electronic motors that automatically focus and zoom the lens, turn on and complete the exposure on the flash, and perform a seemingly infinite number of other functions. All the tasks that, until fairly recently, photographers had to figure out for themselves. In this chapter we're going to look at the different types of compact cameras that are on the market, and I'll discuss their advantages and disadvantages.

In this chapter...

✓ What are my options?

✓ Compact camera types

✓ What will I get for my money?

EVEN AN INEXPENSIVE CAMERA CAN PRODUCE EXCELLENT RESULTS WITH A LITTLE CREATIVE PLANNING

What are my options?

IN CHAPTER 3, *we looked at the choices available to you when buying a new camera. In this chapter we're going to concentrate on the different types of compact camera in more detail. For those of you who are planning to buy a new point-and-shoot camera – whether it's your first or an upgrade – it's important to know what you get for your money.*

You may be asking yourself, "Is it worth jumping from the $50 price point to $300?" for example. Well, there's no easy answer, but I'll try to simplify things by putting point-and-shoot cameras into four major categories:

1 35mm compacts

2 APS, or Advanced Photo System, cameras

3 Digital point-and-shoot cameras

4 Single-use cameras

APS CAMERAS

You also need to know that, in general, you get what you pay for. In short, the more money you spend, the more modes and facilities you get:

1 Your flash power will increase

2 Your zoom lens will zoom further

3 You'll have greater control over exposures

4 Your lens will be better quality

There are new point-and-shoot cameras arriving on the market almost daily. Keep up to date by reading reviews in photography magazines.

COMPACT CAMERA WITH ZOOM LENS

Unique selling points

Camera manufacturers, like all electronics companies, build in "unique selling points" (USPs, sometimes just called SPs) that they want us to believe that we can't do without. Of course, these USPs are meant to seduce us into parting with as much money as possible. I want to help you make decisions that result in you owning the camera that suits your needs and your pocket, not the camera that the industry wants to sell you.

Don't pay for stuff you don't want – check the camera specifications carefully.

Compact camera types

AS I MENTIONED, *there are four basic types of compact camera and you may be interested in any one or more of them. For example, although you own (or will own) a 35mm compact, you might still buy some single-use waterproof cameras for when you go to the beach. Let's look at the cameras.*

35mm compacts

The 35mm point-and-shoot camera has been around a long time: The first one was marketed in 1976 by Konica. It's based on the 35mm rangefinder and SLR (single lens reflex) cameras that have been the workhorses of the professional photojournalist since Leica came on the scene in 1925. The film for these cameras comes in metal cassettes and the camera shoots 1½ x 1-inch (36 x 24-mm) negatives or transparencies (slides). The 35mm point-and-shoot camera is still preferred by the serious photographer over the APS camera because it produces a larger negative. This, in turn, means prints of a higher quality because an APS negative requires more enlargement to produce a print of the same size. The 35mm compact also wins when compared to the digital compact – the image quality is superior – but digital technology is closing the gap rapidly.

35MM COMPACT CAMERA

APS cameras

When the first APS camera was launched, I was very dismissive of it as simply a marketing scam. After all, the negative size is about half the size of a 35mm negative so the *quality* can't be that good. Also, although APS cameras are more compact, they are not so much smaller to make a big difference in your pocket or handbag.

> **DEFINITION**
>
> *Photographers use the word* **quality** *as an all-embracing term that covers sharpness, grain size, color saturation, and contrast.*

However, what has made the APS an attractive alternative to 35mm is the choice of print formats. You can choose from three different print shapes at the flick of a switch on the camera, and you can keep changing throughout the film. When you get your film developed, you are automatically supplied with an index print of all the pictures on the film in miniature, with each picture numbered, making it easy to pick the image you want to blow up. Although you'll notice that the quality of a large print (over 8 x 10 inches [20 x 25 cm]) is inferior to one made from a 35mm negative, the quality is okay, and the convenience factor considerable.

APS CAMERA

I think the APS is the ideal camera to record your lifestyle and to use as a visual diary.

The designs are getting pretty fancy too, ensuring that you look super-cool when wearing one around your neck! The whole design concept of APS was to make picture-taking foolproof – and they've gotten pretty close.

■ **APS cameras** *offer the user three different print formats: classic or C-prints (shown here by a black outline), high-vision or H-prints (yellow outline), and panoramic or P-prints (red outline). All of these are obtained from the standard APS negative. You specify your chosen format on the camera before each shot, and your photolab prints the image to your choice.*

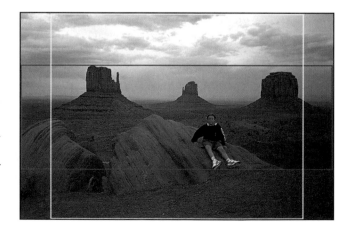

Digital point-and-shoot cameras

The newest addition to the point-and-shoot world of photography is the digital camera. Photography without film is the greatest technical advancement in the last 100 years. The actual taking of the pictures is the same as with a conventional film camera, but the image is recorded on a light-sensing chip instead of on light-sensitive film. The camera's computer stores the images digitally and you can then download those digital files into your computer. If you have the appropriate software you can retouch them, manipulate them, print them out, or e-mail them to friends and family, who can view them on their monitor or print them out themselves. It's really amazing.

■ **You may be unfamiliar** *with the shapes and layouts of some digital cameras, but don't let that put you off. All the usual controls are there, and within a short amount of time you will be comfortable with them all and snapping away just as confidently as with any compact camera.*

Everything that I say about taking pictures throughout this book applies as much to digital photography as it does to shooting on film. (I've also devoted the last two chapters of the book to digital work.)

The great advantage of digital photography is that you can make your own prints, which means no more developing and printing costs.

■ **In bright light** *the LCD screen may be difficult to view, so some cameras offer a brightness control to help compensate for such conditions.*

Digital disadvantages

The main disadvantage of going digital is that the cameras and equipment are still more expensive than their conventional counterparts. Also, unless you are spending several thousand dollars, the quality of digital enlargements is still inferior to film enlargements. However, digital prices are coming down fast, and within a few years they will be competitive with conventional cameras. Another problem I find with digital cameras is the time gap between pictures: While the camera is storing the image you can't take another picture. This takes several seconds, which I find frustrating.

Although most of the new digital models look much like a conventional camera, the big difference is that digital cameras have an LCD viewing screen, which you can use as a viewfinder, as well as providing an optical viewfinder.

> **DEFINITION**
>
> LCD *stands for liquid crystal display.*

Don't use your LCD as your sole viewfinder.

To avoid draining your battery, you should use the LCD for playback only; look at the picture you've just taken and store it if you like it. Otherwise erase it and reshoot it.

Single-use cameras

Most film manufacturers market disposable single-use cameras that come loaded with film, usually 400 ISO. These cameras have a fixed-focal-length lens, one shutter speed (usually $\frac{1}{1000}$ of a second), and a built-in flash that works efficiently up to 13 ft (4 meters). In bright light these machines produce surprisingly good results. There are also underwater versions available.

Single-use cameras are useful if you forget your camera, or for taking to the beach to avoid ruining your normal compact.

■ **Don't risk ruining** *your expensive compact with sand and seawater – just buy a single-use waterproof camera for beach vacations.*

I think the underwater cameras are fun to take on vacation, especially if you anticipate scuba diving or snorkeling.

Special compacts

There are some other compacts that don't quite fit into the four basic types that I've mentioned above. These include the underwater and sport cameras.

Underwater compacts

There are several weatherproof compacts on the market with underwater capabilities. They're waterproof, sandproof, and dustproof, and they can take underwater pictures down to a depth of about 16 ft (5 meters). You can drop them on the beach and wash them off later without worrying about ruining them. They perform very well above water too.

Sport, or off-road, cameras

These cameras are resistant to water, sand, and dust, and are useful for outdoor enthusiasts. However, sport cameras are not suitable for underwater photography.

■ **Waterproof and stylish** – *what more could you ask for on the beach?*

What will I get for my money?

LET'S LOOK NOW at roughly what you might expect to get for your money. I have broken down the market into five price points. As time moves on, we might find that we get more features for less money, but then you have to consider inflation, too Therefore, use this as a guideline only.

Level 1 (under $50)

The basic 35mm point-and-shoot camera will have a fixed-focal-length lens that has no autofocus. The manufacturers set the focus on the lens at about 6–8 ft (2–2½ meters). The fixed aperture, between f5.6 and f8 on a lens of around 32–36mm, will hold most pictures sharp. (These specifications will vary between cameras.) The shutter will be fixed at about ½₁₂₅ of a second. Finally, you will have a flash, probably with an on/off switch; *flash throw* will be approximately 20 ft (6 meters) when using 400 ISO film. However, in spite of their limitations, you can take good pictures with these cameras if your eye is good enough.

BASIC POINT-AND-SHOOT CAMERA

> **DEFINITION**
>
> *The term **flash throw** is used to mean the distance from the camera that the flash will illuminate adequately for a photograph.*

Level 2 ($50–$150)

At this slightly higher price level, cameras include a zoom lens with autofocus. You will also get a more powerful flash and a speed shutter that varies between about ½₁₅ and ½₂₅₀ of a second. Another benefit of paying slightly more is that your viewfinder will be more accurate.

POINT-AND-SHOOT CAMERA WITH ZOOM LENS

Level 3 ($150–$500)

This medium-cost range is a mind-boggling place to be: You get a little more of everything, but most important is the general improvement in lens quality – the image is so much sharper! There are some great-value cameras in this range if you carefully match your requirements with the mode facilities available. At this price you can start to take control of exposure since some models include exposure compensation and backlight compensation.

Level 4 ($500–$1,500)

Once again, in this price bracket you get more of everything and a general all-around improvement in quality on all of the functions. However, when you spend this sort of money, most of it goes to lens quality and flash power. Watch out for the USP gimmicks – buy just what you need.

Level 5 (big bucks!)

These so-called super-compacts can cost thousands of dollars and are targeted at the professional as a "pocket-sized snapshot camera." Ironically, they usually come with a fixed-focal-length lens, although it is admittedly of very high quality with large apertures (f2 and f2.8). Compacts in this price bracket have manual overrides on all of the automatic modes. Aperture and shutter speed are indicated and can even be manually operated.

A simple summary

✔ When considering buying a compact camera there are four major categories from which you'll have to choose.

✔ Compact cameras can vary in cost from small two-figure sums up to four figures.

✔ Generally speaking, you get what you pay for.

✔ The 35mm compacts are capable of producing better-quality images than APS and digital cameras.

✔ Digital cameras are more expensive but they don't use film; this saves you developing and printing costs.

✔ Super-compacts are aimed at very experienced photographers.

Chapter 6

Things You Need to Know

I'VE INCLUDED THIS CHAPTER because I think it's important that we get the point-and-shoot camera basics out of the way. You may feel that some of the information here is too basic and is stuff that you already know, but I think it's good information to be reiterated. Even if some of this chapter is not crucial to you being able to shoot great pictures, you should understand it so you know what that computer and those electric motors are doing inside your camera when you push the button.

In this chapter...

✓ Holding the camera

✓ Exposure – what the camera is doing

✓ Autofocus

✓ Loads of modes

PHOTOGRAPHIC WISDOM COMES NOT WITH AGE BUT WITH AN IN-DEPTH KNOWLEDGE OF THE CAMERA

Holding the camera

I'M GOING TO START THIS CHAPTER *in perhaps the most obvious place – obvious because the majority of the time you will be holding your camera when you take a picture. It is therefore very important that you know how to hold your camera correctly, and yet so many people hold their cameras incorrectly, if not all the time, then certainly some of the time.*

CORRECT HANDLING

There are two vital points to remember when holding your camera:

1 Hold your camera absolutely still when taking a shot. Most out-of-focus prints are caused by camera shake. This can be avoided if you gently squeeze the shutter release button rather than pressing down hard.

If you want to take still-life photographs or other shots that will require slow shutter speeds then you should consider buying a tripod.

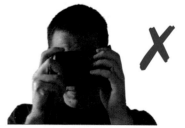

2 Keep your fingers away from the flash, the lens, and the viewfinder in addition to the small autofocus, self-timer, and autoexposure windows. If you cover any of these you will prevent them from functioning properly and, in the case of the lens, you will end up with a picture of your finger.

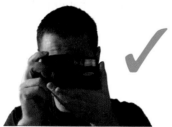

■ **The camera** *is well supported and the fingers are clear of the flash, autofocus windows, and lens. If you are using the telephoto setting, support the extended zoom lens with your forefinger.*

■ **Here, the fingers** *of the left hand are obstructing both the flash and autofocus windows. Also, the fingers of both hands are far too close to the lens.*

Exposure – what the camera is doing

FORTUNATELY, ON A COMPACT CAMERA, *both the aperture and shutter speed are controlled automatically. However, an understanding of how they work will enable you to assess what your camera is doing in different lighting conditions and will empower you to manipulate and control the automatic functions if you want. (For more detailed information on exposure have another look at Chapter 2.)*

A point-and-shoot camera automatically sets the aperture and shutter speed to give the correct exposure for the light conditions and type of film you are using.

This autoexposure, combined with the versatility of color print films, means that you will almost always get a print from your negative. Occasionally, however, there are certain situations in which the automatic exposure may be fooled into giving the wrong reading. If you wish to photograph a relatively small, dark figure against a large area of white, for example, the automatic exposure will correctly expose for the background and, in doing so, underexpose for the figure. The reverse is also true – when photographing a small, light figure against a large, dark background the figure will be overexposed and the background correctly exposed.

Outsmarting autoexposure

On some of the mid-price compacts, there are several ways of overcoming this problem that you get with autoexposure.

a You may have a backlight button on your camera, which is the equivalent of opening the aperture another 1½ f-stops.

b If your compact has an exposure-compensation mode, you can use that.

c Some point-and-shoot cameras have a spot-focus, or focus-lock, mode that the camera uses to read the exposure off a small area, marked by a spot or square in the viewfinder. Place the spot over the subject, push lightly on the shutter release button to lock the focus (and exposure), then, still holding the button down, recompose and shoot.

If your camera offers you none of these modes, you may be able to use one of your built-in flash modes (see Chapter 7 for more details about the flash).

Another problem you might encounter is if you are trying to take a portrait in the shade with a brightly lit area in the background. If your compact is set to its fully automatic mode, the flash will probably go off to throw more light on the subject being photographed. However, if you do not want flash, turn it off and use the exposure compensation, backlight button, or spot-focus mode to solve the problem.

Shutter speeds

Another thing about point-and-shoot cameras is that their shutter speeds are not very fast. Most compact cameras have a maximum shutter speed of between $\frac{1}{250}$ and $\frac{1}{360}$ of a second, so if you wish to freeze fast-moving subjects you need to *pan* the camera with your subject. This will blur the background but give you a frozen subject.

DEFINITION

*The word **pan** is a verb meaning to move the camera in the same direction as a moving subject, always keeping the subject in approximately the same position within the frame. Panning is also used in TV and the movies to follow the on-screen action, and in music to move sound from one speaker to another.*

Autofocus

NEARLY ALL COMPACT CAMERAS focus automatically, but you have to know how to use the system correctly. I found the compact autofocus system difficult at first. I was used to the SLR viewfinder in which the image goes in and out of focus as you move the lens, whereas everything in the viewfinder of a compact always looks sharp.

When you look through the viewfinder of all but the very cheapest compact cameras, you will notice a pair of square brackets in the center – these are focusing brackets. In order to get a correctly focused picture you must ensure your subject falls within the area marked by the brackets. However, the central positioning of the focusing brackets can lead you into the trap of taking pictures in which the main subject is always in the center of the frame. You don't have to do that!

USING FOCUSING BRACKETS

USING FOCUS LOCK

If you want to take a shot where your main subject is off center, you can use the focus-lock, or prefocus, system.

1 Center the subject

Compose your picture with the subject inside the brackets. (Note that if you are taking a closeup shot, ensure your subject falls within the closeup autofocus brackets. See your camera's instruction manual.)

2 Lock the focus

Press the shutter-release button slightly (about halfway) and keep it held down. This locks the focus on.

3 Reposition your subject

Recompose the picture with the subject off center.

Don't change your distance from the subject when you recompose since the focus has been set at the original distance.

4 Take the picture!

Press down the shutter-release button the rest of the way.

Use this focus-lock technique: It's very useful and enables you to make more interesting compositions.

Most of the autofocus systems on compacts work using an infrared light signal which bounces off the subject and returns to the camera. The distance is measured by the autofocus sensor, and the lens elements adjust in order to focus accurately on the subject.

Infinity focusing

Another useful function to have is an infinity setting. This not only allows you to take sharp pictures of faraway objects such as distant mountains, but also allows you to take photographs through glass – for example, through a car or train window – without interfering with the autofocus mechanism.

To prevent unwanted reflections when photographing through a window, position yourself as close to the glass as you can and drape a coat or rug over both your head and the camera.

If you want to photograph a stationary object from a moving vehicle, focus on a point ahead or behind the object to reduce the movement and, therefore, the chance of blur in the picture.

Loads of modes

LCD PANEL

SOME OF THE MODERN compact cameras come packed with loads of modes and programs, each of which is identified by a visual symbol that appears on a dial or in an LCD panel on the camera.

I can never remember which functions each symbol equates to, or which button (or buttons) I need to push to recall a particular program, so I keep the symbols written down in my pocket for reference. You could also stick a list to the back of the camera.

Modes you might encounter

At this point I'd like to say that no matter how much information there is in this book, and how useful you might find it, this book is not a replacement for your camera's instruction manual. Each camera is different and I can't cover every quirk of every model in this guide.

Read your camera's instruction manual carefully and don't lose it.

Apart from such essentials as automatic exposure, focus, and flash there are many other gimmicky devices available. Some of them might be on your current camera or on the next one you decide to buy.

Here is a list of some of the most common facilities you might find on your camera. Some of these may sound like just the thing you need, and you may hate the idea of others.

- **Midroll review with memory** This is useful if you want to take a few shots on ultrafast film, for example, and then go back to your normal film. By pressing a button the film rewinds and takes note of how many exposures were used. When that film is replaced, the camera winds it onto the correct position.
- **Self timer** This function allows you about 10 seconds to get into the picture before the shutter fires.
- **Remote control** This fires the shutter from up to about 16 ft (5 meters) away.
- **Multiple-exposure mode** Using this mode you can shoot two or more exposures on the same negative for special-effects photography.
- **Continuous-shooting mode** This keeps taking pictures for as long as you keep the shutter button pressed down, up to two shots per second.
- **Interval exposure** This sets the camera to fire automatically at intervals without anyone being present.
- **TV mode** This enables you to take pictures off a TV screen.
- **Timecode mode** This automatically prints the date and time on the picture so you'll always know when it was taken.
- **Print-a-message mode** This allows you to print "Happy Birthday" or some such message onto your pictures.

Remember, don't buy facilities you don't want – they cost money and make the camera too complicated.

A simple summary

✓ The camera should be held absolutely still when taking a picture.

✓ You should ensure the flash, lens, viewfinder, and other essential windows are not obstructed by fingers.

✓ Compact cameras set the aperture and shutter speeds for you.

✓ Most compacts have some sort of autoexposure override built in.

✓ To get the best out of your autofocus system you should use the focus-lock technique.

✓ There is a huge array of modes available on compact cameras. Buy only what you need and learn how they work.

Chapter 7

Flash

Flash is a wonderful light source that can be used to capture a picture that otherwise would not be possible. But do we use it too often? And do we use it creatively enough? This chapter will help you figure out one flash mode from the other and help you use each of them in more imaginative ways.

In this chapter...

✓ How far will the flash reach?

✓ Flash modes

✓ Thinking about ambient light

✓ Party time

✓ Flash tricks

OKAY, SO YOUR FLASH MAY NOT LIGHT UP THE SKIES LIKE THIS ONE . . .

How far will the flash reach?

EVERY COMPACT CAMERA has a built-in flash, the power of which (in other words, the effective distance at which it can correctly expose the film) varies between cameras. You should check this before you purchase your model.

I am constantly amazed at the film (and therefore money) that is wasted by people using compact cameras with a built-in flash turned on for long-distance shots. A good example of what I mean is when you see all the little flashes go off around a stadium at a nighttime sports game or concert. At those distances the flash has no chance of making an exposure.

FLASH DISTANCES

Take note of this guide to flash distances – it could save you money! Three variables to be aware of are the power of the flash, the speed of the film, and the difference of efficiency between the wide-angle and telephoto settings on your zoom. Once you understand these principles you will achieve more successful flash photography.

Approximate distance reached by flash – feet (meters)

Vertical scale – feet (meters):
- 132 (40)
- 115 (35)
- 98 (30)
- 82 (25)
- 65 (20)
- 49 (15)
- 33 (10)
- 16 (5)
- 0

LOW-COST CAMERAS

Wide angle:
- 3200 ISO — ~65 (20)
- 1600 ISO — ~49 (15)
- 3200 ISO — 33 (10)
- 1600 ISO
- 800 ISO
- 400 ISO
- 200 ISO
- 100 ISO

Telephoto:
- 800 ISO — 33 (10)
- 400 ISO
- 200 ISO
- 100 ISO

MEDIUM-COST CAMERAS

Wide angle:
- 3200 ISO — ~98 (30)
- 1600 ISO — ~65 (20)
- 3200 ISO — ~49 (15)
- 1600 ISO — 33 (10)
- 800 ISO
- 400 ISO
- 200 ISO
- 100 ISO

Telephoto:
- 800 ISO — ~49 (15)
- 400 ISO — 33 (10)
- 200 ISO
- 100 ISO

HIGH-COST CAMERAS

Wide angle:
- 3200 ISO — 132 (40)
- 1600 ISO — ~98 (30)
- 800 ISO — ~82 (25)
- 3200 ISO — ~49 (15)
- 1600 ISO
- 800 ISO — 33 (10)
- 400 ISO
- 200 ISO
- 100 ISO

Telephoto:
- 400 ISO — ~49 (15)
- 200 ISO — 33 (10)
- 100 ISO

If you want to take long-distance nighttime shots, use fast film (1000–3200 ISO) and turn off the flash. The shutter speed will be slow, so you must support the camera by leaning against a post or seat, but it's worth trying since you can get some very atmospheric shots.

This is also a good way of taking pictures at concerts or plays where flash photography is forbidden. If you can't switch off your camera's flash, hold your finger over it or cover it with some (removable) opaque tape instead. This is just as effective.

Flash modes

IF YOUR COMPACT CAMERA HAS A FLASH, and most do, you will probably be able to exercise some control over when the flash is activated. That way you can decide not to use it at all, for example, if you're taking a bright daytime shot. Let's look at some of the modes that are commonly found on point-and-shoot cameras.

Auto flash mode

When set on automatic, or auto, the flash fires automatically if the camera assesses that there's not enough light to expose the film correctly. This means that your flash may go off not just at night or indoors but also if you are trying to take a picture in dark shadow, for instance.

Flash off mode

This is a very useful mode. If you are in a situation where you you think the camera would fire the flash if set to auto, and that is not what you want, then you can simply switch the flash off. Remember, though, that the shutter speed may then be slower, so make sure you can hold the camera steady, preferably using some sort of support.

■ **The auto flash** *has done a great job here of filling in the faces that would have otherwise been in shadow from the fading twilight sun.*

Anytime flash mode

With this mode, you can use the flash anytime you like – for example, if you feel the subject needs extra light to "fill in" an area that might otherwise be in shadow. The camera balances daylight and flash to ensure correct exposure. This mode is different to auto flash since you have to make a creative decision to use it. Auto flash may fill in areas of shadow when you want it to, but it also may do it when you don't want it to.

Auto flash with sync mode, or night flash

If you are taking a portrait of a group of people at night against a background of city lights, the flash will normally give the correct exposure for the figures, meaning that the background will be underexposed. The slow sync mode gives a longer exposure for the background while exposing correctly for the flash to produce a fully balanced photograph. When in this mode, the camera will select a relatively slow shutter speed (about ¼ of a second), so you will have to lean against a sturdy object to prevent camera shake.

■ **The camera's night flash mode** *has worked out the shutter speed needed to expose the film for the lights of London's Piccadilly Circus and also how much flash is required to light the people.*

Red-eye reduction mode

Everybody has examples of pictures taken with a flash in which the subject appears to have bright red eyes. It's caused when light conditions are poor and the pupils of the eyes enlarge to allow more light to enter the eye so that we can see better. As a result, when the flash goes off, the light is reflected off the red blood vessels behind the pupil back into the camera giving the subject the dreaded red eye! The red-eye reduction mode aims to reduce this effect by firing off several small flashes to make the pupils of the eyes contract before the picture is taken with the full-power flash. However, in my opinion, it doesn't work. Furthermore, the delay between pushing the button and the shutter firing on red-eye mode is too long and the facial expressions that you wanted to capture are often gone by the time the shot is taken.

Shoot without the red-eye reduction mode and use a red-eye retouching pen on the prints. It's easy to do and it works!

Thinking about ambient light

REMEMBER THAT, UNLESS YOU TELL *the camera otherwise, most point-and-shoot cameras will automatically fire the flash when they calculate that the light is too low or that the subject is backlit, in the shadows, or in front of a brightly lit background.*

You need to constantly watch for this. Ask yourself, "Do I want flash for this picture?" You may want your foreground figures to be in silhouette, therefore you don't want flash, since it would fill in and destroy the silhouette.

■ **Comparison pieces**: *The first picture here was shot without flash and the film has been exposed for the background, leaving the lady in the foreground as a silhouette. For the second shot, I turned on the flash and created a good balance between the lady, her house, and her butler. This is the sort of difference the anytime flash mode can make.*

You may want to use a slow shutter speed and support the camera on a tripod, table, or some other stable surface. In these two cases, you must also turn off the flash. You may want a slow shutter speed in order to deliberately blur movement, or you may want to induce camera movement in order to create a blurred effect on the whole picture. In either case you will need to turn off the flash. Make sure that it's you who makes the flash decisions – not the camera.

Cameras have no artistic taste. The creative alternative to flash is a slow shutter speed and a tripod (a light one that will fit in your bag). If you're interested in low-light subjects you will need a tripod anyway.

Party time

MANY YOUNG PEOPLE *of school and college age shoot a high proportion of their film photographing their friends at parties and other social occasions. These pictures provide great pleasure at the time and will be wonderful memories and reminders of their youthful high jinks. The pictures will be a record of their "good ol' days."*

In these cases it is likely that many of the pictures will be taken with a point-and-shoot camera with the flash on, so here are a few flash tips for parties.

■ **This typical party picture** *– the sort of thing memories are made of – was shot using 800 ISO film to preserve some of the ambient lighting.*

a Use fast film (800–1600 ISO). Fast film requires less light to make an exposure, therefore it needs less flash, which, in turn, means the battery will last longer and the flash will recycle faster. Also, the fast film will gather some of the room's ambient light, so you will get more of the location's atmosphere.

b Try to use the wide-angle setting on your camera rather than the telephoto setting. The wide-angle end of the zoom lens lets in three to four times as much light as the telephoto, so again you will use less flash.

c Take a spare battery in your pocket or handbag in case the flash starts to take too long to warm up.

If you're going to a place where you fear your camera might get broken or stolen, take a single-use camera instead.

Flash tricks

HERE'S A COUPLE of creative things you can do with a compact flash. I'm sure you can come up with some others; just get out there and start flashing!

Portrait flash

One of the problems with a point-and-shoot flash is that it's such a harsh light source for portraits. However, by placing a piece of tissue or tracing paper over the flash and using fast film, which is inherently softer than slow film, you can produce a more flattering portrait. Especially outside in the daylight, where the flash diffuses even more.

Flash and the wind

Point-and-shoot cameras cope very well with photographing flowers and plants. One of the great problems when shooting in gardens is the movement of your subject caused by even the slightest of breezes. The flash freezes the movement and produces a beautiful, sharp picture.

Be careful when taking closeups of flowers – be sure that you are framing inside the closeup markings in the viewfinder.

If it's a very sunny day, try to shoot in the shade, or shade off the flower, to prevent a double image, i.e., a daylight exposure and a flash exposure on one photograph.

A simple summary

✔ Your flash will only be useful for short distances. If you are going to take long-distance, low-light shots, use fast film, turn off the flash, and use a good support.

✔ You don't always have to have your flash on. Try out all of your camera's flash modes.

✔ The creative decision to use the flash should be yours. Don't set your flash mode to auto – choose when you wish to use it.

✔ Don't rely solely on flash for capturing a party atmosphere. Combine it with fast film and a wide-angle lens setting.

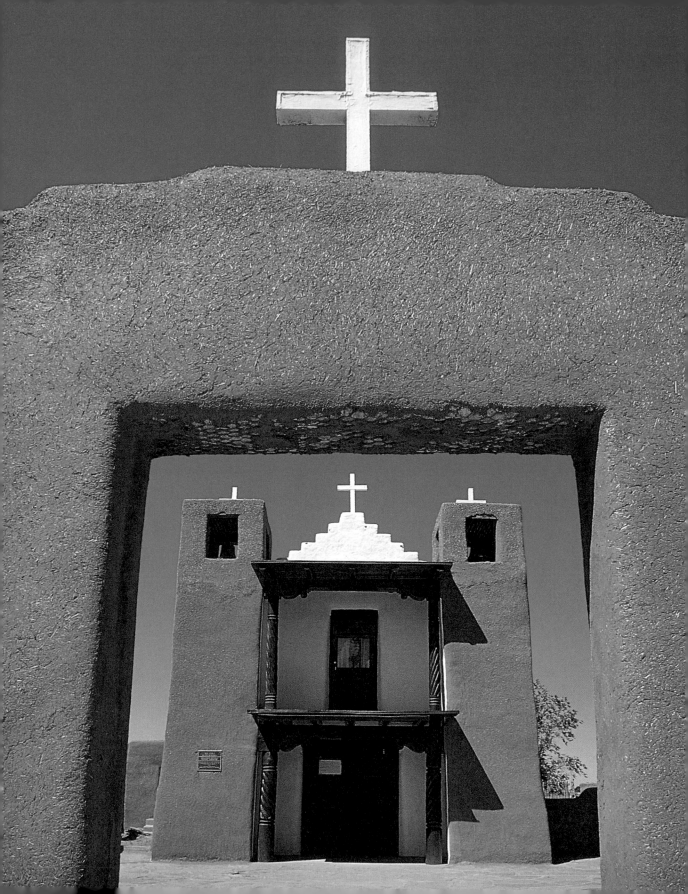

Chapter 8

Framing

THIS CHAPTER IS CALLED FRAMING to distinguish it from a later chapter on composition. By framing, I mean the ways in which you can improve your pictures by learning how to really look through the viewfinder. By doing this you will see the glaring problems that prevent your pictures from looking great. I think of composition as the next stage after framing – the arty, creative version. This chapter is devoted to more practical composition. I'll give you some tips about using your camera's facilities and tricks to turn your snapshots into attractive pictures by framing them well.

In this chapter...

✓ Searching out the ugly

✓ Filling the frame

✓ Composing with the zoom

✓ Horizontal, vertical, or panoramic?

✓ Camera angles – the highs and lows

GATEWAYS AND ARCHWAYS CAN BE USED TO CREATE A FRAME WITHIN A FRAME

Searching out the ugly

FOR OUR PHOTOGRAPHS, we all start out by searching for the beautiful things in our surroundings, because that's what photography is all about, isn't it? Well . . . yes and no.

The first step you need to take in order to end up with a beautiful picture in your viewfinder is to be aware of the ugly things, those things that destroy so many rookies' pictures.

It's often a pole that appears to be growing out of your son's head that destroys a potentially terrific portrait, or the empty beer cans that spoil a landscape.

Only the beautiful remains

Good framing and composition are very much about "searching out the ugly" in order to remove it. Once you've removed it, you'll have a good chance of finding that you are left with just the beautiful.

Many professional photographers are digitally inclined to retouch their compositions later on the computer. I'm old-fashioned — I like to get it right in the camera!

Trivia...

I once made a portrait of a corporate managing director. I didn't spot it at the time, but behind him there was a guy mooning through a window. Sure enough everyone noticed him later! Look at every part of the frame, not just the subject.

■ **The lamppost growing** *out of the top of the girl's head in the first shot here is a classic framing mistake that we've all made! Really look through the viewfinder at every part of the picture, not just the main subject. By simply moving a little you can avoid this.*

Filling the frame

EARLY ON IN OUR PHOTOGRAPHIC JOURNEY, *most of us expect objects in the viewfinder to look much bigger on the final picture than they really are. You may have been surprised and disappointed in the past to discover that, say, your daughter had only taken up a small proportion of the print.*

> **DEFINITION**
>
> *The word* **frame** *is used to describe the area of the world that you see through your camera's viewfinder.*

Let's get bold. Look at all the space that is surrounding your subject and go much closer. In fact, fill the *frame* with the subject matter.

■ **Make an effort** *to get in close and take big, bold pictures. It will feel unnatural at first, especially if you are used to shooting people small in the frame, but the results will be so much better.*

When you get used to filling the frame, you can then start backing off occasionally and making more artistic compositions. But first – get in there, be bold, and move closer!

Remember that, at the end of the day, composition is subjective. As long as the result is how you saw it, it's okay.

■ **For this picture**, *I wanted to emphasize the action rather than the balloon, which is why I have framed the shot this way. I used my compact camera's zoom on its longest telephoto setting – 105mm – and left just enough of the balloon for it to be identifiable. The zoom was essential since I was not able to move any closer.*

Composing with the zoom

ALTHOUGH I TALK ABOUT LENSING SEPARATELY later on in the book, I think it's important that I make specific mention here for point-and-shoot users. The telephoto end of your zoom lens takes you closer to your subject, and your wide-angle-lens end allows you to get more of the subject into the frame, but the zoom does more than that.

Perspective control

The zoom lens is your tool for controlling perspective. You can change the relationship between the foreground and background by changing the focal length of the lens – that is, by zooming in. I can best demonstrate this point through the use of a couple of images.

■ **Changing perspective:** *The top picture was shot with the zoom set at 32mm (wide-angle) and the bottom shot was taken at 85mm (telephoto). Note the different size of the building in relation to the woman in the two images. This is an example of using your compact camera's zoom as a creative tool to manipulate perspective.*

Your zoom lens is not an alternative to walking closer to the subject. Sometimes the wide-angle lens used close to the subject gives a better composition with greater perspective than the same picture zoomed in on a telephoto setting.

Horizontal, vertical, or panoramic?

JUST THROUGH THE DESIGN of the camera and the dimensions of the pictures that APS and 35mm cameras produce, we are presented with a very important compositional decision every time we pick one up: "Will I shoot this picture horizontally or vertically?"

Most amateurs naturally shoot horizontally because that is the way the camera takes them when you simply pick it up and snap. It's not for me to say or advise you on which subjects should be vertical and which should be horizontal – that's your decision. But, please, please, make the decision.

Don't just shoot with your creative brain in neutral. Which shape will make the subject look most interesting? Or "different"? Or dynamic?

■ **It seems so obvious,** *but deciding whether to shoot horizontal, vertical, or panoramic is a major compositional choice. Often we just snap away without thinking, but by turning the camera in our hand we can make a completely different picture. Compare these two shots taken in Venice.*

To add to your list of options, many point-and-shoot cameras have a panoramic mode as well. This can look really good – in fact, you can create some wild vertical panoramas!

The more subjects you shoot in each of the dimensions available to you, the more you will learn about basic format composition.

■ **The extreme proportions** *of the panoramic format can produce some unusual compositions. Play with it and see what you think of the results!*

Camera angles – the highs and lows

THE LAST PIECE OF SEEMINGLY OBVIOUS ADVICE *I'm going to pass onto you in this chapter – and this is something that I still have to remind myself of – is that your standing position is not the only camera angle available to you.*

It is usually easy to move when taking a photograph. Whether it's a jump to the left or a step to the right. Whether you climb a ladder or lie flat on your stomach. Therefore don't take all your pictures from the same eye-level position. Move around.

■ **Here's an example** *of the sort of beach photo you've probably seen a million times – family members and vacationers all around their umbrellas*

■ *. . . But couldn't it have been more adventurous? If the umbrellas are going to be so prominent, get in there and take a picture of the umbrellas! This unusual angle makes for a more interesting photograph.*

■ **By kneeling down,** *I shot this picture from the little girl's height, making Mom look huge. Make your compositions stronger by varying your eye level.*

Change your point of view

Make an effort to look at things from a different perspective. No doubt this is a metaphor for our lives in general!

I'll repeat this tip several times throughout the book because it's so easy to do and can make such a dramatic improvement to the impact of your photographs.

When a subject looks boring, try standing on a chair and looking down on it. Or sit on the ground and look up at it.

A simple summary

✓ There's more to good photography than just focusing on the most beautiful things around you. To take a good photograph, you need to "edit out" the bad parts of your surroundings, too.

✓ Your subject will only fill the frame on your prints if they first fill the frame in your viewfinder. Get closer to your subject and fill the frame!

✓ You can control perspective through use of your zoom lens. That means that you can change the visual relationship between your subject and the background.

✓ Your zoom lens is not an alternative to walking closer to your subject. The more you experiment with the different effects you can achieve, the more you will understand when and when not to use your zoom.

✓ There is more than one way to hold a camera and you should make a choice for each and every picture you take.

✓ There is more than one viewpoint from which you can take any picture. Move around, up, and down in search of the best shot.

Chapter 9

Troubleshooting

SINCE THIS IS THE LAST DEDICATED CHAPTER about point-and-shoot cameras, let's look at some of my compact-camera catastrophes and see what went wrong. Am I brave or crazy? The answer is that, hopefully, by looking at my pictures and understanding why they look the way they do, you'll be in a better position to prevent the same things from happening to your would-be masterpieces. Go on, laugh at me!

In this chapter...

✓ Problem pictures

✓ Framing mistakes

✓ Blurry focusing

✓ Exposure accidents

✓ Obstructions

✓ Lab problems

IDENTIFYING AND SOLVING YOUR PROBLEMS COULD LEAD THE WAY TO A MASTERPIECE

Problem pictures

AT ONE TIME OR ANOTHER I'm sure you've received back some horrible prints from the lab – I certainly have! Depending on your lab, you may have had professional analysis of why they look so bad.

Over the next few pages you'll see some of my bad prints along with my explanation of how the problem could have been avoided. Some of the mishaps are the fault of the lab and some are mine. I trust that by publicly humiliating myself in this way I will help you to become a better photographer.

Framing mistakes

PROBABLY ONE OF THE MOST fundamental difficulties people have with point-and-shoot cameras is framing. This is often because you do not see through the viewfinder what the camera "sees" in the lens, unlike on an SLR.

If you look at the front of your compact camera you'll see what I mean: your viewfinder goes all the way through the camera and the lens is separate. However, there are other reasons why your framing can go awry

■ **Sloping horizons:** *If the horizon is sloping down from left to right it usually means you've pushed the shutter button too hard and jerked the camera out of alignment. Remember to squeeze the shutter gently.*

■ **A slight cutoff** *usually means that you haven't allowed for the 15 percent crop that the photolab machine takes off every picture. Ask the staff for a hand print.*

Blurry focusing

IT'S TRUE TO SAY that many point-and-shoot cameras have no focusing flexibility at all, so here's how I could have avoided the problems below. (Take another look at Chapter 6, too.)

■ **The reason** *that this picture is out of focus is a combination of two factors: I hadn't turned the flash on, and my film was too slow for the low-light conditions.*

■ **In this shot,** *I have camera shake due to insufficient light and the flash having nothing to expose. It would have been fine if the camera had been supported somehow.*

■ **Take a step back:** *This is simply a case of being too close to the subject for the point-and-shoot camera to be able to focus correctly.*

■ **You can avoid the problem** *of the autofocus trying to focus on the car or bus window by setting it to infinity.*

Exposure accidents

IT'S ANNOYING when a beautiful portrait turns out to be covered in darkness; it wasn't even that dark when you shot it, was it? Or, at the other extreme, the whole image looks bleached out. What gives?

■ **Never open the back** *of the camera until the film is rewound or this is what you'll get. It can happen by accident, so be careful.*

■ **The flare effect** *seen in this picture is due to shooting into the sun. A few steps to the right could have made all the difference.*

■ **The person** *intended to be the subject in this shot was too small in the frame for the flash to fire automatically. The flash should have been set to "anytime."*

■ **The dreaded red eye:** *Red-eye reduction modes don't work. Turn it off and use a pen to retouch on the print or make amends on your computer.*

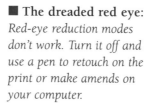

Flash exposure problems

As we've seen on the previous page, exposure problems are often the result of the camera not being able to deal with the ambient light conditions around it. However, sometimes the problem is not surrounding light, but the light created by the flash.

■ **The right-hand side** *of the settee is too close to the flash and has bleached out. In such cases, move further back or recompose the shot so everything is the same distance from the camera.*

■ **The negative** *has been overexposed because I was too close with the flash. All is not lost, though — if you get a picture looking like this ask your lab to reprint it for you.*

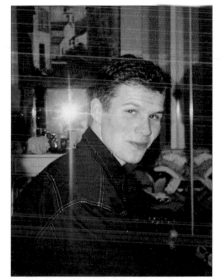

■ **Be careful** *when you are shooting against a shiny surface such as a window or a mirror. You can overcome this flare by shooting at an angle.*

■ **The automatic processing machine** *couldn't cope with the exposure range on the negative. However, your lab should be able to fix it with a hand print.*

Obstructions

PERHAPS IT WOULDN'T *be so bad if you could say, "Nice closeup of my fingertip," but the truth is that the obstruction, whatever it is, is never a nice closeup — it's just a big out-of-focus blur ruining your picture.*

■ **These two pictures** *have suffered from negligence on my part. The shot on the left has my camera strap across it, and, yes, that's my finger in front of the lens above. Hold that camera correctly!*

■ **This is a strange obstruction** *— a drop of water over the lens of my underwater point-and-shoot camera. A tip is to spit on the lens and then water won't stick to it!*

■ **This picture** *was taken through railings, and the lens is obscured by a railing that I couldn't see through the viewfinder.*

Lab problems

THE LAST COUPLE OF SHOTS *I'm showing you don't really fit in anywhere else since they are the lab's fault. They're still worth looking at, so you'll know what they are if you see them among your pictures.*

■ **The white line** *around this swan was caused by a hair that was left in the printing machine at the lab. The negative will be fine so just ask for a reprint.*

■ **This unsightly stain** *is a drying mark on the film. With the right software you can fix it on your computer, but ask your lab for a new print.*

A simple summary

✔ On a point-and-shoot camera, what you see is not quite what you get. Bear that in mind when framing your compositions.

✔ Being aware of the focusing limitations of your camera will help you overcome them.

✔ Opening the back of your camera before the film has been finished and rewound will ruin your pictures.

✔ Don't shoot into the direction of the sun, windows, or mirrors. Take a few steps to one side.

✔ You won't necessarily see something obstructing the lens through the viewfinder, so check that there's nothing in the way.

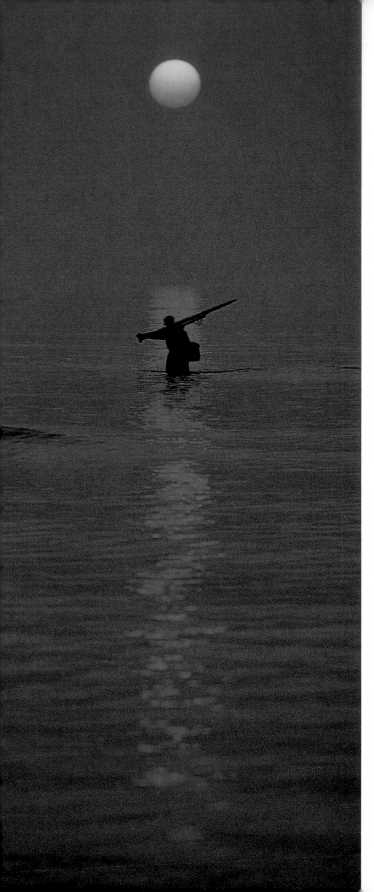

PART THREE

GIVE IT SOME ART AND SOUL

THE ARTY STUFF

BEFORE YOU READ THIS SECTION, I want to underline a few important points. First, the word "arty" is sometimes used almost as a derogatory sneer. Don't accept that. *Arty is inspirational* and is at the core of the best of us, both as people and as communities.

Don't listen to outside voices telling you that you're not artistic. More importantly, don't listen to your own inner voice telling you the same thing. Just because you haven't previously expressed yourself creatively doesn't mean you're not a *potential artist*. Of course you are. The bottom line is that you will certainly produce more interesting pictures than you do now if you get into the arty stuff, and you'll get *a lot more satisfaction* from your work. So get out there and be arty!

Chapter 10

Natural Light

AS A PHOTOGRAPHER, it's important for you to understand what sorts of effects different types of lights will have on your pictures. Even if you ultimately decide to use only studio light for your work, you should know that natural light is the inspiration for almost all artificial effects. Therefore, it's important to study natural light first. Whether you are using window light for a portrait, or sunlight to create a silhouette, I hope this chapter will point you in the right direction.

In this chapter...

✓ **Light is everything**

✓ **Times of day**

✓ **Window light**

✓ **Using the weather**

THE LIGHTING EFFECTS FOUND IN NATURE CAN BE AWE-INSPIRING

Light is everything

OUR CHOICE TO TAKE A PICTURE OR NOT *is decided by subject matter. Or is it? We have all had the experience, at one time or another, of walking down a street, or driving through the countryside, on a dull, gray day when we wouldn't dream of taking a picture. A few hours later, on our way home, the late afternoon sun has broken through and thrown a golden glow down the street or flushed the west side of the hills. Now we feel frustrated that we don't have a camera.*

Trivia...

Somebody once said, "There is no such thing as bad light for photography – you just need to know how to use it." I definitely agree with that.

In cooking terms, if subject matter is the raw material of a meal, then light is the magic ingredient. It's the spices, the sauce, and the Dom Pérignon.

Think consciously about light. When do you use window light? What do you use strong, harsh light for? What is backlighting good for? These are the questions you should start asking yourself.

Even if you think you will use artificial light only, both in and out of the studio, it's important to study natural light first.

Light thinking

To transform your photographs from being simple visual records into exciting, satisfying images you need to understand daylight. The different qualities it has at different times of the day, and how weather affects the photographic quality of light, is important and essential knowledge for the photographer.

The angle at which daylight hits a subject is critical, so you need to bear in mind the following points:

1 It affects the shape of the object it is falling on, or more accurately the apparent shape of the object

2 It affects the texture that the camera can reproduce

3 It affects the picture composition through its manipulation of tonal balance (this is particularly true in black-and-white photography)

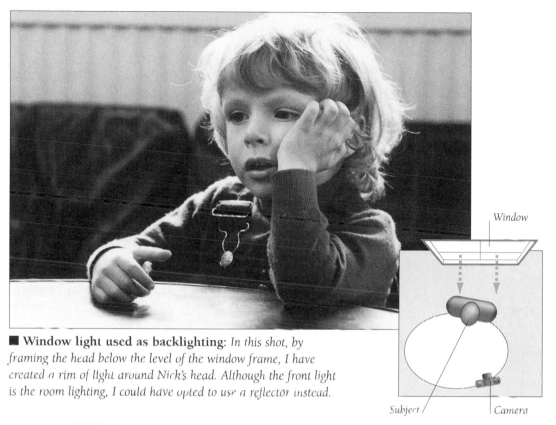

Window

Subject Camera

■ **Window light used as backlighting:** *In this shot, by framing the head below the level of the window frame, I have created a rim of light around Nick's head. Although the front light is the room lighting, I could have opted to use a reflector instead.*

■ **Midday with the sun directly overhead** *is not ideal for portraiture because the face ends up in the shade. It is, however, good for hard-edged color or subjects with strong shapes.*

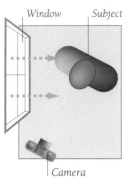

■ **This is a classic** *window-light portrait. I turned my son Nick so that he was three-quarters on to the window. This is easy to do and the results are terrific. However, be careful with your background: I removed a picture and just used the plain wall.*

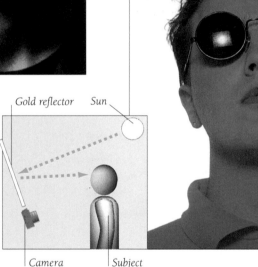

■ **Here I used** *a large gold reflector to bounce the strong Mojave Desert sunlight into the face of former Tears for Fears star Curt Smith. Note the way the gold light tints the picture. I also like that you can see the reflector mirrored in his sunglasses.*

Looking creatively at light

Most lighting setups are reproductions of natural lighting conditions. To make accurate images we need to be able to use the equipment creatively. All technical decisions in photography are also creative decisions, so light needs to be considered almost as much of a creative device as composition, lenses, shutter, and aperture (all of which are coming up in the next few chapters). When you understand how all of these function, you can get them on your side and greatly affect the look of your pictures. (Later on, I will also dip into visualization, which will help you look at everything around you a little differently.)

Times of day

IT'S IMPORTANT when you are beginning to study light that you first understand how light changes as our planet circles around the sun. It is also a good idea to take the time to learn which subjects are best suited to certain times of the day.

No doubt you will have noticed that the quality of daylight changes throughout the day. That's partly because the *color temperature* of the light changes. This change in color temperature alters the color balance of your pictures so that if you photograph your house at sunrise it will appear to be a different color than if you had photographed it at noon.

DEFINITION

The color of light, or **color temperature,** *is calculated in degrees Kelvin (° K). For example, midday is between 5200 and 5400° K. Color temperature readings can be taken on a color temperature meter, and from this reading you can work out what you need in terms of filters or camera/lens settings to get your desired color effect.*

■ **These two pictures** *demonstrate how light can transform a subject in the space of just a few minutes. The shot above was taken in dull, overcast light. Just moments later the autumnal sun arrived to work its magic, making the stag really glow.*

SAME TIME, DIFFERENT VIEWPOINT

One of the great things about natural light is that, even if you stay seated in the same spot, you can find totally different effects just by turning in a different direction. These two photographs illustrate my point. Admittedly these weren't taken at exactly the same time, but there were only a few moments between them.

■ **In this shot** *the mid-morning light bouncing off the sea in the Seychelles has given me a silhouette.*

■ **A few minutes** *later, in the same lighting conditions, I had the kids run from the other side of the beach. When daylight is at a lower-than-noon angle (i.e., before 11 a.m. or after 2.30 p.m.), it can be used as a backlight, sidelight, or front light.*

Film manufacturers balance the emulsion of their color films to produce accurate colors when used with either natural or artificial light. The changing of the sun has a dramatic effect on light and shade – or, in more photographic language, the highlights and shadows on a subject – throughout the day. Therefore, a landscape, or even a face, will look entirely different depending on the time of day at which it is shot.

Also, there is a huge range of color-correction filters available today. They are made of gelatine and come in various sizes. Using these, you can manipulate the existing light into almost any color that you want. They are coded using WRATTEN numbers. WRATTEN 4Y, for example, is a very pale yellow and WRATTEN 40M is a strong magenta filter. However, many photographers prefer to rebalance the color of their pictures later using manipulation software on a computer.

Don't worry too much about color balance when you are shooting color negative, or print, film. Any unfortunate color casts can be corrected later in printing.

Window light

THE FAITHFUL OLD WINDOW *has been the traditional light source for painters and photographers for centuries. Don't underestimate it or take it for granted – window light can be very versatile.*

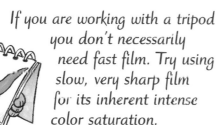

When shooting by window light remember that you are using natural daylight and that the color balance will therefore change with the time of day.

The window light is my favorite portrait light, as it has been for many photographers. Most of us own a window, so that's one less thing to go out and buy!

If you are using a point-and-shoot camera, don't turn on the flash when trying to capture window light – it will destroy the light's quality.

Sometimes, on a dull day, it may seem that the window light is too low for photography, but that is because you are more familiar with brighter outdoor light. Although there may not be a lot of light, it can be of a beautiful quality. All you need are a tripod and a long exposure.

If you are working with a tripod you don't necessarily need fast film. Try using slow, very sharp film for its inherent intense color saturation.

■ **Professional photographers** *go to great length to reproduce window lighting for food, but you can't beat the real thing. The classic still-life light has the window behind the food and about 3 ft (1 meter) higher.*

133

I have always felt that a flash attracts too much attention to take natural or documentary-style, journalistic pictures with it.

At this point I think it's only fair to tell you that *available-light* photography is not easy on a point-and-shoot camera because the maximum aperture of the lenses is smaller than on SLR cameras. However, that's not to say it can't be done.

If you are attempting available-light photography on a compact camera, remember that the wide-angle mode lets in four times as much light as the telephoto mode because it works at a larger aperture. So stay on wide angle.

Available-light photography is at its moodiest in black and white. I recommend that you really look at those low-light situations . . . and turn off the flash.

> ### DEFINITION
>
> **Available light** *is a term used to describe photography utilizing existing light only. Often available-light photography refers to pictures taken in low light. Many of the most moving and powerful journalistic photographs ever taken have been available-light pictures. Unfortunately, too many photographers seem to have lost the art of this type of photography and allowed the flash to take over. With the fast film available today, there is virtually no situation that cannot be photographed without flash.*

■ **Even though it's nighttime** *it doesn't have to mean flash! I took this picture on Bonfire night. The bonfire gave me plenty of light, and it's the firelight that's injected the atmosphere.*

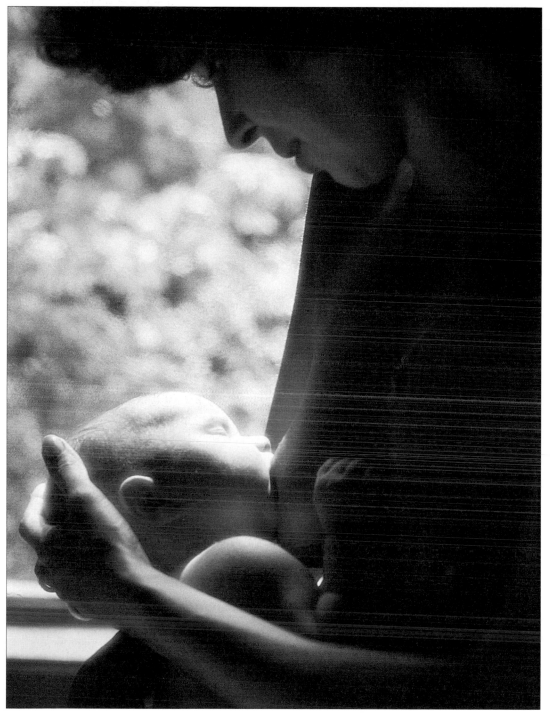

■ **I have used the window light** *as backlight in this picture. Note that I have exposed just for the highlights – the baby's face – and not used a reflector to lighten the shadows. I wanted a moody feel.*

Using the weather

WEATHER HAS JUST AS DRAMATIC AN EFFECT *on light quality as the time of day. Many great pictures have been made on a stormy, black-clouded day. It is sometimes on those days that seem so unsympathetic to photography that a shaft of light can burst through and create a magical effect.*

As with the time of day, you need to be aware of the photographic potential of different weather conditions so that you can anticipate possibilities. The last thing you want is to find yourself saying "I wish I had my camera, but it didn't look like a very nice day."

■ **I love stormy, black-skied days for landscapes** *because this is the sort of thing that can happen. A spotlight has burst through the clouds and lit up the Grand Canyon. I even got a rainbow thrown into the bargain! It's not worth the risk of packing away your camera on days like these – you may regret it.*

I always keep two plastic shopping bags and some rubber bands in my camera bag. Then, if it rains, I cut a lens-diameter-sized hole in the closed end of the bag and fasten it around the lens with the rubber band. This enables me to look through the opening of the bag, keeping the camera dry.

■ **One of the greatest** *things about rainy days is the way the light bounces off all the shiny, wet surfaces.*

A simple summary

✔ Light is possibly the single most important factor in your decision to take a photograph.

✔ The way an object looks – its shape, texture, and color – is greatly affected by the angle at which it is hit by light.

✔ In many cases artificial lighting is set up to replicate the effects that are found with daylight.

✔ Midday has a color temperature of 5200–5400° Kelvin.

✔ Film is manufactured to produce accurate colors at noon in daylight.

✔ You can change the look of a scene by using color-correction filters over your lens.

✔ Window light has long been the favorite light source of photographers and painters.

✔ Even bad weather can offer great photographic opportunities – it pays to be prepared.

Chapter 11

Artificial Light

THERE ARE BASICALLY TWO DIFFERENT light sources available to the studio (or indoor) photographer – tungsten and electronic flash. Tungsten light provides continuous light; the sort of lighting we have in our homes is tungsten. We are all familiar with electronic flash: it's what you find on a point-and-shoot camera, and the studio version is much more powerful. Both of these light sources have their advantages, and most professionals who earn their living in the studio use both systems.

In this chapter...

✓ Before you start

✓ Tungsten light

✓ Electronic flash

✓ Dedicated flash

ALTHOUGH IT'S NOT EXACTLY KIDS' STUFF, ARTIFICIAL LIGHTING NEEDN'T BE TOO DIFFICULT

Before you start

BEFORE WE GO ANY FURTHER *I want to say something. Having a good understanding of daylight, or natural light, is a solid basis for learning to artificially light your pictures. Whether we're talking flashguns, studio flash, or tungsten light, it makes sense to try to reproduce your favorite daylight effect inside with artificial light.*

I am of the opinion that, for the first-time lighting director, it is easier to start off with tungsten lights. With these, you can see exactly what you're doing and they are also cheap to buy or construct. You use the camera meter exactly as you do for daylight. I would suggest you start a file of your favorite lighting-dominated pictures that you've pulled out of magazines. Try to work out how they were lit and then copy them. Have fun!

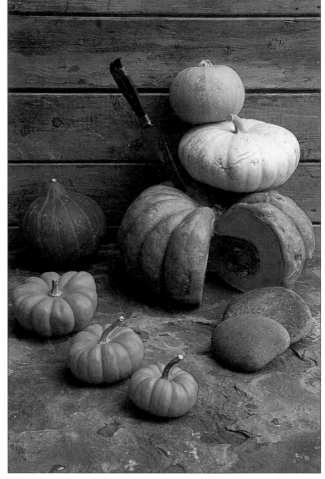

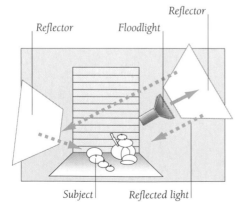

Reflector Floodlight Reflector

Subject Reflected light

■ **For this still life** *I bounced the light off a large white card placed 5 ft (1.5 meters) from the subjects. Another white card opposite acted as a reflector to fill in the shadow. I used an 82A filter to convert tungsten light to daylight and shot on slide film.*

Tungsten light

THE FIRST ARTIFICIAL LIGHT *that photographers worked with was tungsten light. Hollywood's great cinema photographers in the golden age of black-and-white films perfected the use of spots and floods to create the glamour we associate with that period. We have never surpassed those lighting setups. In fact, many will say we have never matched them either. However, still photographers learned their lighting skills from Hollywood and created those great film-star portraits.*

■ **This is classic** *Hollywood lighting: just one spot 4 ft (1.2 meters) above the camera. A piece of fine stocking across the lens makes an excellent soft filter. Combine the two to give a Rita Hayworth look to your lady friends.*

There's a whole generation of young photographers making retro Hollywood portraits. Tungsten has the great advantage that what you see through the lens is what you get on the print. It's much easier to see the effects that you are creating with tungsten than it is with electronic flash (unless you are very experienced). Tungsten light is also cheaper to buy and the exposure will be handled through the camera's metering system as with daylight. Many portrait photographers still prefer tungsten for black-and-white photography (myself included). That is because the warmer color of the tungsten light has the effect of improving skin tones. It lightens darker spots and creates a smoother texture in almost the same way as using a light orange filter with flash does.

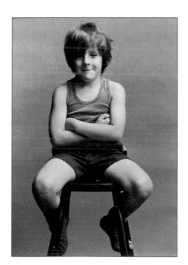

■ **A simple** *portrait light typical of a window light. This is actually bounced off a white umbrella, but a card would do just as well. You could also use your flashgun for this setup.*

Trivia...
When I was younger I tried to use every light in the studio on every picture. These days I usually use just one light source with reflectors.

EFFECTS OF A SINGLE LIGHT SOURCE

I shot this series to show you the dramatically different effects you can have on a face just by changing the angle of a single light source, in this case an ordinary old mirror-back flood. Note how the shape of the face seems to change as I moved the light.

■ **For this first shot,** *I positioned the light just above the camera.*

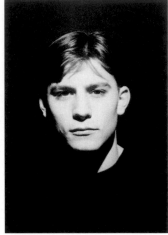

■ **The position** *of the light for this shot was about 4 ft (1.2 meters) above the camera. It gives a slightly darker look.*

Halogen lighting

Most modern spotlights and floodlights use halogen lights. These are compact and can produce high wattage with much less heat than traditional tungsten lamps.

Never move halogen lights while they're switched on. They are very delicate and could explode.

INTERNET

www.phototechmag.com/previous-articles/sept99-kerr/kerr1.htm

This article, "Controlling Light for Photography" by Norman Kerr, gives some great analysis of what can be achieved with just one studio light.

Halogen lights are expensive and the lamps themselves are fragile and expensive (bad combination), but they're definitely much cooler (temperature-wise) to work in (especially for the model) when in a confined space. They are also ideal for location work because you can fit a whole studio's worth of lights into one small case.

Never attempt to change a halogen bulb using your bare fingers. The moisture on your fingers will damage the coating and the bulb could explode. Always use a tissue or gloves.

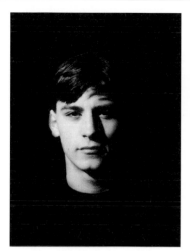

■ **Here the light** *is coming in at a three-quarters angle from approximately 6 ft (2 meters) above the camera.*

■ **To hide half** *of the face in shadow I placed the light at head height and directly to the side of the face.*

■ **I achieved** *this look with the light placed about 2 ft (60 cm) off the ground directly in front of the camera.*

Electronic flash units

RECENTLY, ELECTRONIC FLASH UNITS *have become the main light source used in professional studios because of two major properties. First, the light is balanced to daylight film, so the photographer is guaranteed perfect (as in natural) color balance on every frame. Second, the duration of the flash is so short – $\frac{1}{100}$ to $\frac{1}{3000}$ of a second – that the photographer can freeze movement automatically to get a sharp picture.*

Always check your shutter-speed setting when you are working with flash to ensure that your camera will synchronize with the flash. Most 35mm SLR cameras will synchronize with a flashgun on $\frac{1}{200}$ of a second or slower.

Also note, though, that you should never set your shutter at faster than its recommended sync speed. You will end up with blank film.

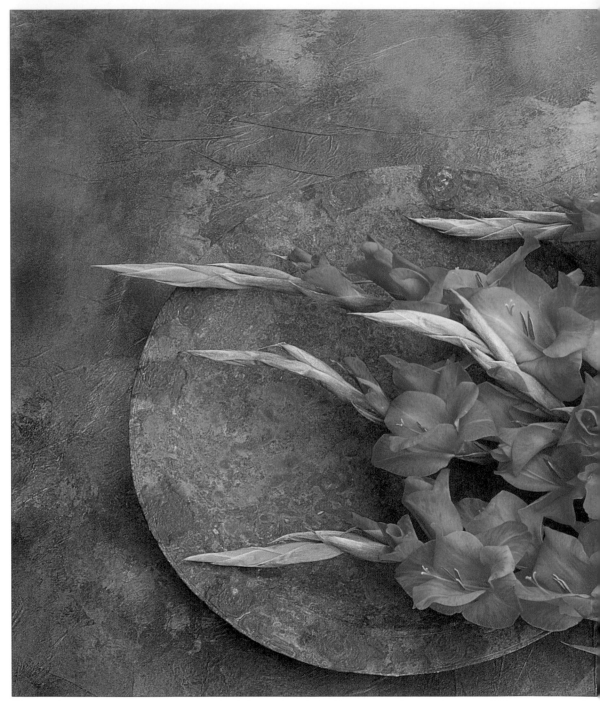

■ **I used a professional studio-type flash here,** *but if I had been near a big window, I would have used that instead. I bounced a flash into a white umbrella and hung tissue paper over the umbrella to soften the light. The larger the area of your light source, the softer the light will be, and vice versa.*

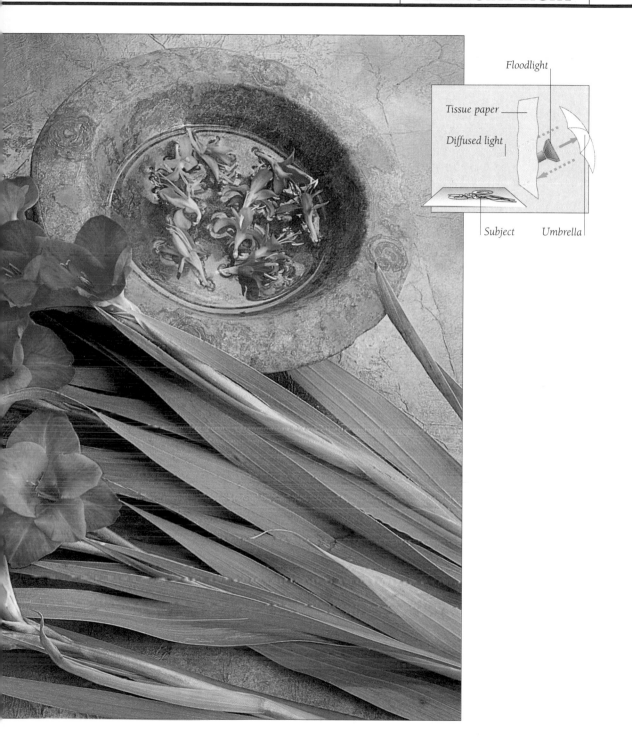

Floodlight

Tissue paper

Diffused light

Subject

Umbrella

Reproducing daylight

Most often, photographers use flash systems to reproduce daylight effects, and usually the flash is diffused in some way, maybe by being bounced out of a white (or sometimes silver or gold) umbrella or by firing it from behind a translucent plastic sheet or tissue paper. There are many methods but almost always the aim is to reproduce window light in its many forms. Flash units produce spotlights, fiber optics, dim headlights, strip lights, semilights, and more, but we are trying to reproduce natural light.

The large studio flash systems and the portable systems (they all have trade names: monoblocks, monolights, compact systems, for example) have built-in tungsten guide lights. These guide lights are on a dimmer switch connected to the flash power switch and get brighter and dimmer as the flash power is increased and decreased.

LIGHT METER

Your camera's meter cannot measure the flash output of studio flash units; you need a separate light meter.

The guide lights give a pretty good indication of how the flash picture will look. However, most photographers shoot Polaroids™ to help them gauge how their final picture will look.

Most medium-format and all large-format systems make a Polaroid back or Polaroid holder so photographers can shoot an instant guide without changing cameras. At least one company also makes them for 35mm cameras.

■ **This is the sort** *of flash setup that you would expect to find in a professional studio. There's really no need for the casual photographer to invest in something like this.*

Dedicated flash

THE MAJOR CAMERA MANUFACTURERS *now produce* **dedicated flashguns***. These are extremely sophisticated – they can do almost everything but wash your car! These flashguns work with the camera to produce a wide range of flash effects, and they can even be used to enable autofocus in the dark.*

DEFINITION

A **dedicated flashgun** *is one designed by camera manufacturers to work only with their own cameras.*

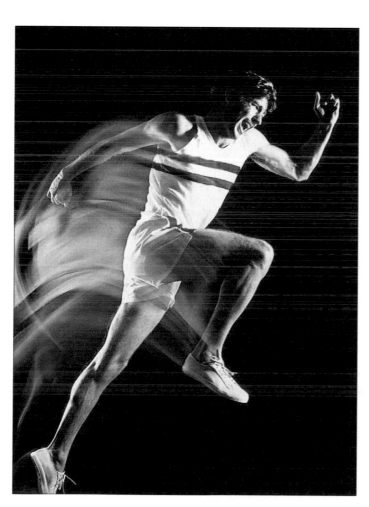

Trivia...
My first professional studio flash unit was a second-hand French model (probably fifth-hand!). I couldn't afford white umbrellas, so I painted ordinary umbrellas with white emulsion. They looked decidedly uncool but worked pretty well!

■ **Here I wanted to blur** *the runner to give the feeling of speed, but also freeze him to see the action. I lit him with tungsten light and took a meter reading. The shutter was set to ½ of a second to get the blur, and two flash units (one each side of the runner) fired at the end of the half-second, freezing the movement.*

I can't tell you how to operate your flash technically in this book because each system is different. You need to study the manufacturer's instruction book.

Buy a TTL (through-the-lens) metering remote cord with your flashgun. This enables you to physically move the flash off the camera while still maintaining all the dedicated features.

This means you can use it as a single-source light for the studio, a backlight or sidelight, and you can diffuse it or bounce it. And you still have automatic exposure!

Using dedicated flash outdoors

I use my flashgun to alter existing light balances outdoors. For example, I will make the foreground lighter in relation to the background. Prior to the advent of dedicated flashguns, this was a tricky calculation, but now I can tell the flashgun what I want to achieve and presto!

■ **To change the existing tonal balance** *of this scene, I used my camera's dedicated flash. It's a very simple procedure. With the flash set on automatic, I set the camera at -⅔ of a stop, resulting in a darker, less distracting background, but one that is still readable.*

For instance, set the flash for correct exposure and set the camera to underexpose by 1 stop (half the normal exposure). That way you'll end up with a correctly lit foreground (most often a portrait) and a dark (but still readable) background. Check it out!

INTERNET

www.photography.about.
com/arts/photography/
library/weekly/aa
122099.htm?terms=
Home+Lighting

This is a useful article in About.com's photography pages on how to photograph celebrations, parties, and other events that take place in an indoor setting.

Don't assume your dedicated flash is like your old flash. Study the instruction book or you could make mistakes.

A simple summary

✔ Before learning about artificial or studio lighting you should first ensure you have a good knowledge of natural light.

✔ Tungsten lighting was the first type of artificial light that photographers ever worked with.

✔ Tungsten lighting is good to work with because it looks the same on a print as it does in life.

✔ Halogen lights are able to produce a large amount of light with much less heat than traditional tungsten lamps.

✔ The main light source used in professional studios is the electronic flash unit.

✔ Flash systems are usually used to produce a daylight effect.

✔ Dedicated flashguns are high-tech flashes produced by manufacturers to work only with that same brand of cameras. They can be extremely versatile.

Chapter 12

Lens, Aperture, and Shutter

I'VE ALWAYS HAD A PROBLEM with teaching methods that separate technique and creativity. Many books split them up, as if you need to have a split personality to be a photographer – a technical you and a creative you. In fact it's one and the same. I know plenty of photographers who master the technical side but can never express themselves creatively. In part, I think it's because they don't realize that the technical decisions they make when taking a picture are also creative ones. In this chapter I want to show you how to make creative use of your camera's most fundamental elements.

In this chapter...

✓ Lenses – what can you do with them?

✓ Using filters

✓ All about aperture

✓ Getting to grips with shutters

YES, YOU CAN SLOW DOWN A WATERFALL!

Lenses – what can you do with them?

LONG LENSES AREN'T DESIGNED SOLELY *to get you closer to your subject; nor are wide-angles only used "for getting more in." They both have inherent characteristics that we can exploit creatively.*

Telephoto lenses compress the perspective in a photograph. That means they give the effect of pulling the background up closer to the foreground. With very long telephotos (500–1000mm on a 35mm camera), the foreground can look almost like it's pasted on to the background, and mountains that are hundreds of miles away can appear to be

LENS EFFECTS

This series of pictures illustrates how a change of lens can interpret the same subject differently. This understanding is the beginning of a new grasp on creative photography. With each of these pictures, not only have I changed lens, but also I've moved back away from the model to keep her the same size in each shot.

INTERNET

www.amateurphoto.about.
com/hobbies/amateur
photo/library/bllenses.
htm?terms=lenses

This page has some good information on lenses as well as tips on filters.

■ **This first picture** *was taken with a 24mm (wide-angle) lens, which exaggerated the distance between the model and the monument.*

right next to each other. You won't really notice a pronounced compression of perspective on a compact camera, but it will still be noticeable enough on, say, a 135mm zoom to give you a considerable compositional change from the wide-angle setting.

Modern lenses have a coating that has considerably reduced the flare you used to get when backlight hit the lens.

■ **This Grand Canyon picture** *was shot on a 300mm lens. The escarpments appear to be almost pasted together although they are hundreds of yards apart. The perspective has been compressed.*

■ **The 105mm lens** *has pulled the monument closer to the model than our eye sees it. This is the same as most compact cameras on telephoto setting.*

■ **The 300mm telephoto lens** *has pulled the monument much closer than the eye sees it. The girl now appears right next to the background.*

Selective focus

Another important quality of telephoto lenses is that the longer the lens, the shorter its inherent depth of focus. Remember that you control the potential depth of focus of each lens with the aperture. The ultimate in potential *selective focus* is a telephoto lens that is wide open. So, telephoto lenses can be used to manage color (or tones if you're shooting black and white) and perspective.

> **DEFINITION**
>
> *When you focus on one plane and throw the rest out of focus by using a large aperture, this is called* **selective focus**.

■ **These shots were taken** *with a 35–105mm zoom at 65mm. The first one was stopped down to f16 to produce front-to-back sharpness; for the second one I opened up to f3.5 to selectively focus on the glass.*

Photographers often use the term short lens to describe a wide-angle lens and long lens to describe a telephoto. This refers to the focal length of the lens.

The wider the angle of the lens, the greater its depth of focus, and the greater its ability to exaggerate perspective. For example, if you focused a 20mm lens at about 6½ feet (2 meters) and stopped it down to f16, everything would be sharp from about 4 inches (10 cm) from the camera to infinity. Even with the aperture wide open it is difficult to see the effect of selective focus with a wide-angle lens.

In fact, it's almost negligible on an 18–24mm lens. Therefore, the wide-angle lens can be used to produce exaggerated perspective and hard-edged color compositions.

Zoom lenses

The zoom lens can produce a little graphic touch all of its own. Use a long shutter speed (say between ⅛ of a second and 1 second), then zoom from wide-angle out to telephoto during the exposure, and you'll get the sort of fun effect shown here.

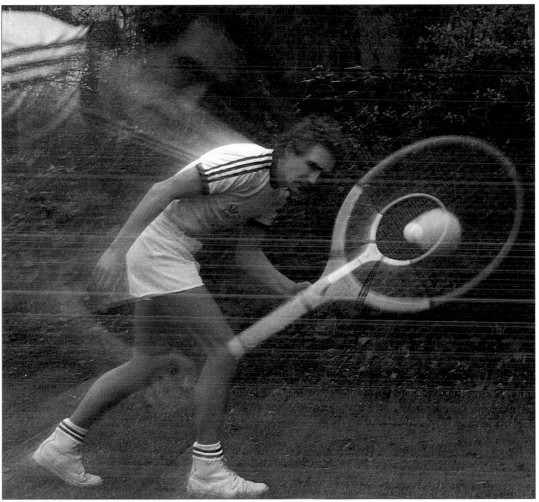

■ **I made this photograph** *using a 35–70mm zoom lens stopped down to f22, so I needed a slow shutter speed (¼ of a second) to compensate. I used a tripod and the model remained perfectly still. I started the exposure with the lens set at 35mm and zoomed through to 70mm in approximately ⅛ of a second. The last half of the exposure was at 70mm. These timings are approximate. You will see that the speed of your zoom will affect the look of movement in your pictures.*

Using filters

ALTHOUGH COMPUTER *software can produce any effect that an on-lens filter can (and more), many photographers still prefer to use traditional filters on their cameras. That is because they want to visualize the effects in the viewfinder. That way, they can produce an effect more in harmony with the subject in front of them.*

SCENE SHOT WITH NO FILTER

Filters for color film

For color work there is a huge range of filters that are not for special effects but that are used more subtly, just to fine-tune the color. You may want to make the skin tones a little browner, the sunset pinker, or make the whole scene a touch bluer. The filters that you use to do this sort of work are color-correction filters.

SHOT WITH 2A WARMING FILTER, TO INTENSIFY COLORS

■ **The effect you see here** *is the result of simply breathing on the lens on a cold day. I like the feeling it gives more than any soft-focus filter — and it's easier on your pocket.*

■ **I jazzed up the colors** *in this shot by using a 2C filter, a darker version of the 2A. Other warming filters that would do the same job are the 81 series (A–EF) or the KR series (1–15).*

Professional photographers carry a large selection of color-correction filters in their camera bags. The other type of filter that the travel photographer never leaves home without is the polarizing filter, which works in a similar way to your sunglasses. By cutting down the reflections on surfaces, the polarizing filter enables you to reproduce more saturated colors in your pictures. For example, it creates dark blue skies with white cloud formations (if there are any clouds, that is).

Graduated filters

The other family of filters that is useful to color photographers is that of graduated filters. As the name implies, they are colored at the top and graduate to clear at about halfway down. This allows you to manipulate the color in half of the picture while leaving the rest of the shot as it is. Some good examples of when to use this would be to make a gray sky blue with a blue grad, or create a sunset effect by using a pink grad. Who said the camera never lies?

■ **I used a blue grad here** *to make a gray sky blue. Note that the sheep and grass in the bottom area are unaffected because the bottom half of the filter is clear.*

SUGGESTED COLOR FILTERS

The list below is just a small selection of the filters that are available. These are some of my personal favorites; I think they are worth trying out.

Type	Color	Effect
Polarizer	N/A	Creates more saturated color
81A and 81C warming filters	A pinkish brown	Skin tones, saturates most colors
Blue grad	Half blue, half clear	Blue skies
Pink grad	Half pink, half clear	Sunsets
Neutral-density grad	Half gray, half clear	Darkens area without altering color

Filters for black-and-white work

Color-correction filters are also very important in black-and-white photography. They are used to manipulate the tones in an image. They do this by lightening the tones at their own end of the spectrum and darkening the tones at the other end of the spectrum. So, if you shot a red kite in a blue sky using a red filter, you would produce a black-and-white print with a nearly white kite in an almost-black sky. The polarizer and the grad filters are also valuable for black-and-white work. They do basically the same job as on color film. Give them a try and see what you think.

■ **A typical red-filter** *black-and-white picture. The filter has darkened the blue sky and, in so doing, has given more emphasis to the clouds.*

SUGGESTED BLACK-AND-WHITE FILTERS

Here I have listed some of my favorite filters for black-and-white work. You can use others, of course, but I find these are the most useful.

Type	Effect
Polarizer	Cuts down reflections, similar effect to sunglasses
Orange	Darkens blue skies, clears up skin blemishes
Red	Same effect as the orange but to a greater degree
Yellow-green	Lightens the tones of foliage
Infrared (almost opaque)	Maximizes the contrast between light and dark tones
Neutral-density grad	Darkens the whole area without altering tonal contrast

SPECIAL-EFFECTS FILTERS

There are literally hundreds of special-effects filters that you can buy to add an endless degree of creativity to your pictures. I would suggest you search through the Cokin and Hoya catalogs to see what tickles your fancy.

■ **The soft-focus** *filter has given this London scene a romantic, foggy atmosphere.*

■ **The starburst filter** *turns every source of light into a star*

■ **A rainbow filter** *on this picture has thrown a rainbow effect across the sea.*

■ **Using the split-image filter** *here has made one solitary candle appear as though there are many.*

All about aperture

THE APERTURE CONTROLS THE DEPTH OF FOCUS *in the photograph. The smaller the aperture (the smaller the hole), the greater the depth of field will be; the larger the aperture, the shallower the depth of focus. This means that if you want a picture that is sharp from foreground to background you need to stop down to a small aperture.*

Stopping down will provide you with sharp, hard-edged color (or tones, if you're shooting in black and white), so you'll need to consider every line, angle, and color carefully in the viewfinder because once they are hard-edged they will affect your composition. However, if you want one part of the image sharp (maybe a portrait face) and the background out of focus, you need to open up the aperture.

INTERNET

ubmail.ubalt.edu/
~dhaynes/photo/depth.
htm

This web page contains an article on depth of focus from Introduction to Photography *by David Barnes.*

■ **For this shot,** *because I was using a 200mm telephoto lens, with its inherent short depth of focus, I needed to stop down to f22 to hold sharpness from the foreground to infinity.*

APERTURE

As I said earlier, the aperture controls the volume of light that enters through the lens to expose the film. However, its creative job is to control the depth of focus of the lens. By controlling the depth of focus, you control where the emphasis is in the picture. I have used this series of shots to demonstrate how you can use depth of focus to tell your story.

■ **A 50mm lens** *stopped down to f16 has kept both the girl and the background sharp. I am showing you both the girl and her environment.*

■ **Now that I have opened up** *to f5.6, the shorter depth of focus means I am placing more emphasis on the girl.*

■ **Now I am wide open at f2** *and your eyes are drawn to the girl because the background is completely out of focus.*

Using aperture creatively

The creative effect of aperture is most apparent on color and tone management. When the aperture is wide open, the out-of-focus colors will merge together into a soft background, and the out-of-focus foreground becomes a soft-colored frame for the sharp object that is the point of focus. Black-and-white tones are softened and merge at the edges. Open up the aperture when you want the viewer to concentrate on the object you've focused on, and stop down when you want the viewer to take in every detail of the picture, from foreground to background. If I was, for instance, shooting a portrait of a famous gardener I would probably stop down to show the garden as well as the gardener.

■ **It was important to me** *that I kept the man, his dog, his cat, and his house sharp. All those components are important because they are evidence of what kind of man he is. I used the ultimate depth-of-focus combination: a 20mm wide-angle lens stopped down to f16.*

■ **In the composition opposite,** *I wanted the viewer to see only the girl, so I used a 180mm telephoto lens wide open at f2.8. The out-of-focus trees have been made into a soft, sympathetic background that adds to, rather than detracts from, the picture.*

Getting to grips with shutters

THE SHUTTER IS THE PART OF THE CAMERA *that controls the amount of movement in the resulting photographs. This is because the longer the shutter is open, the more light the film in the camera is exposed to. This has important creative applications.*

The fact that a fast shutter speed freezes a moving object means that, graphically, it holds that object sharp and hard-edged in the picture.

All the colors (or tones, if you are working with black-and-white film) will be well defined. A slow shutter speed will blur the subject and give an entirely different graphic look to the picture: the colors and the edges of forms will merge together, and the emotional impact on the viewer will be entirely different to that from a fast-shuttered image.

SHUTTER SPEEDS

This series of pictures shows you the effect that the shutter has on movement. Once you understand the creative role of the shutter you really can add another dimension to your photography. By using the shutter creatively it's possible to further express how you feel about a subject, not just record what it looks like. And that's what we are all aiming to achieve.

■ **The cyclist was traveling** *at a normal road speed when I shot this picture. The camera was stationary and the shutter speed was 1/500 of a second.*

You can also use a slow shutter speed on static subjects and let the camera move through the exposure to produce an almost surreal image.

A photographer friend of mine has so many hangovers that he always shoots on a fast shutter speed just to avoid camera shake!

■ **Shot at ¼ of a second,** *the sparkler has exposed a beautiful arc against the black background, which is essential to the success of the picture. Try some really slow shutter speeds – they can be wild!*

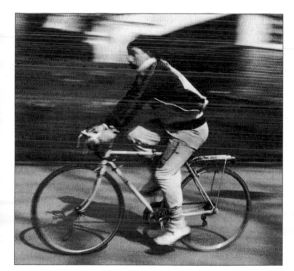

■ **I panned with the bike** *for this shot taken at ⅓₀ of a second. The cyclist is fairly sharp and the background has an interesting movement streak to it.*

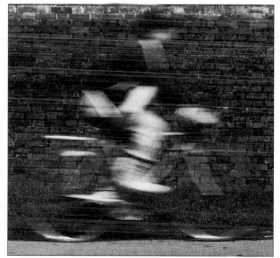

■ **I kept the camera still** *and shot on a shutter speed of ⅛ of a second. There is a real feeling of speed about the shot.*

■ **In this shot,** *I wanted to capture the power of the surf as well as the courage of the Australian lifeguards. The ¹/₂₀₀₀-of-a-second shutter speed has frozen every drop of the action.*

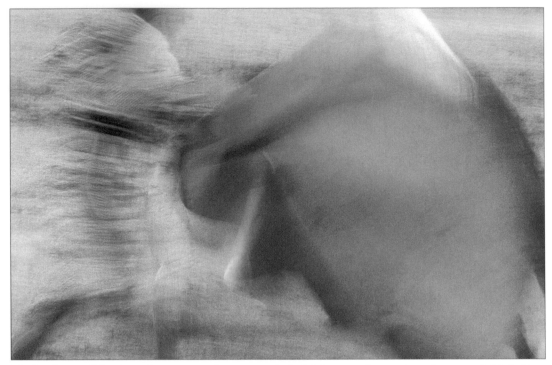

■ **This beautiful, slow-shutter-speed picture** *of a bullfight was taken in Spain by my wife Michelle.*
The ½-second shutter has merged all the colors together. It looks just like a painting.

Making a choice

As with all so-called technical decisions in photography, the *aperture priority* or *shutter priority* decision is, most importantly, a creative one.

If you have a 35mm SLR, don't let the camera automatically set the shutter–aperture combination. Make a creative choice.

I often shoot action on a fast shutter speed and then later think, "Maybe this picture would've been more interesting if I'd used a slow shutter speed and blurred the movement." Try to shoot moving subjects with both fast and slow shutter speeds and see which result you find most pleasing.

DEFINITION

Aperture priority and shutter priority *are modes on semiautomatic cameras, where you select the setting for one and the camera automatically sets the other. I'm using it here to emphasize the need to make a creative decision regarding one or the other.*

A simple summary

✓ Telephoto lenses compress the perspective in a picture – that is, they make the background seem closer to the foreground than it really is.

✓ The term selective focusing means to focus on one plane (that is, one distance from the camera) and keep everything else out of focus.

✓ A wide angle lens is often called a short lens; a telephoto lens is a long lens.

✓ The wider the angle of the lens (that is, the lower its millimetre value), the greater its depth of focus.

✓ Your creative use of lenses can be increased through the addition of color-correction filters.

✓ Filters come in many different colors and effects, and they can be used successfully for both color and black-and-white photography.

✓ The depth of focus in a photograph is controlled by changing the lens aperture: the larger the aperture, the greater the depth of field, and vice versa.

✓ When the aperture is wide open, out-of-focus colors merge together to form a soft background.

✓ The shutter speed dictates for how long the film is exposed to light.

✓ Using a fast shutter speed when photographing a moving subject will freeze the subject in the picture.

✓ A steady camera combined with a fast-moving object and a slow shutter speed will result in a blurred image.

Chapter 13

Learning to See

I T ALWAYS SURPRISES ME just how little of the world people actually see. I don't mean "see" as in being aware, I mean it in a more all-absorbing way – the difference between seeing and looking. If you want to be able to take interesting pictures, first you have to learn how to see them. In its most basic form, that can be a commitment to not always shoot from eye level. However, there is much more to it than that. In the next few pages I'll give you some essential advice about learning to see and making interesting images.

In this chapter...

✓ The alternative point of view

✓ Beauty out of the mundane

✓ Color management

✓ Color thinking

TAKE THE TIME TO REALLY LOOK AT THE WORLD AROUND YOU

The alternative point of view

AN ALTERNATIVE *American photographer named Ralph Gibson made a great series of pictures over a long period: using a normal 50mm lens on a 35mm camera, he shot everything from just 2 ft (60 cm) away. The result was a very powerful vision of his world that was fresh and exciting. A Coke™ bottle sitting on a Harley-Davidson says "USA" just as much as the Statue of Liberty. Other examples of terrific alternative points of view that spring to mind are an Irving Penn portrait of Miles Davis consisting solely of Davis's left hand and a Richard Avedon portrait of Muhammad Ali that was an image of his fist.*

What I am trying to say is that there is always another way of taking a picture – a fresh approach, a less obvious, and therefore surprising, image that will have a great impact on the viewer. Ask yourself the question "How else could I take this picture?" Sometimes it won't work, but that doesn't matter; the times when it does work it's exciting!

INTERNET

www.artisdead.net

This site contains not just photography, but a range of work from several fields of the arts. There are often some interesting photographs here, so check it out!

■ **Sometimes a mere section of the subject** *can tell the story in a more interesting way than the whole thing. To me, this shot undeniably says "authority."*

Vertical or horizontal?

On the subject of alternative viewpoints
We all know that most cameras take
rectangular pictures, but how many of
us consciously decide which way to turn
the camera when we are about to take
a picture? "Vertical or horizontal?" is a
question you should ask yourself every
single time.

*Always take a look at your
subject before you shoot.
Don't automatically take
a horizontal picture.*

■ **I was struck** *by how beautiful this
guard's helmet was. I used my 80–200mm
zoom to crop in tightly. Look hard for the
alternative picture: it's always there, you
just have to find it.*

■ **By shooting from such a low camera angle** *I was able to remove all the
distracting foliage from behind these girls and use the sky as my background. I
took this picture with a 24mm (wide-angle) lens with a red filter to darken the sky.*

Trivia...

*There's a scene in the film
Dead Poets Society in which
the teacher (played by Robin
Williams) makes the whole
class stand on their desks to
view the room from a different
angle. This symbolic gesture
reflected his philosophy on
life in general.*

Beauty out of the mundane

EVERY DAY WE WALK PAST *mundane, even ugly, things. Living in the 21st century, many of us are increasingly confronted by neglected "stuff," usually discarded by our fellow citizens. Is it really all ugly and worthless? I suggest you take a closer look, just as Irving Penn did in the 1970s when he held his controversial "Street Material" exhibition at the Metropolitan Museum of Art in New York. The pictures are of old cigarette butts and garbage that he picked out of the gutter and shot with uncompromising clarity in the studio.*

At the time, many reviewers criticized Penn's images, but I think they are masterpieces and beautiful. Don't be too ready to discard the trash and the seemingly mundane – take a fresh look at it instead.

For example, I've always been fascinated by the graphics created when posters stuck on the boards around a construction area are torn and become multilayered designs. Sometimes they are as exciting as many highly acclaimed abstract paintings. I call this ripped-off art. Here's a couple of mundane subjects that I hope will illustrate the point.

■ **The beautiful window light** *coming in from behind this would-be still life has brought these mundane subjects to life and made a worthwhile photograph. Open your eyes to the possibilities around you.*

■ **It's just an old bike** *and a neglected wall in Goa, India, but I love both the color and the composition. Forget about the actual objects and try to see the shapes and colors.*

■ **Perhaps** *an inner-city garbage dump is not the most obvious of places to find beauty, but this photograph is a personal favorite. There are great potential pictures that we walk past every day. We just need to be alert to the possibilities.*

Trivia...

As I stood taking this photograph at a dump, the site caretaker approached me from behind and asked me what I was doing. I told him him I was taking a picture. "What the hell for?" was his response, and he walked away throwing his hands up in disbelief. He was amazed that I could find something worthy of a photograph among all that garbage.

177

Color management

OUR EMOTIONS *are deeply affected by color. Different colors and different combinations of colors produce different emotional responses from us, or in us. Unfortunately, not many photographers use this knowledge in their color work. Ultimately, at the highest level, the style of a photographer working in color develops and becomes individually recognizable because of his or her own responses to color.*

We are all individuals and we will be attracted to different colors and color compositions.

We know that cool colors (for example, blues and greens) can have a calming effect on some high-strung people while at the same time have a depressing effect on others. Hot colors (like reds, oranges, and yellows) have a stimulating, positive effect on some laid-back people, but can prove too stimulating for other people.

The density and contrast of your colors will be considerably affected by exposure. Underexposure, or highlight exposure, produces saturated colors and high contrast. Overexposure, or shadow exposure, produces washed-out colors and soft contrast.

Here are a few examples of thinking in color, where color management not subject matter has created the mood.

■ **I planned** *this shot of a spice market in Singapore because I wanted to produce a warm sepia tone to the picture. This is a good example of color management. Don't just let color happen.*

INTERNET

www.thirdeyephoto.
com

*The great Third Eye
Photowork Collection
web site exhibits many
photographs shot from
unusual points of view.*

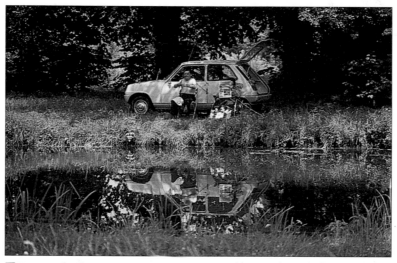

■ **It was the harmonious arrangement** *of greens that caught my eye in
this scene. The French fisherman plays second fiddle to the color. The more
you work on your color awareness, the quicker you will improve.*

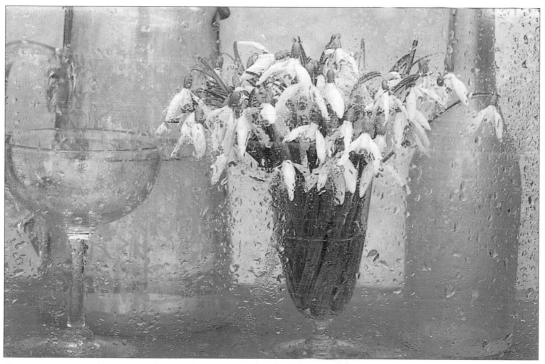

■ **By creating a blue photograph,** *I have added to the melancholic atmosphere of the picture. Think
carefully about what you are trying to say when you begin introducing colors.*

Color thinking

WHEN YOU ARE *setting up portraits or still-life pictures, it's important to be aware that every color you introduce will influence the mood of your picture. Experiment with background and color combinations to see what moods you can create. This is the only way to learn what the end result will be.*

When shooting on location, train your eye to become increasingly selective. Look at objects as colored or tonal shapes, animate and inanimate, rather than what they actually are. For example, a red truck parked next to a green field is a red rectangle against a green background. You can then ask yourself, "Where will I place that red rectangle?" instead of thinking, "What a gorgeous truck, I must take a picture."

■ **This picture** *is all about seeing color; it wouldn't be interesting in black and white. The joy of shooting color lies in finding the patterns that are all around us.*

The pop artists of the 1960s, such as Andy Warhol, left behind some great examples of how to create mood through the use of color. Photographic images were often the basis of their paintings.

Don't just throw colors into your picture because they happen to look nice. Be selective and manipulate your color selection.

■ **The deliberate** *use of these hot colors gives this inanimate subject a feverish, sexual feel.*

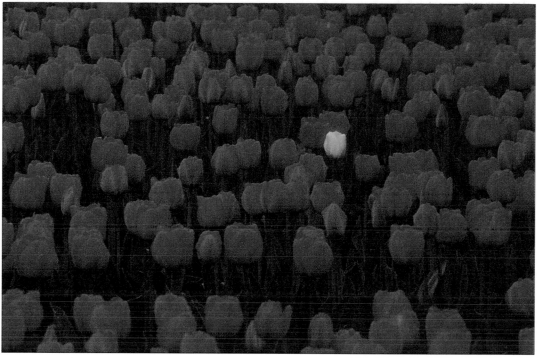

■ **In spite of all the incredible colors** *available to us, this is one of my favorite pictures. The tulips of Amsterdam are a great sight – a real symbol of spring. I found this yellow tulip to star in my shot.*

A simple summary

✔ Always look for the most interesting way to depict your subject. To find it, you need to take the time to look for it.

✔ The things we see every day can be worthy of a photograph – even the ugly stuff! Set aside your preconceptions and take another look.

✔ The colors you choose will produce emotional responses. Use them wisely.

✔ Colors can be used to convey a feeling almost regardless of the subject matter.

✔ Think of subjects as colored shapes from which you build an appealing design.

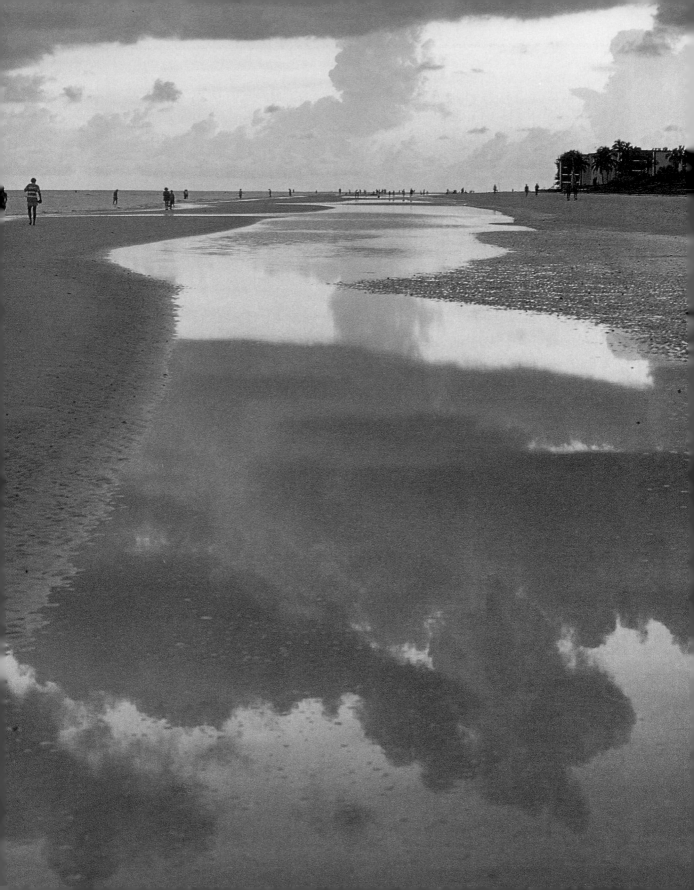

Chapter 14

Space and Composition

I THINK OF PHOTOGRAPHIC COMPOSITION as a secret knowledge – almost subversive, a "them and us" kind of thing. Most people looking at photographs believe they are being emotionally moved only by the subject matter of the picture, and to a degree they are: They are made sad by a picture of starving children, or joyful by a picture of a snowball fight, for example. However, they are unaware that the composition of the photograph also has a powerful influence on how they interpret the picture. The photographer can exercise a subliminal influence over the viewer. The viewer gets a message from the photographer but doesn't know exactly how the photographer is delivering it.

In this chapter...

✓ Thinking composition

✓ Here are the laws!

✓ Photographic composition

✓ Creating visual effects

Thinking composition

THE TRADITIONAL LAWS *of composition were passed down to us by painters, but with the advent of the camera they started to evolve. They have continued to evolve along with the camera. Compositional awareness (or the lack of it) is what ultimately separates an average photographer from a very good one – that's what I believe. The ability to compose your pictures well will empower you to take pictures that capture how you feel about a subject and to pass that feeling on to the viewer.*

Trivia...

In the early days of my career I composed my pictures based on whether they looked nice or not. It was not until I worked with graphic designers that I learned the rules of composition and my photography improved dramatically.

Early photographers borrowed their compositional structures from painters. Well, kind of. In fact, many of the early photographers were painters experimenting with a new high-tech medium. The compositional structures of traditional art were formed without the benefit of the optical variations that we photographers have today. Since they couldn't visualize a landscape painting through the wide-angle end of a telephoto lens, it was not until photographic optics grew sophisticated enough that it became possible to manipulate perspective.

This development of photographic lenses resulted in a compositional feedback. In the second half of the 20th century, photographers started to influence the compositional form of painting, instead of the other way around. In the 1920s, the *Surrealist* artists came along and broke many of the old painterly rules. They took objects and put them together in new and startling ways. It is worthwhile checking out the Surrealists because some of their compositions are exciting and there is much to learn from their outrageous (at the time) images.

It's very important to know about a few of the classic laws of composition because they can form a solid basis for you in your work.

Don't just snap away – always think of your composition before pressing that button!

DEFINITION

*The **Surrealists** created paintings, drawings, and photographs that were inspired by dreams. Salvador Dalí, Pablo Picasso, and Marcel Duchamp were the leaders of the movement. Man Ray was the most famous Surrealist photographer.*

Here are the laws!

I DON'T LIKE TO BE BOUND BY LAWS, nor do I wish you to be, but there are some basic compositional pointers that you should adhere to. Even if you ultimately decide you want to go with your own ideas, give these a try first!

INTERNET

www2.southwind.net/
~tkalp/pw2/Comp.htm

This page of Wichita South High School's web site contains some sound advice and information on photographic composition.

The law of thirds

Divide your frame into thirds both horizontally and vertically, as illustrated, so that you have nine equal-sized parts. The law of thirds states that the four points where the lines intersect are the strongest points in which to place the most important feature of your picture.

■ **The height of the wave** *and the direction the surfer was facing led me to place him at the top left intersection on the rule-of-thirds grid that is etched in my brain. He wouldn't have looked as good at any other point in the frame. Try placing your subjects at all four intersections and see the difference.*

Positive and negative shapes

Positive and negative shapes are more obvious and more easily recognized in black and white. The positive shapes are the main features, or the subject matter, and the negative shapes are the shapes between and around the main features of the picture. The dynamics of the picture are as dependent on the negative shapes between and around (to the edge of the frame) the main subject or subjects as they are on the positive shapes.

■ **In this picture,** *the white space (the negative shape) between the figures is as important to the graphic impact of the photograph as the shapes of the figures (the positive shapes).*

The golden triangle

The rule of the golden triangle is based on the equilateral triangle, and it's mostly used in the composition of portraits. The triangle is a powerful form and can be placed anywhere in the frame. The triangle will form the positive shape and the background and/or foreground will be the negative shape around the triangle. The geometric strength of the triangle provides the subject of the portrait with its strength, and it's a dynamic starting point when learning to compose portraits.

■ **When you first start** *taking portrait photographs I would suggest that you try to use the golden triangle rule. It's a very strong, tried and tested compositional form.*

Photographic composition

HAVING LAID DOWN A FEW LAWS, *I will move onto what I call photographic composition. It has to do with space management in the viewfinder – it's not about art and graphic design. It's about placing the subject in your viewfinder and telling the story as effectively as you can.*

I used to keep a file of favorite photographs and paintings that I had torn out of magazines in order to copy the compositions. It was a great learning experience. We can all learn from the masters.

During the learning process, you'll inevitably make compositions that don't work very well. However, that shows that you're trying. Your compositions will evolve to be different from mine or anybody else's – you will develop your own style. So be outrageous, be bold, try being different!

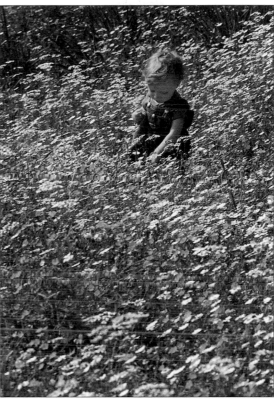

■ **For this composition** *I went with common sense. I used the space in my viewfinder to tell a story. By making the boy small and keeping him in the top half of the frame, I have illustrated the billions of wild flowers that cover Majorca, Spain, in the spring.*

Leaving a space

Many of the seemingly spontaneous compositions that we see in journalistic photographs are not grabbed shots but, in fact, well planned. Some of the great pictures of Henri Cartier Bresson are good examples. He often made compositions in the viewfinder, leaving a space for a figure, such as a cyclist, to fill. Then he pushed the button when the cyclist appeared in that allotted space. So try composing and waiting. See if it works for you. (You can, of course, direct someone into your allotted space!)

Check out the patterns

Keep your eyes peeled for patterns. You can isolate them to make exciting pictures. Here's a couple of examples to point you in the right direction.

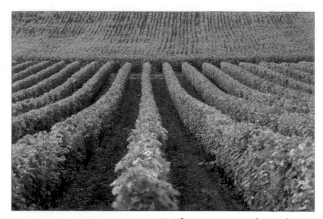

■ **These vineyards** *and grape fields have man-made patterns that were waiting for me to isolate a small section for my picture.*

INTERNET

www.photography bygarrett.com

This is my own web site. Why not visit and see if there's anything you like?

■ **This great array** *of plates was in the Savoy Hotel's kitchen when I arrived, but the pattern only revealed itself to me once I looked down from up a ladder. I used an 18mm (wide-angle) lens to exaggerate the perspective.*

Creating visual effects

ONCE YOU'VE LEARNED THE LAWS *of composition, started looking for patterns, and left space in your pictures, you can start to consider other compositional effects. There are many options and I'll take you through some of my favorites in the next couple of pages.*

Symmetry

A symmetrical composition is a well-balanced composition in which the visual feel or the shapes on one half of the picture are echoed on the other. In general it has a calming effect on the viewer. On the other hand, often it's not dynamic or interesting.

Frame within a frame

I think that introducing a second frame into the frame of your photograph creates uncertainty and a touch of surrealism. This is a good device for making the viewer think about the picture more than they might otherwise.

■ **By photographing these men** *through a huge piece of piping I have placed them inside a circle, thereby creating a round composition within the rectangular 35mm frame.*

Scale

By introducing an element of known size into a picture we can dynamically portray just how big or small our subject really is. However, we can also use scale to create an optical illusion and trick the viewer into believing that the picture's subject is smaller or bigger than it really is.

Repetition of shapes

A faithful standby is the use of repeating shapes. You often see this compositional form combined with good use of perspective. A good example is a Victorian London terrace where the repetition of the columns makes a satisfying pattern.

■ **A classic standby for photographic composition** *is the repetition of shapes. These trees work very well, creating an aesthetically pleasing pattern.*

Eliminating space for a reason

In a portrait, cropping in around the head and eliminating any "breathing space" creates a feeling of tension, because the person's face looks trapped in the picture by the edges of the frame. The person has, in a sense, nowhere to go, and the effect can be a claustrophobic tension. Try this yourself. Also try shooting a few frames where you loosen the framing and leave space around the face. You will notice the difference in graphic tension.

■ **Artist Wes Walters** *is a very intense man, and I have tried to convey that by framing very tight on him. I have eliminated any space from around him. This type of closed-in composition adds tension to the picture.*

Space and movement

The position in which we place a moving subject in our frame has a profound influence on the viewer. If the runner has just entered the frame on the right and there's a lot of space on the far left, you will give the impression that the runner has a long way to go. If, however, you compose with the runner on the left and about to leave the frame, he seems to be at the end of his or her journey.

■ **The boys in the water** *seem to explode out of the picture; this adds to the feeling of the power of the waves and to the excitement of their play. Don't be afraid to try unusual compositions – it's how you learn.*

Focal point

At first, use the focal point in a simple way. Take an open, featureless picture and then introduce your focal point to it. It may also serve as a scale reference. A small focal point will make a dramatic difference to your pictures.

Technically, the focal point is the area of the picture on which the photographer focuses. With regards to composition, we are referring to the object in the picture that attracts and holds the viewer's attention.

■ **The use of a focal point** *is beautifully demonstrated by comparing these two road shots. You can get a much better sense of scale in this second picture. I think you'll agree that it was worth waiting for the car heading toward Death Valley.*

A simple summary

✓ The laws of composition are long standing, and being aware of them is vital to the creation of good photographs.

✓ The law of thirds shows that there are four key points in your frame, one of which should contain your picture's most important feature.

✓ The golden triangle law, often used in portraiture, urges you to create an equilateral-triangle shape within your frame.

✓ You should aim to include important shapes between the subjects of your composition just as much as you aim to create good shapes with the subjects.

✓ You can learn a great deal about composition by trying to copy your favorite artists' photographs or paintings.

✓ There are many visual effects you can use to make your pictures more informative, appealing, or different. These include using symmetry, a second frame, and scale.

✓ The focal point is what you want the viewer to look at.

PART FOUR

SOME PICTURES MIGHT COMBINE SEVERAL THEMES

PHOTOGRAPHIC THEMES

ONCE YOU HAVE A GRASP of the basics of photographic techniques, the next step is *applying* this knowledge to specific subjects. I have grouped the subjects into the classic themes of photography. This section is aimed mainly at you rather than your equipment. It is about how you as a person learn to see the world as a photographer. It's about becoming more *visually aware*, and it's also about simplifying photography.

I want you to be able to take great pictures without making a big deal about it. I want you to *experience* the joy that I've had taking pictures, without some of the hassles and disasters that I've had on the journey. You'll still make mistakes but, hopefully, not as many. The great shots you get – and you *will* get great shots – will draw you back to photography time and time again.

Chapter 15

Portraits

THE OLD SAYING "never judge a book by its cover" cannot apply to the portrait photographer. In fact, the exact opposite approach is required: we must learn to observe the cover because it's all we have. I believe the visual evidence presented by a subject is an accurate map of what was and is going on inside the person – the personality or character of the person. The lines on the face of an old man have been earned during a long life; the tension in his hands, and general body language, betray what is being felt beneath the surface. To become a good portraitist you must develop your observation skills so you can capture the essence of the people you photograph.

In this chapter...

✓ Putting your subject at ease

✓ Types of portrait

✓ Black and white vs. color

A GOOD PORTRAIT REVEALS THE SUBJECT'S INNER SELF

Putting your subject at ease

THE GREAT AMERICAN PHOTOGRAPHER *Richard Avedon said of his portraits, "They are also pictures of me, of the way I feel about people." I certainly agree that portraits can reveal as much about the photographer as they do of the subject. I also know from personal experience that if we make an effort to photograph our friends, family, or clients sympathetically and with style, we can give them a great deal of pleasure.*

I spent the early years of my career as a fashion photographer, and I was amazed to learn that these beautiful and confident models were also vulnerable and nervous below the surface. It just goes to show that we are all worried about what we will look like when we have our portrait taken.

One of the most essential skills for portraiture is the ability to put your subject at ease. And in order for you to be relaxed enough to make your subjects relax, you need to be on top of your technique.

■ **It often requires** *some effort on your part to bring out your sitter's personality. These two shots of Sir John Betjeman are good examples. We were having a serious discussion about poetry when I took the first picture. The second shot (the next frame, in fact) shows his response to a joke I made about one of his poems.*

Be prepared. Plan where (if on location) and how you are going to take the portrait. Have the camera loaded with film and fresh batteries. Even if you are nervous, and you might be at first, look like you know what you are doing. Make your subject feel they are in capable hands. If you are using lights, set them up in advance. I would suggest you use somebody else to sit in while you set up the lighting. Have a look at chapters 10 and 11 for more information on lighting and suggestions. However, remember that those dull, overcast days that aren't ideal for most photography can produce soft, flattering light for portraiture.

■ **This shot was taken** *on a dull, overcast day. As you can see, it produced a sympathetic light for the sheep farmer. A 135mm lens shot wide open (f2.8) has added a soft, out-of-focus background.*

Music and conversation

If you are shooting indoors or in a studio environment, put on a little background music. Music is a great soother of nerves. However, be sure it's not too heavy since that can have the opposite effect. Have a large selection of music on hand, and ask the sitter if he or she has any preference.

Give the impression that you have all the time in the world for the shoot. If your subject wants to sit and chat, sit and chat. Use the time to observe the sitter.

Most of the portraits you take initially will be of family or people you know. Steer the topic of conversation to one they enjoy, where they feel safe. Be prepared to take plenty of pictures, two or three rolls, and keep talking while you are shooting. The expressions the sitter makes when answering your questions often create magical pictures.

Let the sitter know that you are taking lots of shots. This eases the pressure for that "one good picture" (it takes the pressure off you too) and helps your subject relax.

If you think about it, with people you know, you can predict what sort of expressions they will make for any question that you ask them. That way you can shoot a variety of expressions, like their laugh, smile, or frown.

POSING AND CAMERA ANGLES

The most important tip for posing a portrait sitter is to have them lean toward the camera. Although the body language is far more dynamic when they are leaning toward you, many portraits are taken with subjects leaning away.

Don't just let portraits happen, control them. Be in charge and tell the sitter how you want them to pose. They will be grateful because they are probably too self-conscious to know what to do themselves.

Since most of us, whether we're amateurs and professionals, are trying to flatter (or at least please) the subject of our portrait, we need to know how to deal with the usual human frailties.

a If a man is going bald, shoot from below the chin line and use side lighting (never top or front lighting).

b If your subject has a double chin (or two), shoot from slightly above head height and have them stretch forward and look up at the camera.

c Many people display their nervousness by tensing their mouth. Ask them to fill their cheeks with air and blow it out – hard. This relaxes their mouth and makes them feel so silly they almost always laugh. There's your great happy portrait.

■ **Christina thought** *I'd gone completely crazy when I asked her to fill her cheeks with air and blow hard! However, it relaxed her and she laughed.*

d If the subject has a long nose, have them look straight at the camera with their head straight, and use as long a focal length as possible. The long lens (telephoto mode on a compact camera) will compress the perspective, making the nose look shorter.

e Some people stare when they are nervous. Just quietly ask them to close their eyes and lower their chin to their chest. After a few seconds get them to slowly lift the head and open their eyes as they do. Stare gone – magic!

f To produce a dynamic, "I'm-in-charge" portrait, shoot from about chest height looking up at your sitter. The sitter should keep his head still and simply look down at the camera with his or her eyes. I shoot most of my corporate portraits like this.

Trivia...

The great portraitist Yousuf Karsh was making a portrait of the larger-than-life British prime minister Winston Churchill, who, as usual, was smoking a cigar. However, Karsh was having problems getting Churchill's trademark "British Bulldog" expression.

Legend has it that the photographer jumped out from behind his camera, snatched the cigar from Churchill's mouth, and stuck it between his fingers. Churchill was furious and glared at the camera, creating a very famous portrait.

■ **By looking up at this cowboy** *I feel that I have really captured his natural authority, which so impressed me when we met in the mountains of Colorado.*

Choosing clothing and backgrounds

Generally, I like my sitters to dress in plain, unpatterned clothes, especially for head-and-shoulders shots. I try to remove anything that will distract the eye from the face. Sparkly earrings can be distracting, for example. However, having said that, if your favourite aunt just wouldn't be herself without her floral dress, beads, and ostrich-feathered hat, then that's what she should wear.

I also think it's important to keep the backgrounds simple on formal portraits. You can buy large sheets of colored paper in specialty paper stores, but I also like to color boards with spray paint. You can make clouds or matted effects that are atmospheric but that don't distract from the face of your sitter, since he or she is the focal point of the portrait.

■ **Usually I don't like to distract** *from the face with patterned clothing. But, let's get real, Aunt Sue just wouldn't look the same in a simple black dress, now would she?*

Types of portraits

THERE ARE MANY DIFFERENT TYPES *of portraits, but they can be squeezed into two main families: the environmental portrait and the cosmetic portrait. We will look at each of these in detail, but first it's important to understand how they differ.*

The cosmetic portrait is probably the type of photographic portrait we are most familiar with. This is a picture in which the sitter is the sole subject, and there is little else in the

shot. For example, this type of photograph might be used by an actor to put with his résumé when looking for work.

An environmental portrait, on the other hand, is about more than the physicality of the sitter. The world that the sitter inhabits is also of great importance. An example of this might be a farmer with either his land or his farm animals in the background.

INTERNET

www.photography.ca/
otherartists/karsh.html

Check out this web page for a handful of portraits by Yousuf Karsh, in addition to a brief biography of this important portraitist.

Environmental portraits

Taking portraits of people in their own environment is great because the background and props show us who this person is – their interests, taste, or lifestyle are also in the picture. This is an ideal situation for the wide-angle lens (or the wide-angle mode on a point-and-shoot camera).

■ **This is a good example** *of an environmental portrait. It was important to me that I show not only this tough Australian farmer and his sheep dog, but also the land that made them tough. I shot it with a 28–70mm zoom lens set at 30mm and stopped down to f11 to keep the background sharp and clear.*

203

You need to be careful when posing your sitter on location, however. Find an appropriate place in your viewfinder and make sure that the subject's head is clear of lampposts, doorknobs, and anything else that may end up looking like horns or other appendages.

If you are taking photographs indoors, look at the natural lighting before you automatically turn on the flash. It may be low but it could be of a beautiful quality.

Also, try using a tripod, turning off the flash, and asking the sitter to stay still while you make a long exposure.

■ **This portrait** *was shot in a dimly lit café in Italy, with my camera supported on my camera bag. The exposure was ¹⁄₁₅ of a second. Using a flash would have killed the moody lighting, and it would have also disturbed the subject.*

Cosmetic portraits

Since a cosmetic portrait is intended to show the sitter in a flattering fashion, you need to be able to achieve that goal. In this section, I'll give you a few useful tips to help you on your way.

As a general rule, focus carefully on the eyes. They are, after all, the windows to the soul.

■ **For cosmetic reasons,** *I used an orange filter over the lens for this photograph, simply to hide the fact that it was a "blotchy-skin" day.*

If your subject has blotchy skin or acne, I would suggest using black-and-white film (400 ISO) with an orange filter. If the acne or blotches are very pronounced try using a red filter. The filter will absorb the red in the blotches and produce a clearer skin tone. (If you have a point-and-shoot camera, you can try holding the filter in front of the lens, or in front of the flash if you are using it.) A soft-focus filter is another option and it also flatters older women. Try finding one that is only slightly soft.

Portraits by candlelight are very flattering. The flickering directionless light is soft and produces a warm glow. Generally speaking, the longer the lens the more flattering a close-up portrait becomes. But bear in mind that lenses over 200mm are often unmanageable.

Never push a wide-angle lens too close to a face (unless you don't like the person!) since you will get an elongated head and a long nose.

If your sitter has bags under the eyes or dark eye sockets (I'm describing myself here!), place a silver reflector on the table, like aluminum foil, and have them lean over it. The silver reflector bounces light back up and fills in the dark eye sockets, removing much of the baggy look. It also puts a bright highlight in the eye, which gives the sitter a bit of a twinkle. And we all need a bit of a twinkle once in a while!

■ **I used a silver reflector** *on the table below business tycoon Richard Branson to bounce light up into his eyes. It added the visionary sparkle that I was looking for.*

Black and white vs. color

ALTHOUGH NOT EVERYBODY DOES, *I prefer black-and-white portraits to color portraits. There, I've said it. However, I think that color works well for some photos, like glamour shots of young stars or a portrait of your daughter in her prom dress. Color can have a glossy look and, obviously, if you have a special outfit that you want to record for posterity, color is the best choice.*

But I believe that most people look better in black and white than they do in color. I think they carry a greater authority and strength. On the other hand you might disagree! It's all a matter of taste.

■ **I chose black-and-white** *film for this shot of actor Julian Holloway because I feel that black and white is stronger for portraits, especially male portraits. I put a black scarf around his neck to remove any distractions from his face, and I cropped off his balding head for obvious reasons (sorry, Julian!). This was shot on a 6 x 6-cm Hasselblad, and the medium-format negative has produced a complete range of tones.*

A simple summary

✔ Before you can even begin to shoot a portrait you must be able to put your subject at ease. This is an important skill of the portrait photographer.

✔ Soft background music will help relax most people.

✔ Friendly chatting is not only relaxing but also helps you get to know your subject a little better.

✔ Ensure your sitter's clothes aren't too garish, unless such attire is part of the subject's personality or character.

✔ Learn how to flatter your subject. Different faces require different angles and techniques.

✔ Choose relevant backgrounds for environmental portraits, but beware of false appendages!

✔ I think that most people look better in black and white than in color. You may not! Try both and see which you like.

Chapter 16

Landscapes

O F ALL THE CLASSIC THEMES in photography the one that leads to the most disappointments is the landscape. Friends often show me pictures from their vacations, and when we come to a landscape shot they say, "I don't understand this one – it just didn't come out like it looked." What has happened is that they didn't know how to turn an inspiring view into a landscape photograph. When we survey a scene, our eyes dart around, pick out the most attractive features, and reassemble them in the brain as a perfect landscape picture. A camera can't do that – it only records what we point it at – not the majesty of the full scene.

In this chapter...

✓ Landscape tradition

✓ The importance of light

✓ Choosing your film

✓ Point-and-shoot landscaping

✓ Think comfort

CAPTURE THE ESSENCE OF THE LAND

Landscape tradition

PAINTERS HAVE THE GREAT ADVANTAGE over photographers that they are able to completely alter their landscape. They can move a tree or remove an unsightly object altogether. However, the basic principles that govern them govern us as well. The traditional rules are that a foreground leads the eye toward a focal point and that the eye is held in the picture by a background. And the dominant ingredient was, and still is today, light.

Photographic composition

Early photographers relied entirely on painterly composition, and they continued to do so, because of lack of choice, until the development of wide-angle and telephoto lenses. However, wide-angle lenses allowed photographers to exaggerate perspective, and telephoto lenses were able to condense perspective and isolate a section from the landscape. In a turn of events, the composition of many 20th-century painters became influenced by the techniques used in photography.

Today, the classic foreground–focal point–background composition is still the basic form for landscape photography. However, we must also search the views in front of us for patterns and use the lenses we have at our disposal. Forget how you feel emotionally about the patterns and concentrate on finding them.

You may end up with a simple picture of just a rock in front of cumulus clouds, but the print could capture the emotional feeling you had for your whole surroundings.

■ **Using a 24mm (wide-angle) lens** *I was able to make full use of the swirling rock formations at Zion National Park. Notice how all the lines in the picture lead your eye toward the cliff faces in the background.*

■ **The plains of the Serengeti desert** *in Kenya seem to go on for ever, and it can be difficult to get a sense of scale. That's where a focal point – such as these trees – comes in useful.*

What is a focal point?

When I refer to a focal point the sort of thing I mean is an isolated farmhouse, a great lone tree, or a horse in the middle of an open piece of land . . . or a boat in the middle of a lake. Do you get the idea?

A focal point is something toward which you want the viewer's eye to be drawn, something that stands out from the rest of the frame.

Where do I find a pattern?

By "patterns" I mean things like ploughed fields, different-colored crops planted side by side, or a range of hills found by your telephoto lens. Some landscapes combine all these and more. If you are lucky (or alert) you may find a farmer ploughing those aforementioned fields with a flock of birds flying above him.

If you have running water in your picture (like the sea or a waterfall), choose a slow shutter speed (between $\frac{1}{15}$ of a second and 1 second) to give the water a soft, milky, fluid appearance, to contrast with any rocks surrounding it.

The importance of light

THE QUALITY OF LIGHT *falling on a landscape dramatically influences the patterns and form of the final photograph. Traditionally, early morning and late afternoon provide the most dramatic lighting effects. However, heavy, dark-clouded skies can also suddenly be broken by a shaft of light at any time of day, and those conditions often provide the potential for great landscapes.*

■ **Landscape photography** *is dominated by light effects. This Australian scene was captured during a brief pause on a stormy day. The black clouds are there, but light has broken through to highlight the trees.*

Light is fleeting, and its great effect is often only present for a few moments. You need to work fast sometimes, so keep a loaded camera and tripod ready. If carrying a tripod is too much of a hassle – you like landscapes but not *that* much! – try a mini tripod that you can set on a rock or brace against a tree.

I find a compass helpful when I am in a beautiful place and the light is boring. I set the compass and, by calculating where the sun will rise and set, I get a feel of how the shot will look in early or late light. Then I can plan to be in the right spot at the right time.

If your camera has overexposure compensation (+ or -), bracket the exposures from -2 and through to +2. You will then have pictures where you have exposed for the highlights (-2) as well as shots where you have exposed for the shadows (+2). You can decide later which effect you prefer.

Choosing your film

I LIKE TO EXPERIMENT *with different types of film for landscapes. If I am shooting a subject that I feel needs to be very sharp, and where I want to reproduce every detail perfectly (like an old tree stump or a rock formation), I usually shoot with slow film, a 100 ISO. At other times I use very fast film for a grainy effect. You can create the look of an Impressionist painting with 1600 ISO color, while 3200 ISO black and white can give the look of an old etching.*

I can't tell you exactly what film to use. It's your personal creative choice that should dictate your selection of film. Try as many types as you can and see which ones produce the results that you like best. After all you are taking photographs that will appeal, first and foremost, to you, aren't you?

Whatever type of film you choose, a polarizing filter is the ideal companion for shooting landscapes. It will increase contrast by darkening blue skies and bringing out the cloud formations.

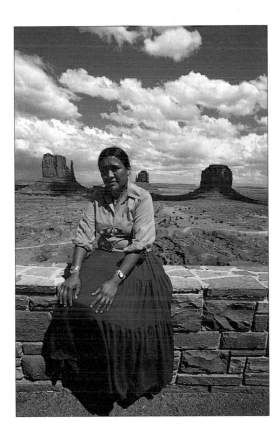

■ **A polarizing filter** *is a great tool for use in color landscape photography. By cutting back the reflected light for this shot (in the same way that sunglasses do), the sky has become a deeper blue, so the clouds appear whiter and stand out more.*

Black and white

Having said that film type is a personal choice, I will say that I am hooked on black-and-white film for landscapes and I recommend that you try it too. It will take time before you start seeing colors in terms of tones (we'll look at that in Chapter 22). You can increase your black-and-white enjoyment level by doing your own printing also, but, these days, most photo-development labs provide a good black-and-white service.

■ **Here I used** *an 18mm (very wide-angle) lens to play around with the perspective. I fitted a red filter to the lens and it's really worked its magic on the sky.*

Of course, the greatest landscape photographs aren't taken from a public rest stop. Nor are they the result of just jumping out of the car and taking a couple of pictures. They are the result of hard work and dedication.

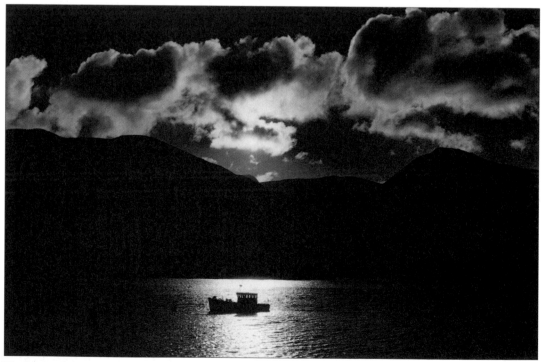

■ **The early morning light** *over this Scottish loch was very intense so I used a red filter on a 28–70mm zoom lens set at 60mm, and I waited for the sun to go behind the clouds to avoid flaring. In this kind of situation, add 2 stops to avoid underexposure.*

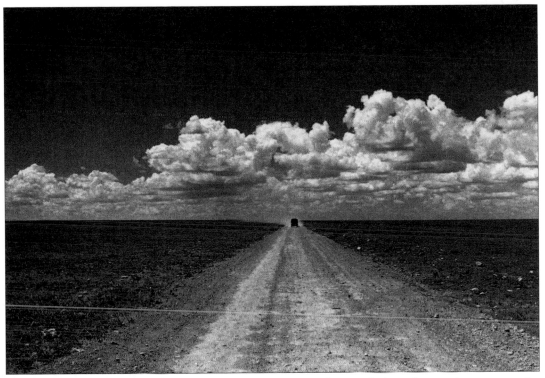

■ **Just an old dirt road,** *some cumulus clouds, and a tiny truck — you don't need many elements to make a satisfying image. Once again, the red filter has done a great job on the sky. Keep it simple; less is more.*

To get high-quality shots you'll probably have to walk for miles with your camera and tripod, after having risen from your bed 2 hours before dawn to make sure you capture the dawn light as it hits the landscape!

I don't want to turn you off, but by understanding what makes a great landscape and by being prepared to make a real effort you can improve your pictures immensely.

The filters that work with black- and-white landscapes are orange and red. Orange will darken the blue sky (and make it a darker gray), and a red filter will make the blue sky almost black with white clouds.

No doubt you have seen many Ansel Adams landscapes using those filters.

INTERNET

www.photography. about.com/arts/ photography/library/ weekly/aa071999.htm

"Who's Ansel Adams?" you ask! You can find out by looking at this web site.

Point-and-shoot landscaping

THERE IS NO REASON why you can't shoot good landscapes with your point-and-shoot camera. All the same principles apply regardless of which camera you use. Simplify, and be aware of the need for dramatic light.

If you have a zoom lens don't use it just to save some walking. As we discussed in Chapter 12, you can use your lens creatively, not simply to get more in on the wide-angle shot or get closer on the telephoto setting. Your wide-angle lens will exaggerate the perspective, which is great on cloudy skies, and your telephoto lens will compress the perspective by pulling background mountains up closer to a boat on the water, for instance. You can also use the telephoto lens to isolate the patterns you have spotted inside the view that you are looking at.

■ **The stormy sky in this scene,**
shot on an APS with a 28mm fixed-focal-length lens, really makes this picture. The composition is a classic painterly one. The foreground rocks lead your eye to the road, and the road takes you to Monument Valley's famous monoliths. The tiny car makes a good focal point.

Many point-and-shoot cameras have a panoramic facility built in, which can work well for landscapes. But remember that you still need the same compositional disciplines.

Think comfort

I DON'T THINK THERE IS ANY OTHER photography theme that rewards effort as much as landscape does. To take really good landscape pictures you need to be up before dawn and home after dark. Since you sometimes need to walk all day, and it is often too hot or too cold, your comfort is as important as your photographic eye and technique.

MAKE IT EASIER ON YOURSELF

You can't – or at least I can't – take good pictures if you're cold, hot, or tired. I can't walk if my feet are sore or if my sunburned neck hurts. Although you can't control the weather, there are some basic steps you can take to ensure your comfort level is as high as possible. Once all your personal needs have been cared for, you will be free to shoot masterpieces. The following list contains some of the points that I think are essential for any landscape-photography trip.

- Wear a shirt with a collar to protect yourself from the sun
- Take a hat – essential in both hot and cold climates
- Wear good waterproof hiking boots with thick socks to protect your feet
- Take energy bars to eat
- Carry a full water bottle
- Bring sunblock if it's sunny
- Take a flashlight in case you need to find your way in the dark
- A space blanket is useful if you need to keep warm
- Take a cell phone for emergencies
- If you are driving remember to landmark your car by parking it near a tree or rock – it's easier to get lost than you might think!
- A compass can help too

WATERPROOF HIKING BOOTS

COMPASS

■ **Here's another shot** *of Monument Valley – this time from a different camera position. I isolated the monuments using a telephoto lens and used a pinkish filter to exaggerate the color. In addition, a neutral-density graduated filter darkened the sky.*

A simple summary

✔ The classic landscape picture has a foreground, a focal point, and a background.

✔ A focal point is something to which the viewer's eye is drawn.

✔ Look for patterns in the frame to add some texture to your photo.

✔ Light is arguably the most important element of landscape photography.

✔ Experimenting with different film is the only way to find out which you prefer, leading you to make informed creative choices.

✔ The same landscape principles apply regardless of whether you are using an SLR or a point-and-shoot camera.

✔ Consider your personal comfort when you are setting off on a landscape-photography trip.

Chapter 17

Still Life

STILL LIFE IS THE PHOTOGRAPHIC THEME that allows us the greatest amount of control. We choose the objects to be photographed, the background, the lighting, the film, the lens, and the camera angle. We create the composition by just moving objects around. Still life is the closest that photographers can get to painting a picture. I find that, when I go to create a still life, I have to slow myself down to enjoy the contemplative process. Once you get into it, you will find that it's therapeutic. In this chapter, I'll discuss the qualities a still-life photographer needs and pass on some tips that the professionals use in creating images.

In this chapter...

✓ Getting inspired

✓ Considering your viewpoint

✓ Composition

✓ Light and color

✓ A word to the wise

YOU CAN FIND INSPIRATION IN THE MOST ORDINARY OBJECTS

Getting inspired

I THINK THE BIGGEST OBSTACLE *we all encounter when it comes to still life is not knowing where to start, that is, not knowing what to photograph. A good place to start is by studying the old masters.*

Look at works by painters such as Matisse, Chardin, and Cézanne, and photographers like Penn, Kertez, Man Ray, Miro, and Meatyard. Study their compositions, their balance of color, and their lighting. You can also gain inspiration by studying the objects that they chose and thinking about why they chose them.

The sincerest form of flattery

Don't be embarrassed by copying (or trying to copy) old masters. It's a great way to learn, and if you know your art history you will find a number of famous photographic still lifes that are in fact copies of – or "inspired by" – old paintings.

Props and the squirrel mentality

Most still-life specialists were squirrels in their former life, I'm sure of it! My wife Michelle is a still-life photographer. She has been collecting objects for years. She spends a weekend in the country and comes home with stuff like an old flaking piece of fencing or a rusted teapot. She knows they will look great in a picture she has in mind. In fact, it's probably more accurate to say that the props inspire her to take the picture in the first place! Look for color and, especially, different textures. Of course you may be a collector already.

■ **This shot was based** *on a postcard I bought at a gallery. The props are not exactly the same, but I copied the flowing composition that the artist created: everything flows into the next object, from the top tulip down to the bottom petal. I used a big window for lighting and shot on a cheap compact.*

If so, start by making a still life with the artifacts you've collected as its theme. Then consider what you are going to use as a base and background. Collect objects that are sympathetic to, or work well with, the theme and put them all together.

Found still life

There are potentially wonderful still-life pictures all around us that we just don't see. Still life is as much the art of selection as it is of creation. The ability to select or to find the patterns that exist around us is something we develop during our whole career as photographers.

Sometimes a still life that you shoot on vacation can say more about the country or area you're in than a grand landscape or cityscape. Artifacts in the picture are often symbolic of a specific location.

I love food and I often make a still life of a meal or the café table after a drink and snack. It reminds me later of happy times I enjoyed. There are no rules – just try to develop your critical eye and practice, practice, practice.

■ **Think about colors.** *For this picture I used a bright blue background, from the opposite end of the spectrum to the orange flowers. They fought each other on the page to produce a vibrant color image.*

Considering your viewpoint

BEFORE YOU CAN START MAKING DECISIONS *about your composition you need to set up your camera. A tripod is a necessity, not only to keep the camera steady, but also so that you can run back and look through the viewfinder while you compose the picture.*

Never start composing a still life without the camera set up in position — it will look completely different in the viewfinder.

Once you have set up the camera on the tripod you might think that you can start putting your shot together, but you have another major consideration — your camera angle. When you slowly move the camera up and down the tripod with your eye glued to the viewfinder you will understand why. Camera angle has a dramatic effect on the apparent shape of objects. A bottle viewed from above appears entirely different than when it is viewed from the base. It's a good learning exercise to shoot the same setup from several different angles.

■ **These two pictures demonstrate** *how the camera angle can influence the shape of objects in your still life. You can see how the glass appears to be a different shape as the height of camera's viewpoint changes.*

Lenses

The choice of lens is another photographic decision that makes a huge difference to the composition of the picture. As I said in Chapter 12, a wide-angle lens exaggerates perspective. In other words, the objects closer to the lens will appear larger and those further away will appear proportionately smaller. A wide-angle lens – about 28mm – is often the choice of pros because it allows you to be physically close and to look into the objects.

■ **Altered viewpoints:** *The picture on the left was shot on a 200mm (telephoto) lens. The tree branch appears to be over the basket and the background is out of focus. The picture on the right, shot on a 50mm lens, shows us that the branch is in fact behind the basket. The telephoto lens has compressed the perspective.*

Conversely, a long-focal-length lens will compress perspective and give the impression that the objects are closer together than they would appear to the eye. The other property of lenses that is important to consider is the depth of focus (or depth of field). The inherent depth of focus of a wide-angle lens means that you will find it easier to keep the subjects sharp from foreground to background.

A lens holds two-thirds of its sharpness past the point of focus and only one-third in front of the point of focus. So focus about one-third of the way into the picture for maximum depth of focus.

You may wish to keep one subject sharp and leave the foreground and/or background in **soft focus**. You can also choose a long (telephoto) lens for its lack of depth of focus. A 28–105mm (or similar) lens is useful for still life because you can look at wide-angle and long-lens effects without changing lenses.

If you are using a point-and-shoot camera, remember that you will get greater depth of focus from front to back on the wide-angle setting.

Choice of film

The final major choice is film. You can use a slow film (25–100 ISO) for the ultimate in sharpness and fine grain. Or you can go for a fast film (800–3200 ISO), which will give you a grainier, softer result. This can give you a lovely painterly, almost Impressionist feel.

Sometimes I breathe onto the lens to give the picture a foggy look in addition to the grain of the film. This can look great.

Most professional still-life photography is shot on large format (4 x 5- or 8 x 10-inch) cameras, because they are the ultimate for smooth, sharp reproductions of a subject.

Composition

WHEN YOU START COMPOSING still-life pictures, I suggest you begin by just placing objects together in a random way – to see if they will work together.

When you are putting props together on a background, try to see them not as what they are but simply as colored shapes of various sizes and volumes. That will help you with the composition.

Once you are happy that the colors and shapes are well placed, build the picture around one dominant object. This is what I do, and, as I add each prop, I make sure that it relates comfortably to the others. The purpose of this exercise is to combine all the individual objects together to form an aesthetically pleasing whole.

Learn to look carefully at negative space. This is the space between objects that leads the eye from one item to another and connects the objects to form one composition.

■ **This composition** *was based on a simple figure eight. The bright colors of the fruit against the green background have created a wonderful summery feel.*

Choosing a background

When you are satisfied that you have a harmonious group of props, it's time to make a decision about the background. Do you want to use a white or plain-colored background that will focus the viewer's eye completely on the props? Or do you want a "real-life" look by using a table as a base and a wallpaper background? What about a window, or a peeling painted wall?

While we're on the subject of composition, make a decision about whether to shoot a vertical, horizontal, or panoramic composition. It's a personal decision; some of us see things vertically and some horizontally. I will leave the choice to you, but think about it.

INTERNET

www.amateurphoto. about.com/hobbies/ amateurphoto/library/ weekly/aa030498.htm

Check out this web page for some great still-life tips.

■ **I rescued the background** *for this shot from a garbage tip, and the props were borrowed from my wife's prop cabinet. I started with the clock and began adding the other bits and pieces, making sure that the negative spaces between the props made harmonious shapes.*

Light and color

MOST OF THE LIGHTING EFFECTS *that professionals use are based on reproducing window light, so why not go straight to the source? Set up next to the window for sidelight, in front of it for a back-lit picture, or adjacent to it for a cross-light effect.*

Important accessories to window light are reflectors and a large sheet of diffusing material, such as tissue paper, tracing paper, or fiberglass sheeting. You can buy these items at most professional photographic stores. You can change the color of the light with your reflectors and diffusers. For example, use gold reflectors and a light yellow diffuser (net curtains are good) to reproduce a golden sunset light. In fact, you can manipulate the colors any way you want with reflectors and diffusers of various hues. You can also set up formal still-life pictures outside in the garden using daylight.

When shooting daylight still-life pictures, add wheels (with brakes!) to the legs of your still-life table base. That way, you can move the setting for the lighting effect you desire. This is what the pros do.

■ **As the sole light source** *for this photograph, I used the window that you see in the shot at a three-quarters angle, and combined that with a white reflector opposite the window to fill in the shadows. You will be amazed at how effective reflectors can be in still lifes.*

■ **Still life on an old fishing boat in the Loire:** *To soften the light I used a large diffuser, which you can buy cheaply at any big camera store, plus a gold reflector below and in front of the camera to warm the light.*

BAG OF TRICKS

All still-life photographers have their bag or box of essential items that they can't live without. This is my list of essentials.

- Surgical gloves for handling items without leaving fingerprints
- Tweezers for removing annoying items like hairs
- Colored spray paint for making your own backgrounds
- Scissors
- Permanent markers for retouching marks on objects (scratches, for example)
- Sticky-tac for holding things in place (especially round objects)
- Dulling spray for removing fierce highlights from shiny surfaces
- Make-up brushes for removing crumbs
- Paper towels for mopping up spills
- Rods for hanging things from
- A fine water spray for putting dew on flowers or condensation on bottles and glasses
- Duct tape, because it is strong and can be reused for many jobs
- Double-sided tape for sticking things together
- A powerful staple gun for fastening backgrounds in place

Black-and-white still life

Still life is a great theme for teaching yourself about black-and-white photography and learning to see colors in terms of tones of gray. Soon you will discover what densities of gray various colors convert to. By shooting a multicolored still life in both color and black and white, you'll start learning to see in tones.

■ **I was attracted** to the repetition of the curved shapes of this bread display in a midwestern restaurant. I moved it all closer together to condense the composition, then I used a tripod. The light, from a skylight above, was low but of a beautiful quality, and I knew the picture would look great in black and white.

■ **The tones of gray** in this shot of the remains of a meal I had in Tuscany are very different to those in the picture above. I rested my camera on the back of a chair and shot on a compact with a 32mm lens and the flash off.

A word to the wise

IT'S IMPORTANT TO REMEMBER that you will have disappointments shooting still lifes, just like any creative endeavor. You'll have pictures that don't work as well as you had hoped and envisioned. The reason for the disappointment will almost always be that you didn't notice something – a small, black hair in a glass of milk, for example – that has appeared, as if from nowhere, in your picture.

Trivia...

I once spent a day (and lots of film) taking a still life for a new soft-drink ad. The result was great – apart from a fingerprint on the side of the glass that I hadn't noticed!

In still life more than in any other area of photography we have to eliminate the ugly before we can be left with the beautiful. Don't give up, though; with practice you will improve very quickly.

A simple summary

✓ Don't worry about inspiration – borrow some ideas from your favorite still-life paintings.

✓ If you intend to shoot a lot of still lifes, consider collecting props for use in your pictures.

✓ Be alert to the possibility of still-life studies around you. Why go to the trouble of creating what you could find elsewhere?

✓ Different viewpoints will alter the apparent shapes of objects.

✓ Lenses and film can have a marked impact on your work. Try as many as you can.

✓ For the purposes of composition it's useful to see things solely in terms of shape and color.

✓ Window light is the classic choice for still lifes, and it's more adaptable than you might think.

✓ Shooting black-and-white still lifes is a great way to teach yourself how to see in shades of gray.

Chapter 18

Children

THE BIRTH OF A CHILD often sparks the beginning of a serious interest in photography. People often buy their first good camera in the hope of taking better pictures of their children. I had been a professional photographer for years by the time my first son was born, but Nick's arrival certainly ignited my interest in photographing children. I kept a loaded camera nearby for about 12 years. I shot mostly in black and white and the intimacy of this long-term project was a far cry from my photojournalism work of the time.

In this chapter...

✓ *Births and beginnings*

✓ *Babies and toddlers*

✓ *The world of the child*

✓ *Kiddie portraits*

Births and beginnings

I BEGAN THE PHOTOGRAPHY of my own children right at the start: I was present at the birth of our first son Nick. I had popped a point-and-shoot camera in my pocket just in case I didn't pass out and was capable of taking a picture. It was fine with the hospital staff and my wife Michelle said something like, "A photograph is the last of my problems – I don't care if you shoot Gone With the Wind in here right now!" I waited, was supportive, and did all the "new man" stuff, and, finally, I took the picture below about 2 minutes after Nick appeared.

Before you start shooting, you might need to get hospital permission, and, of course, you must stay out of the way. A flash can be intrusive, so this is the ideal time to use a fast film, like a 3200 ISO black and white or a 1600 ISO color.

If you are using a point-and-shoot camera, remember that your wide-angle lens has a larger aperture than the telephoto and will enable you to shoot better with available light. That moment of the birth of your child is a magical one – try to get a photo of it.

■ **I attended Nick's birth** *with a point-and-shoot camera in my pocket, loaded with 1600 ISO black-and-white film, not knowing whether any of us would be up for a picture. This is now a favorite family picture and I'm glad I had the camera with me.*

Don't just shoot the firstborn

I also took pictures of Matt's (my second son's) birth, but the one we love most is the one shown here of the two brothers meeting in the hospital for the first time. It's a situation that one can anticipate will make a great picture because it is a big family moment – and memories are made of moments like this.

■ **The key to this picture** *was anticipation: I knew Nick would be fascinated by baby Matt. I had my camera loaded with 1600 ISO film and used a large-aperture lens (35mm, f1.4). The slightly wide-angle lens let me get close and intimate. Flash would have killed the mood.*

Babies and toddlers

PHOTOGRAPHING *young babies is not difficult from a logistical point of view. They're pretty easy to photograph because they are not yet on the move. In fact, it's probably the only time your kids won't run away or tell you to get lost! I am fascinated by babies' tiny hands, feet, and ears and have taken lots of closeups.*

■ **For this picture,** *mother and baby sat near the window. I shot with a 105mm lens, concentrating on the composition. I love the hand position.*

I don't feel comfortable firing flashes into babies' faces so I don't use a flash. I do, however, make sure I have another important piece of equipment – a drool cloth! Babies always decide to regurgitate some milk just when you begin shooting. Once you start shooting you must keep going and take lots of pictures. You might then catch one of those great smiles that pediatricians say are caused by wind – no way!

Working around the baby

As babies start to really move, photography becomes a two-person job – they move so fast and safety must come first. Make sure the studio, or wherever you are shooting, is warm. If the baby is yours you will know when he or she is at his or her best. Is it after a nap? After a meal? If the baby is not your own, ask the parents these details and plan the shoot accordingly. You can't fit baby pictures into your schedule, you must fit into the baby's schedule.

Lighting the scene

I always prefer to utilize the natural light coming through the window, and I recommend you try it too. I use a white reflector opposite the window to bounce the light back toward the baby. You will also need a tripod because using a flash would ruin the quality of the window light. Use 800–1600 ISO color film or 1600–3200 ISO black-and-white film.

When babies are crawling, they are always on the go. If you can't keep them still long enough to grab a sharp picture, use a flash. The flash will freeze the moment and you

can catch a great action picture. If you shoot on an SLR camera, bounce the flash off the ceiling or wall. Or, better still, use a large white card or sheet – 3 x 4 ft (1 x 1.2 meters) is good – and you will soften the lighting. Most 35mm systems include a dedicated flash and I highly recommend you purchase such a system because it enables you to produce perfectly exposed bounced flash or fill-in flash every time. It's worth the investment.

Even with a flash I would recommend fast film (at least 800 ISO) because it requires less flash power, so the batteries last longer and, very importantly, the flash recharges more quickly.

The world of the child

NOW WE REALLY WANT TO *take a peek into the world of the child. This is the area of child photography where most of the great pictures come from. When it comes to photographing kids doing their own thing you need to have your priorities straight. I used to "stage manage" situations in which children would be really involved and interested. I would take them to their favorite places or organize games with their friends and I didn't touch a camera until they were having a good time. Only once they started having fun, did I get out the camera and take pictures.*

■ **This picture** *was taken during the magic show at Matt's birthday party. I lay on the floor to capture the kids' faces. They were absorbed with the magician and not interested in me at all – perfect!*

My children and their friends became used to seeing me with my camera. Photography was a normal part of our family life and the children just went on with their lives unselfconsciously. However, there were many moments along the way when I had to put the camera down because I thought taking photographs would have been intrusive or an abuse of their trust.

My photography of children became a professional endeavor after people saw my personal pictures. As a professional photographer of children I began using models, but I remained convinced that, regardless of whose kids they were, my "good parenting" techniques were just as important as the photographic ones.

Always be prepared

When you are spending a day with the family and the thought of an SLR and zoom seems too much, pop a compact camera in your pocket. Children have a habit of creating wonderful photo opportunities when you don't have a camera handy and it's those moments that you will most want to capture. Having your compact camera loaded with film and fresh batteries means you have a chance to get those shots. If you find you were not close enough when you took the photo, enlarge the action in the print. When you use a compact camera, the pre-focus technique is very important.

■ **Matt had just** *been told to come in and wash for lunch (for the tenth time). I was nearby and snapped his expression. It always pays to keep a loaded camera handy.*

Avoiding "red eye"

When shooting kids I recommend that you do not use the red-eye reduction mode on your point-and-shoot camera.

The delay, created by red-eye reduction modes, between pushing the button and the shutter going off is hopeless for kids' portraits — the expression you loved when you pushed the button is gone by the time the shutter goes.

Use a red-eye reduction pen instead. They are effective and easy to use. In my opinion, red-eye reduction modes don't work – or I've never found one that does!

MAKE IT NATURAL

The bottom line when photographing children is don't make it a big deal. Try to keep it as a normal part of family life. Pros also need to keep that same relaxed atmosphere in their work.

Never create bad family tension over a photograph. If the child doesn't want a picture taken for whatever reason, you need to respect their wishes. There will always be another opportunity.

My favorite equipment combination is an SLR camera with an 80–200mm zoom. The zoom is ideal because you can compose without having to move. Things can happen so fast that you don't have time to move anyway. I use a fast film – 800 ISO color or 1600 ISO black and white – so that I can cope with most light conditions. Exceptions to this would be while on the beach or in similar consistently bright conditions. Then I use 100 or 200 ISO color or 25 ISO black-and-white film.

■ **These shots were taken** *in Vienna, a city that is famous for its pastries (among other things). Matt was in heaven – so I just let the motor drive run. I love motor sequences of children.*

Kiddie portraits

ALTHOUGH THERE IS A WHOLE CHAPTER on portraits in this book, there are some special considerations you need to bear in mind when taking portraits of children.

High on the list of priorities must be to pick a location that is not going to make it difficult to keep the kids focused on the job at hand.

A distraction-free zone

The studio is the only opportunity we have of photographing children without any background distractions. When I say studio I don't necessarily mean a formal place full of lights and props but simply a well-lit setup with a plain background, for example outside against a white wall, or on a porch – basically any location with plenty of light. I often spray large sheets of plywood and use those as a background, but a bedsheet can be effective too. I get my tripod and set the camera at the child's eye level. Too many pictures of children are shot from the eye level of an adult, looking down on the child. It is more powerful and, in fact, more dignified to be at the child's level.

If you are shooting just head and shoulders, don't use a wide-angle lens because you will distort the face and end up with an elongated head and big nose. Instead, use the telephoto setting on your point-and-shoot or SLR (70mm or longer is fine). If you only have a fixed-focal-length compact or wide-to-normal lenses for your SLR, shoot from the waist up to avoid distortion.

Kids should be kids

Children have a short attention span so be prepared before you bring them in front of the camera. Play some of their favorite music. You need to commit yourself to the task, so learn to be an entertainer in addition to a photographer. Don't scrub off all their personality for the shoot. Let them come as children – relaxed and charming.

The mood of the child will reflect your mood, and he or she will pick up on any tension you are feeling.

If you are photographing children other than your own, I would advise that you ask their parents to stay out of the way or even the room. This way you can develop your own relationship with the kids without them looking to a parent or guardian for approval.

Also, some photographers start talking kid talk when they are shooting kids, which often insults the children and doesn't make for good photographs.

If it's not possible to create a daylight studio environment, bounce flash (for SLR users) is a very sympathetic light source. If circumstances demand that you use the built-in flash, that's fine, but you will probably need to use a red-eye reduction pen to retouch later. Perhaps try using black-and-white film instead. If you are considering creating your own lighting, check out Chapter 11.

■ **For this shot** *of Nick I set up the white background and the light before he came in. He was in the middle of getting ready for bed, and I wanted to capture his tousled, natural look.*

Informal, or snapshot, portraits

There is no technical advice to give you here; it's all general. Great snapped portrait opportunities can pop up everywhere – around the house, on the beach, at the shopping mall – you just need to be aware of the potential. As I have said before, keep your camera handy to capture the natural charm of the child. Most of my best informal portraits have been made when I have observed the children for some time and have framed and focused on them before attracting their attention. It is often one frame and they're off.

■ **This is a good example** *of a child who is happy in his surroundings. I used an 80–200mm zoom – such a useful lens for child photography – set at about 150mm.*

■ **These two little boys** *were too deeply absorbed to notice me. I was attracted to the protective circular shape they had formed. I shot this on an 80–200mm zoom set at 150mm and used a large aperture (f4) to throw the background out of focus.*

Group portraits

From time to time we all have to take a group portrait of children. It's not easy. First of all you have to take twice as many pictures as you think you need, since there is often a kid with his or her eyes shut . . . or worse!

Use a tripod so you can keep your hands free to "conduct the orchestra" as it were.

You need to be tough. Stay in charge and place every child exactly where you want him or her. Be "no nonsense." Also, have a good idea of the composition before you shoot.

The kids must be able to see the camera out of both eyes, so tell them to shut each eye one at a time to make sure that they can. Also, since you are the one on show and behind the camera, you need to throw yourself into the entertainer role. Making a fool of yourself can create great pictures. Any lens will be fine – just get all those kids looking good.

■ **During this class portrait session,** *one kid started the binocular look and, surprise surprise, they all wanted to do it! I just snapped away. Note the low camera angle, so they are looking straight at me.*

■ **School sports day in the Seychelles:** *I pre-focused on the finishing line, easily predicting the winner's joyful expression. Don't just snap away – think about it. The best ad lib is a rehearsed ad lib.*

Events

Whether it's a christening or a sports day, the most important consideration is the schedule of the event. Talk to the person in charge to find out exactly what's going to happen, and where and when you should position yourself for the highlights of the event. You can't chase an event because you will find yourself scrambling to grab pictures. Also you will inevitably bother everybody else by excusing yourself to try to get into good camera positions.

When photographing events, always ensure you have plenty of shots left on the roll and a new roll ready in your pocket.

I would say that photographing children, especially my own, has given me more pleasure than any other area of photography. I feel creating pictures of your children that will become cherished by the whole family should be a part of family life, and the camera should be as familiar as the telephone or TV.

A simple summary

✓ If you want photographic records of your kids, start at the beginning – their births – and make the camera a normal part of your life.

✓ Do your part to deter sibling rivalry: if you photograph one birth, photograph them all!

✓ No matter whose toddler you're taking pictures of, you will have to adapt to the kid's schedule.

✓ If possible, use natural lighting for photographing children.

✓ No matter where you go with your own kids, make sure you've got a camera on hand – you'll regret it otherwise.

✓ Don't miss a great shot waiting for the red-eye reduction to kick in – retouch the picture later.

✓ Let the child act like a child. Get the parents out of the way and have some fun!

✓ When shooting group portraits be sure to turn on your charm. It's the only way to get great shots.

✓ Don't follow action. Set yourself up and wait for the action to come to you.

Chapter 19

Action

W<small>E'VE ALL BEEN</small> knocked out by great sports photographs in the press. There's no way the average person can produce images like those. Most sports photographers are specialists – they don't do anything else. Their equipment is very expensive, they have unique access, and they plan some pictures for months. However, not all action is sports action; catching the look between two people in a restaurant is as important an action picture as a shot from the Super Bowl. You can take terrific action shots simply by knowing your equipment, good planning, and concentration.

In this chapter...

✔ Interpreting action

✔ Getting an angle on the action

✔ The advantage of autofocus

✔ Point-and-shoot action

EVEN SUBTLE ACTION SHOTS CAN BE DRAMATIC

Interpreting action

EVERYONE LOVES A GOOD ACTION SHOT. *Whether it's a closeup of the knockout punch in a boxing match or a goalkeeper making a vital save, or even something less dramatic, like someone making a mad dash for shelter in a sudden rainstorm, a good action picture lets you feel what the subject of the photo is going through.*

The first thing you should know is that there are several basic ways in which we can photograph action, each of which results in a different effect.

1 Keep the camera still and use either a fast shutter speed or a flash. This gives the effect of freezing the action.

■ **I have frozen** *Matt's jump with flash in this picture. You can see every detail of the action. If there had been more light I could have frozen the action with a fast shutter speed instead.*

2 Use a slower shutter speed (between ⅟₃₀ and ⅟₆₀ of a second) and pan the camera with the action going past you. This results in the moving object being sharp because you moved the camera at the same speed as the object, keeping it in the middle of the viewfinder, while the background will be streaked, giving the impression of speed.

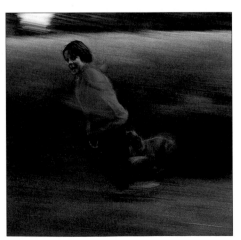

■ **This time I panned** *with Matt as he ran past me. To give a good feeling of speed I used a shutter speed of ⅟₃₀ of a second. The combination of the fast shutter speed and the pan has had the effect of leaving the face recognizable while blurring everything else.*

(3) Shoot on an even slower shutter speed (¼ of a second) and allow everything to move – the action, the camera, yourself – everything. You end up with a semi-abstract picture of blurred movement, which can look stunning in color. Ernst Haas used this technique in the 1950s for his magnificent series on bullfighting and rodeos.

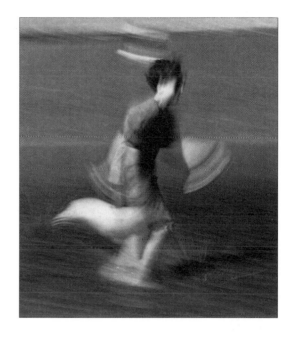

■ **This time** *I went all the way and used a ¼-of-a-second shutter speed on this pan. Everything is blurred. I love the swirling shapes. Try it in color – it can look really great.*

(4) Combine the use of flash with a slow shutter speed. The slow shutter speed blurs everything and the flash freezes the movement to make a blurred picture with a frozen central image. The latest dedicated flashguns allow you to set the flash to go off at the end of the shutter movement so the movement is behind the action. This results in a pleasing effect.

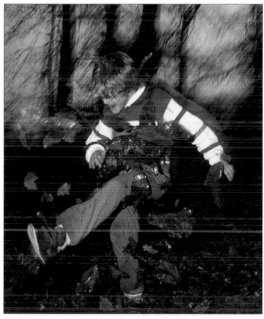

■ **There is a combination** *of flash and daylight in this shot. The flash has frozen the main action, but the ⅟₃₀-of-a-second shutter speed is slow enough to add some blur for a different interpretation of movement.*

Don't punch the shutter button. A punch will jerk the camera and the result will be an out-of-focus picture. You need to squeeze it gently.

Getting an angle on the action

AN IMPORTANT CONSIDERATION *of action photography is the angle at which the action is coming at you. This is a key factor in the shutter's ability to freeze the action.*

To illustrate the importance of angle, consider the following. An action of a cyclist going past you would require $\frac{1}{500}$ to $\frac{1}{1000}$ of a second to remain sharp. However, if the cyclist was coming toward you at the same speed at a three-quarter angle, it would only take $\frac{1}{250}$ of a second to keep it sharp. Furthermore, if he was coming directly at you, it would only require between about $\frac{1}{60}$ and $\frac{1}{125}$ of a second.

Never chase the action. Anticipate where it is going to occur. Whether it's the finish line of a track event or the goalmouth at a soccer game, get there first, be focused, and wait for the action to come to you.

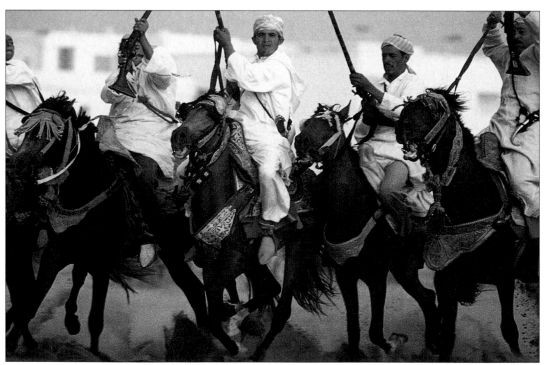

■ **These galloping horses in Morocco** *are sharp even though I only used a shutter speed of $\frac{1}{125}$ of a second because they are traveling toward me.*

You must anticipate peak action. If you press the button when a high jumper is at that moment at the top of his leap, when for a split second he is not going up or down, you can freeze action on a slow shutter speed ($\frac{1}{60}$ of a second). There are many examples of this in action pictures taken in the 19th century.

The great saying by sports photographers is "If you see the peak action in your viewfinder, it's too late." You must be pushing the button before the action peaks in order to capture it.

■ **I caught this action** *at about $\frac{1}{90}$ of a second. The boy is at the peak of the action, not going up and not going down. I could have frozen him at $\frac{1}{30}$ of a second.*

■ **As the horses** *flew past me I was able to capture that feeling – creating a blurring effect – using exactly the same shutter speed of $\frac{1}{125}$ of a second.*

The advantage of autofocus

THE RAPID IMPROVEMENT in autofocus technology over recent years has been a great bonus for the sports photographer. It has allowed photographers to concentrate on composition and content without having to be anxious about the sharpness of the image. If you set your camera and lens on continuous autofocus and make sure your shutter speed is fast enough to freeze the action, you will be able to take sharp action pictures.

Motor drives are also useful but don't be fooled into believing that the autofocus and the motor drive combined will take great pictures for you. You still need to plan, anticipate, and compose your shots.

No matter how much cool photography equipment you're lugging around, it is still *you* who has to take the picture. Someone with a point-and-shoot camera and an intimate knowledge of the sport or action subject will produce better pictures than a person with all the gear and no understanding of what they are trying to photograph.

USING A MOTOR DRIVE WITH AUTOFOCUS

The autofocus has made this sort of action sequence so easy. I love making motor-drive sequences when shooting action. A series of action frames taken at a rate of up to 2½ shots per second tells a much different story than a single frame does. This series shows us how well coordinated and well balanced children can be.

■ **Capturing action** *isn't all about sports. This romantic interlude is about anticipation, too. It's all about grabbing that magic moment.*

Even the smallest movement is an action, and all action photography – and that includes more than sports photography – always requires anticipation and concentration to capture the moment.

When covering a sports event look for nonaction picture opportunities too, such as the anguished loser or the deep concentration of an athlete in preparation.

When I shoot sports I take two SLR bodies, one 35–70mm zoom lens (f2.8 autofocus), one 80–200mm zoom (f2.8 autofocus), one 300mm (f4 autofocus), 400 ISO color film and both 400 and 1600 ISO black and white (depending on the weather), a monopod, a folding stool to sit on, a flask of coffee, and a pen and notebook for captions. I also have to wear a photographer's jacket with reinforced pockets!

I recommend you use a monopod when shooting with long lenses. Telephoto lenses get heavy and a monopod allows you to get the weight off your arms and concentrate on sharp, exciting pictures.

■ **This action has been frozen** *by a very fast shutter speed, ¹/₂₀₀₀ of a second. The camera has shown us more than the human eye can see. The splashing water has been frozen into a beautiful pattern of droplets. Aren't the possibilities of photography great?*

Point-and-shoot action

I CAN'T PRETEND that you have the same potential for shooting great action shots with a point-and-shoot camera as you do with a modern SLR.

Some of the greatest sports pictures are made by remote-control cameras. The photographer sets up a camera position in anticipation of where the action will occur. He or she then fires the shutter (usually with a motor drive in full swing) with an infrared shutter release from up to 650 ft (200 meters) away.

INTERNET

www.geocities.com/click
brah/surfphototips.htm

Check out this web page for some useful tips on how to photograph surfing action. There are some great photographs too!

■ **I planned this shot.** *I knew that most of the peak action would be near the hoop, so I camped out there. I prefocused on the anticipated action area and concentrated on hitting the peak of the action. I missed a few and so will you, but don't worry – you'll get a couple of good shots that'll make all the waiting worthwhile.*

I have discussed the point-and-shoot camera in detail in Part Two, but I should go over the specific points again with regard to action photography.

(1) The shutter speeds of point-and-shoot cameras aren't as fast those on SLRs. In fact, the shutter speed is often relative to the price of the camera. They start at about $\frac{1}{200}$ of a second for a basic model and go up to $\frac{1}{500}$ of a second for an expensive one. However, with most point-and-shoot cameras you won't actually know what the shutter speed is (unless it's a super-compact). Don't worry, we can outthink the machine and still produce some fantastic action shots. For example, if you use a fast film, say 800–1600 ISO, and the light is reasonably bright, you will force the camera into shooting on its fastest shutter speed. If you want to go for a panned or blurred artistic picture, force the camera to use a slow shutter speed by loading slow film (100 ISO).

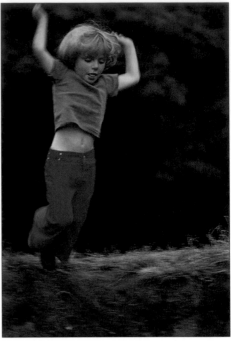

■ **To capture this moment** *I prefocused on the bank with my point-and-shoot camera and waited for the child to jump. There is a little blur, but I don't mind that.*

(2) The autofocus is much slower on a point-and-shoot camera.

Autofocus lenses designed for top-of-the-line SLR cameras have a built-in motor that drives the autofocus – they can now follow, and stay focused on, most moving objects.

(3) The telephoto facility is much shorter in focal length and the maximum aperture much smaller than on an SLR camera. At 115mm telephoto setting the maximum aperture of a point-and-shoot camera is about f10. On the other hand, SLR telephoto lenses that are 300mm long can have a maximum aperture of f2.8. That means that the lens will let in eight times as much light on to the film and allow you to use a faster shutter speed to obtain correct exposures.

(4) You can offset the slow autofocus system of a point-and-shoot camera to some extent by practicing the focus-lock, or prefocus, technique described in Chapter 6. This way, you will still be able to create some great action pictures.

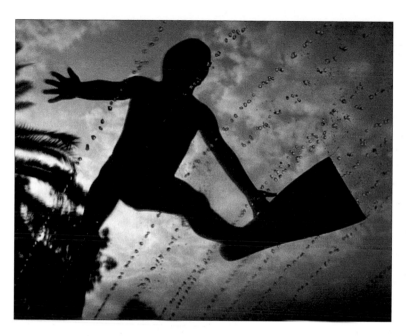

■ **Look for the unusual**
angles on action. I was in the
pool with my underwater
camera when Matt jumped
over the top of me. I love
that crazy angle!

A simple summary

✓ Regardless of what type of
action you are shooting, try
to capture the spirit or feeling
of the moment

✓ The best action shots are those
that show the peak action. Learn
to anticipate peak action in order
to capture it.

✓ There are basic ways to capture
action, each of which gives a
different result.

✓ Autofocus and motor drives are
great . . . but they can't take a
great picture for you.

✓ You will get a totally different
picture by shooting something
moving past you than you
will shooting the same subject
moving toward you at the
same speed.

✓ Point-and-shoot cameras have
certain shortcomings when it
comes to photographing action.
However, it is still possible to get
really good results if you know
how to override the system.

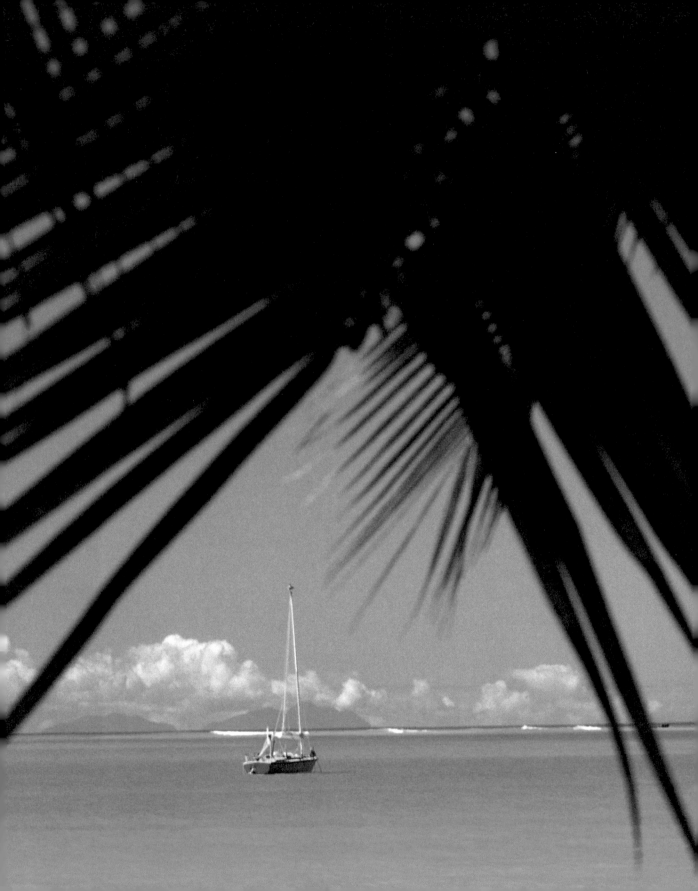

Chapter 20

Travel

TRAVEL PHOTOGRAPHY embraces almost the whole range of classic photographic themes: traveling photographers make portraits, landscapes, still lifes, and architectural pictures. However, I think travel photography requires its own chapter because of the special circumstances in which you'll have to take your pictures.

In this chapter...

✓ **What is travel photography?**

✓ **The travel photographer**

✓ **Thinking equipment**

✓ **Land-based travel pics**

✓ **Extra tips for the land based**

✓ **Underwater and the beach**

✓ **Travel themes and obsessions**

THE SECRET TO BEAUTIFUL TRAVEL SHOTS IS MAKING SURE YOU'RE NOT ALL AT SEA

What is travel photography?

FOR MOST OF US, *travel photography means vacation photography. In the real world that carries the baggage of logistical problems such as not enough time, terrible weather, kids fighting in the back of the car, a bored partner desperate to get back to the hotel in time for happy hour, scaffolding all over your favorite building, an upset tummy, sunburned shoulders . . . I could go on forever! Having taken pictures in more than 75 countries I have encountered them all. But am I bitter? No!*

Okay, so travel and taking photographs – not just snapshots but satisfying pictures that will evoke great memories for years – is a hassle. However, most of the hassle is caused by the normal stress of traveling. This chapter deals with the techniques of successful travel as much as it does with photographic technique and discusses the logistics of traveling as much as the actual taking of the photographs. This is all important because, after all, it's people who take pictures, not cameras.

■ **Matt was happy** *to be photographed at the beach because he thought he looked cool. I shot this with an underwater point-and-shoot camera – these are great for vacation photos.*

The before-leaving-home stuff

Most of us don't just get up in the morning and decide on a whim to go on vacation. So, before going away, there is a lot that we need to do. I feel that the following points are invaluable.

Research

Great vacations and great travel pictures are the rewards of great planning. Research is the key word. Don't automatically book the package tour because it's easy and, at first glance, good value. I find that, by booking a flight myself and researching the local hotels, I get a better deal than the package tour.

I recently went to Goa in India for a 2-week rest in the sun. Going against my own advice (because I was lazy), I booked a package deal. The hotel was part of a well-known international chain and nothing special. On my second day I found a wonderful family hotel that was very comfortable and had wonderful food. I could have stayed there for a fraction of the price of the big-name hotel.

Making an agenda

These days there are excellent travel guides available to almost anywhere on earth. Whether you are staying in your own country or going abroad, buy some and study them before you set off. Plan the holiday based on photographic potential. What part of the country is the most beautiful at the time of year of your vacation? Are there festivals going on? Is it too hot, too cold, or just right? Make a list of your criteria.

I would advise against taking hotel-organized tours. There is a handful of reasons: you can't stop to take pictures when you want to, the tour may only go to the most touristy places, and there will always be too many people around. Do as I do: Use a local guide or cab driver and go alone or share the costs and experience with a like minded individual, couple, or family that you've met at the hotel.

Camera: old or new?

Every time you go on a photography vacation you'll have to make an equipment choice. Well, you won't *have* to, but the chances are you will make a choice: whether to take your old camera (which might not even be that old) or to buy a new one. Either way, there's a couple of points to bear in mind.

Never take a new camera on a trip without first shooting at least two rolls as a test and to "get to know each other."

Try out all the modes on a new camera. I suggest that you make yourself a list with diagrams of all the modes, as a reminder of what they all do. Otherwise you might forget. I know, because I do. And don't forget to pack the instruction book in your camera bag.

The same advice applies to your old camera. Get it out and check that it's working. Shoot a roll and have it processed 2 weeks before you leave, in case it needs to be repaired or replaced.

■ **Don't go away** *with any camera – new or old – without first making sure it's in good working order.*

Other important pieces

A few weeks before you go away, create a checklist of everything you need to do and cross off items as they are accomplished. Don't forget your travel insurance (and be sure to check the small print). I always pay that little extra to include the cost of flying home in case of illness or accident (especially with children). Also, if you are traveling to exotic locations, check the current state of diseases in that part of the world, and start taking the correct pills if necessary. The situation is always changing so check it out. I always make sure my tetanus and hepatitis shots are up to date. Also, check the legal situation in the areas where you are traveling. For example, is it illegal to take any pictures of airports, military personnel, and other potentially "sensitive" subjects?

Always make sure you have small bills of the local currency to tip cab drivers and service staff when you arrive.

The travel photographer

MY WIFE AND I TRAVELED all over the world with our two sons from babyhood until they were in their late teens, so I have had to develop my diplomatic and negotiating skills over the years. Just because you have a partner (and perhaps children) doesn't mean that you are no longer enthusiastic about your photography . . . right?

However, although the photography may be an important aspect of your vacation, it's possible that the rest of your family couldn't care less about it. It's important that photography adds enjoyment to the whole family's vacation and doesn't introduce tension. Sometimes your partner may be more interested in getting back to the hotel in time for happy hour than in photographing the glorious sunset over the mountain range. So be it, fair enough, give in. "No happy hour" can mean "no happy tomorrow" and a black mark against photography. So bear that in mind.

■ **I shot this stunning** *Art Deco-style Miami Beach hotel on a compact camera with the zoom at 105mm. There was a lot of light so I used 100 ISO film for sharpness, fine grain, and color saturation.*

Getting "that shot" while keeping the family happy

I have often noticed a potential masterpiece in the late afternoon while driving toward the hotel. In such cases, I jump out and very quickly take a compass reading and then drive on. If by early morning the light is potentially interesting, I go out early, take a shot, and then rejoin the family in time for breakfast. I have my "masterpiece" and the family is content. Perfect.

Cars and children

When traveling by car with your kids, don't be too ambitious: you will never get as far each day as you think. Start looking for a hotel or motel by 4 p.m. That tension of finding a place to sleep when everybody is tired and grumpy can be uncomfortable. In fact, take pillows and blankets so the kids can take a nap on the way. Since we had boys we always took a football so they could let off some steam at every stop. Once you get settled in at the hotel, maybe the kids can take a swim while you go out and take a nice sunset shot.

■ **Dawn in the Masai Mara** (*Kenya*) – *with the family fast asleep, I went out with the camp guide John, made some pictures (300mm lens, 800 ISO film), and got back for breakfast.*

I find that physical discomfort or general stress from things going wrong distracts me from my photographic quest. So I now know that I should not ignore my personal needs or it will show in my photography.

Rather than being an obstacle to taking pictures, I found that the children added to my travel photography. Many of my favorite vacation pictures are of the boys. They were always enthusiastic about running up a big hill or climbing rocks to give me the scene I needed. Children also open up photo opportunities because they make contact with people or stimulate an introduction that can prove productive. When in Kenya years ago, my son Nick (who was 6 at the time) used to love playing with African children and was fascinated by their homemade toys. He broke down barriers and we found ourselves laughing and chatting (usually in sign language) with the parents, who normally had little contact with white people. Also, the sympathetic atmosphere always led to photographs.

Nick became interested in graffiti and hip-hop culture at age 13 and started taking pictures of graffiti wherever he went; so he became a travel photographer too.

If your whole family is interested in photography, that's great, but, if no one but you is, you have a couple of courses of action:

a Visit picturesque places that the whole family will be interested in

b Go off and take pictures by yourself and leave the family to do what they want to do

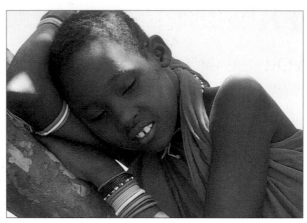

■ **This Masai girl** *had become friendly with Nick, and once she had relaxed, she let me take a picture. The light was hard, but I shot this photograph under a tree in lovely, shaded light. Having kids with you can be a barrier breaker. They are oblivious to racial tensions.*

I usually planned half a day for pictures and half a day for family – although family times often produced the best pictures.

Women travelers

Research the culture of the country you're visiting with regards to the woman's role, and act appropriately. Cover up in Muslim countries, for instance, or you will attract unwanted attention, both as a woman and as a photographer. Don't take a handbag out with you – too easy for thieves. As an alternative wear pants and jackets with secure pockets.

Keep equipment light – it seems to get heavier as the day gets longer. Take a phrase book and don't drink too much, since women's toilets are often few and far between. Don't buy gifts on the way (this applies to men, too) – carrying them is a real pain while you are shooting. Instead, set aside separate shopping days.

Always carry a cell phone, and note the address and telephone number of your hotel before you leave for the day.

Be VERY wary of offers by men to be your guide. Do your research and know where you are going. As a woman you can often communicate more easily in foreign climes. My wife Michelle made some fine pictures of a harem of Muslim women preparing for a wedding in Marrakech. I would never have been allowed to get near such a situation. A light monopod is great for when you need to take a longish exposure. It also serves as a walking stick and as a defensive weapon.

Thinking equipment

NOW WE GET DOWN *to that big question: What equipment do I take? At the bottom of this page you'll find a suggested list for the point-and-shoot photographer. Turn the page for my list of suggestions for advanced SLR 35mm photographers.*

One thing I would advise is that you take your film with you rather than buying it at your destination. Even if you are visiting a city in the summer you will often find you are shooting on the shady side of the street or indoors, so 400 ISO film should be standard.

I recommend you take 20- or 24-exposure films rather than 36-exposure films because it means you can load fast film of 1000 or 1600 ISO into your camera for very-low-light situations, like restaurants, and not be stuck with too many unused exposures.

SPARE FILM: ESSENTIAL EQUIPMENT

COMPACT LIST

This is my suggested equipment list for the point-and-shoot photographer:

1. A 28mm fixed-focal-length compact – they are small and you can "get more in" because they have a wide-angle lens

2. A 35–100mm zoom compact or similar (32–85mm or 36–115mm, for example) for the versatility and the telephoto facility

ZOOM COMPACT

3. A few throwaway, single-use compacts – just in case

ADVANCED LIST

The following list is what I take:

1. Two 35mm SLR bodies

2. A 28–70mm f2.8 zoom – a good all-round workhorse of a lens

3. An 80–200mm f2.8 zoom – takes me from long focal length to telephoto

4. A 300mm f4+1.4 tele converter – I use this when I want to compress perspective, but if I don't carry it on me, it's used to work from inside the car

5. An 18mm very-wide-angle lens for city panoramas or interiors, or if I want to exaggerate the perspective for graphic effect (see Chapter 12)

6. A 28mm PC (perspective-control) lens – I take this if I am planning to shoot architectural pictures

7. A 50mm f1.4 lens – a lens with a very large aperture, which allows me to shoot in low light without resorting to flash

8. A dedicated flashgun, which I use only in emergencies or for special effects

9. A 28mm fixed-focal-length compact camera, which I will slip into my pocket for when I can't be bothered to take all the other gear (but would hate myself if I missed out on a good picture)

Also, I carry the following accessories:

- A polarizing filter
- A red filter
- A yellow filter
- Spare batteries (I install new batteries at home before traveling, too)
- A compass
- A flashlight in case of emergencies or if I need to add some light to a still-life picture
- A compact tripod that fits easily into my suitcase
- A space blanket folds into nothing, makes a fine reflector, and is also comforting to have for emergencies

Packing worries

As I said earlier, if you're not prepared for the everyday stress of travel, you won't be up to taking good pictures, so there are certain items that are must-haves on holiday.

The essentials for me are:

- Guide books
- Maps
- A compass
- A good novel
- Swiss Army knife
- Plastic bags
- Elastic bands
- A cell phone
- A space blanket
- Several pens, including a permanent waterproof marker
- Spare batteries (2 sets)
- Sunblock
- Moisturizing cream
- Lip balm
- Sunblock
- A sun hat
- Sunglasses
- Pills, if appropriate
- Sodium chloride tablets for hot weather
- Eye wash
- Painkillers
- Insect repellent
- Insect after-bite lotion
- Underwater goggles and snorkel (I hate renting much-used ones – urgh!)
- Receipts for all my equipment in case I'm stopped at customs
- Toiletries
- Vitamins

When traveling to both hot and cold locations on the same trip I pack for hot weather and take thermal underwear for cold plus a puffy jacket that will squash up and take up little space. I pack my photographer's jacket for all locations.

■ **I find** my photographer's jacket to be absolutely indispensable when traveling. It's got plenty of pockets for spare film, batteries, and other bits that I need to do the job.

Land-based travel pics

IN THESE PAST FEW CHAPTERS I've covered most of the subjects that you'll encounter on your travels from both technical and creative points of view. However, here are some tips on other subjects that may interest you – things that are specific to travel photography.

On safari

Lodges or safari camps? Both can be pricey, but safari camps in places like the Masai Mara Game Reserve, in Kenya, are by far the most enjoyable. You are really out among the animals à la *Out of Africa* and, although you sleep in tents, the food is usually excellent and you are well protected by guards at all times. Included in the price is a guide and a four-wheel-drive vehicle at your personal disposal. This is fantastic for photography. The guides have a great knowledge of and respect for the animals and they respond to your enthusiasm.

Instead of a tripod I use a beanbag – three-quarters full of beans or pebbles – inside a plastic bag. I lay this over the car's window ledge and then sit the telephoto lens on the bag. This offers great flexibility and support. A conventional tripod is not as useful, since there is nowhere to set it. Animals are at their most active early in the morning and late afternoon, when the light is low, so you need faster film than you would at first expect. Using 400–800 ISO should be fine.

■ **Sunset in the Masai Mara** *with the whole family on board. The boys were knocked out by this sight – one that none of us will ever forget. I used a 400mm lens to "pull up" the sun, making it appear both larger and closer to the animals. I supported the lens on a beanbag.*

To be honest, it's unlikely that you will be able to shoot dramatic individual shots of wild animals with a compact camera, but you can take wonderful shots of herds of wildebeest and buffalo, for example. For wildlife photography, a 300mm lens almost becomes the norm. Most wildlife photographers work from 200mm up to 1000mm.

Patience is required by the truckload for safari shoots. The great wildlife photographers plan and track for many days just to get one great shot. You must research your subject. The more knowledge you have of the animals you are photographing, the more you will be able to anticipate a good shot.

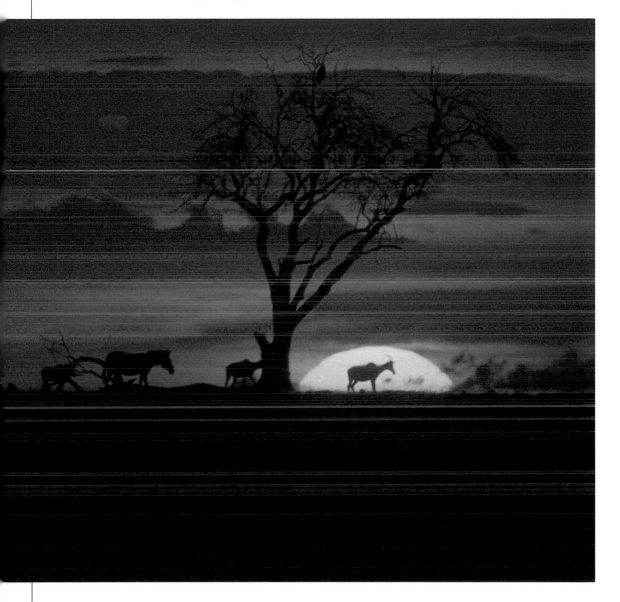

Remember you're not at the movies. These animals – although they're not there waiting to gobble you up – are dangerous.

Never get carried away and go off-road in a normal two-wheel-drive car to photograph a big game animal. It is very dangerous.

At the zoo

Of course, you don't have to go all the way to Africa for great animal shots: try the zoo. Although many people are not happy with the idea of zoos, they have improved greatly during recent years.

Talk to a gamekeeper to find out about feeding times, and get advice about which are the star animals – the photogenic ones. The zoom on your compact will usually get you close enough for a good zoo portrait. Remember though that you will still need 800 ISO film because your zoom only has a small aperture.

■ **I took this photograph** *at the zoo. I was able to see the tiger over the fence. I used an 80–200mm zoom set at 200mm and shot at f2.8 to throw the background out of focus and make it seem less like a zoo.*

Landmarks

If you are in a country where you face a language barrier, a useful tip is to buy a set of postcards of all the famous landmarks of the city. Then you can show them to cab drivers or friendly locals so they can drive or direct you where you want to go.

You should be able to figure out, with your map and compass, when the light will be falling on the buildings or monuments you wish to visit. You can then plan your days to be at each location in the best photographic and viewing light.

Always carry the name, address, and, if possible, a picture of your hotel, then you will (hopefully) never get lost. Taking a bus tour on the first day in a city is good for getting your bearings and you can mark the places of personal interest on your map as you go.

■ **For this dawn shot** *of St. Peter's in Rome I found my camera position the day before. It was shot on a 200mm lens and I used a tripod to steady the ⅟₃₀-of-a-second shutter speed.*

Getting the best light

Often I have gotten overexcited on the first day of my holiday and wasted film. With the aid of your compass, calculate what time of day will bring the best light for the landmarks you wish to photograph.

Don't shoot all your film on the first couple of days. You will start to see better pictures as you go along.

Once you have the geography and features of the city in your head and on your map, consider photographing local culture, sports, and historic events that interest you. You've already done research on all these at home . . . haven't you?

Architecture shots

Most specialized architectural photographers use large format (4 x 5-inch) cameras because the larger negative size ensures the ultimate sharpness in the fine details of the building. Also the camera movement enables the photographer to correct perspective. Professional travel photographers mostly use 35mm and correct perspective with a perspective-control (PC) lens. I use a 28mm PC lens.

Light is the magic ingredient in architectural photography. Generally speaking, your research and reconnaissance should tell you at which time of day the light is most sympathetic to your building, since light suits most structures and brings out the detail. If your time is limited, spend 70 percent of that time looking and 30 percent shooting. Walk around and find the most dramatic angles. Don't just try to work close up with a wide-angle lens and setting. Move back and take in the whole building in its environment. If your lens will take you close enough, shoot some details too, especially on old buildings.

■ **The Lloyds Building in London,** *which I always felt was a load of factory-like junk! I walked around it till I found the angle that best described my feelings for it, then I shot it on 100 ISO transparency film, using a 20mm lens.*

Because of its fine grain and sharpness, slow film is the preferred choice for architecture, but don't let that get in your way: 400 ISO is fine. When shooting interiors you will mostly need a tripod or monopod. Turn off the flash (if you can't turn it off, put your finger over it) to ensure you capture the lighting and atmosphere that the architect created.

For SLR users, a polarizing filter will increase contrast and produce dramatic dark skies with white clouds in color. On black-and-white film, a red filter will do the same job.

INTERNET

www.photosecrets.com/ tips.htm

PhotoSecrets is a series of travel guides aimed at photographers. This page of their web site contains a whole load of useful tips.

■ **The dramatic light** *on the building really makes this shot. To exaggerate the perspective I used a 24mm lens and, with the exposure-compensation mode, I shot at -1 stop, resulting in the shadows going almost black.*

Extra tips for the land based

THE FOLLOWING ARE TIPS *for taking photographs on land. Although I say they are for land-based photography that's simply because I'm assuming that, If you are shooting at the beach or underwater, you will probably not be wearing the sort of clothing I mention here!*

Always take at least two credit cards away with you and ID other than your passport. When you explore, leave one credit card and your passport in the hotel safe with your travelers' cheques, airplane ticket, and other valuables. Also separate your cash so you have some with you and some back at the hotel.

When you go out taking photos, put emergency cash in your sock or bra in case you are pick-pocketed.

Dressing sensibly

It's very important that you wear good walking shoes and a shirt with a collar so that the camera straps don't cut into your neck. Fit wide straps to your cameras for the same reason. A photographer's jacket allows me to carry spare film, a notebook and pen, a map, a flashlight, a Swiss Army knife, a small compass, postcards, and two extra lenses. This means I don't need a camera bag! In cities you will walk a lot so look after your own comfort . . . and safety. A military-style jacket is also a good idea – it's strong and has plenty of pockets.

Communicating with the locals

Successful travel photographers are great communicators, especially in places where they don't speak the language. Sympathetic sign and body language plus a smile are important. Don't be afraid to ask the locals for favors, like "Can I shoot a picture of the city from your balcony please?" You will be surprised how cooperative people can be. After all, you are showing interest in their city, which they appreciate.

When photographing people be polite and ask first. Most people say yes, but some will say no. If they say yes, don't waste their time – be ready with your film loaded and camera set up.

In developing countries the question of tipping models comes up. I feel it's only fair to pay people who are kind enough to pose for me. Not a lot of money – but it can be their only source of income. Do what you feel is the right thing.

Underwater and the beach

THE UNDERWATER WORLD is fantastic and a rich subject for photography. However, the sheer wonder of it can induce such an adrenaline rush that it's easy to get carried away, and that can be very dangerous. Safety is more important than photographs.

For the novices among us – by that I mean those who are snorkeling for the first time – be sure to wear a waterproof sunblock with a high SPF like 15, 30, or 45. Sunburn can be severe when snorkeling close to the surface.

If scuba diving is more your thing – and you are experienced – you should be well versed in safety procedures. When taking pictures, you need to be even more disciplined than usual. Never dive with a company that does not ask for your diving licence first, and be sure to check their equipment. If you're not an experienced diver and are traveling to a great reef location, consider taking a class before you go. Although many famous dive resorts offer classes by excellent instructors, it cuts into your photography schedule. Even when snorkeling, don't do it alone – have a partner. Also, I don't dive even in the tropics without a wet suit since I don't like coral cuts or sunburn.

Never get carried away with the picture potential and dive alone or leave your diving partner.

■ **This picture was shot** *with an underwater camera on Australia's Great Barrier Reef. Note that the color is greenish. I could have corrected that with either a red filter or by using flash, but I liked it as it was.*

Trivia...

Some years ago I was taking some underwater pictures while snorkeling in Cancún, Mexico. I got so carried away that the sea swell made me very seasick. I won't go into detail, but it wasn't a pretty sight!

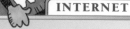

INTERNET

www.fodors.com/focus

This web page, "How to Take Travel Pictures Like a Pro," gives some great hints and tips for all manner of travel photography. It's definitely worth having a look at.

You can take wonderful underwater pictures with underwater point-and-shoot cameras. They have a built-in flash which is great because it puts back the red and yellow color that the water filters out. Midday is the best time for underwater photography because the sun is directly overhead and gets maximum penetration through the water surface. Early and late in the day the sunlight bounces off the water at an angle and you lose a lot of light.

Underwater cameras are also ideal for beach photography since they are impervious to sand and salt water. You can sit them on the beach, wash them off in the water later, and keep shooting.

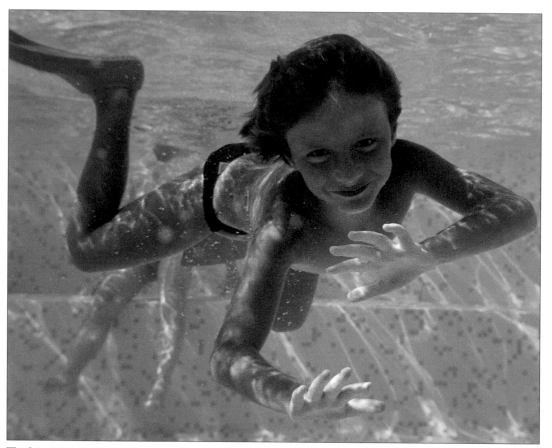

■ **This is one of my favorite** *vacation pictures of my son Nick. It was shot on a compact underwater camera in the hotel swimming pool. I sat on the bottom of the pool wearing a weight belt and using a long snorkel. You must wear goggles for underwater shots or else you can't see through the viewfinder.*

Get as close to your subjects as possible, because everything looks closer underwater than it really is. Also the flash will bounce off small particles floating in the water and upset your exposure.

Color balance

The biggest problem with underwater photography is color balance. The water filters out the colors at the warm end of the spectrum, and the deeper you dive, the more blue-green the color cast becomes, and exposure becomes more of a problem. Flash becomes essential for capturing the reds and oranges of some reef fish. By using print film you can improve the color balance later in the printing stage (or your photolab can) – although I love that underwater cast sometimes.

Underwater cameras

There are several excellent underwater cases that you can fit your standard SLR into, but they are expensive. I suggest that you look for a second-hand underwater camera instead. They are tough and last forever.

If you are taking your good camera to the beach, you need a waterproof, sandproof bag. Also, some film manufacturers sell great plastic zip-up film bags.

If I'm going to the beach, I put my camera in a zip-lock freezer bag and place it in my camera bag with a freezer pack to keep it cool. I ensure my hands are sand-free before I remove the camera.

Sand in your camera leads to very expensive repairs. And if you drop your camera in saltwater you may as well throw it away – it is irreparable. If you cannot make your camera beach safe you should use disposable cameras.

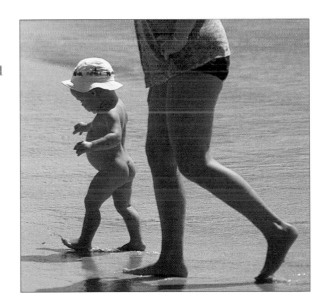

■ **This is a typical beach snapshot,** *but a safe one. I shot it on my underwater point-and-shoot camera. That way there was no risk of sand or saltwater damage.*

Travel themes and obsessions

MANY TRAVEL PHOTOGRAPHERS *get locked into recurrent themes that can become obsessive. I confess that I have a thing about markets and roads. I have taken loads of shots of both. I have a photographer friend who is hooked on doors. He has shot thousands of doors all over the world. But seriously, to find a subject that really interests you on your travels can lead to a unique set of pictures that will prove very satisfying.*

■ **I'm hooked** *on markets. I used a 24mm lens for this one in Barbados, so that I could look down onto the produce. It also provided me with an attractive perspective composition.*

When you get home

We have always collected lots of little bits and pieces on our travels that have become family memorabilia. I often use the objects to make still-life studies when I get home – sometimes months later. It's great fun and brings back loads of memories.

■ **Michelle came home** *from Italy with a big collection of pasta – every color imaginable for pasta dishes of every type. She composed them on a light box, which has captured the translucent quality of the subject.*

A simple summary

✔ Before booking your vacation, research and plan what you are going to shoot and when.

✔ Make sure your camera works. If it doesn't, buy a new one.

✔ Don't let photography cause grief for the family – it's their break too!

✔ Women should research the female role in countries they visit and act appropriately. It seems medieval but can save any hassle.

✔ Take appropriate clothing for the climate as well as for the type of days you have planned, whether you are walking or driving.

✔ If you want to photograph the locals, ask them first and be ready. Reward their kindness by ensuring they don't have to wait.

✔ If underwater photography is your thing, be aware of safety concerns and never go out diving alone.

PART
FIVE

TAKING THINGS MORE SERIOUSLY

THIS LAST SECTION OF THE BOOK is really about whetting your appetite for more and inspiring you to go further than you first thought you would. Some of this section is an *insight* into how professional photographers work and the equipment they use, but there's also information about black-and-white photography, details on what happens *behind the scenes* after your roll of film is finished, and a fact or two to shed some light on digital photography.

I mention, but won't go into detail about, darkroom techniques and the use of camera movements on a 4 x 5 monorail camera. However, you can *advance your knowledge* from this book with further reading or night classes. Get out there and do it!

Chapter 21

Medium and Large Formats

D O WE REALLY NEED THE EXTRA HASSLE of large, heavy cameras? What are these strange, antiquated machines used for? And why? Medium and large format cameras are still used often by professionals, and they have a serious fan base among amateurs, too. This chapter looks at these cameras in depth and reveals the benefits, and otherwise, of going large.

In this chapter...

✓ Why go larger than 35mm?

✓ Medium format cameras

✓ Large format cameras

✓ Comparative image sizes

285

GO ON . . . BIG IT UP!

Why go larger than 35mm?

THE MOST OBVIOUS DIFFERENCE between a 35mm camera and medium and large format cameras is that the medium and large formats produce bigger negatives (or transparencies).

The larger negative size then produces a sharper, finer-grained print because it requires less enlargement to produce a bigger image. Professional photographers, who don't require the speed of handling that 35mm cameras provide, go for medium format cameras for the extra quality and control that they can achieve.

Medium format cameras

THE TERM MEDIUM FORMAT photography describes photography undertaken on any camera in between 35mm and 4 x 5-inch large format. The medium format camera is the workhorse of the professional. The original classic medium format is the 2¼ x 2¼ inch, or 6 x 6 cm.

MAMIYA SLR

Initially, the Rolleiflex twin lens reflex (TLR) camera was the standard – in fact, they are still on the market – but the Rolls-Royce of medium formats is the SLR Hasselblad – very expensive, but superbly built and designed.

Other medium format cameras available include the following:

- 6 x 7 cm, made by Mamiya and Pentax
- 6 x 4.5 cm, by Pentax, Mamiya, and Bronica
- 6 x 8 cm, by Fuji
- 6 x 9 cm, by Linhof

All medium format cameras use 120mm film. Unlike 35mm or APS films, the 120mm is a roll of film wound around a spool that is underwoven with paper.

Quick roll change

One big attraction of medium format cameras is that they are mostly of modular construction, that is, the camera itself is a separate box. The film is therefore loaded into a magazine that clips onto the back of the camera. This means that you can have several magazines with both color and black and white loaded and change your choice of film quickly midroll. You can also buy Polaroid™ magazines for most medium format cameras. Professionals use Polaroids as a test before making their final exposure.

I use a Hasselblad for black and whites when I want a smooth, fine-grained image — for example, on portraits and landscapes.

Although the medium formats can produce such high quality, it doesn't mean that they are better than 35mm cameras. The 35mm is faster to use, more convenient, and lighter. I would never think of using a Hasselblad for photojournalism, for instance.

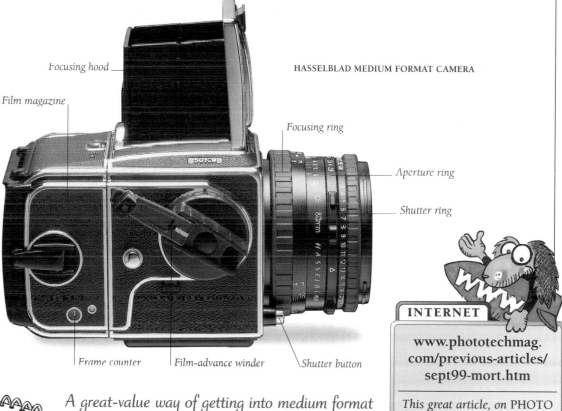

HASSELBLAD MEDIUM FORMAT CAMERA

Focusing hood

Film magazine

Focusing ring

Aperture ring

Shutter ring

Frame counter Film-advance winder Shutter button

A great-value way of getting into medium format photography is through the recent rangefinder 4.5 x 6-cm cameras. You look through a viewfinder just like with a compact camera.

INTERNET

www.phototechmag. com/previous-articles/ sept99-mort.htm

This great article, on PHOTO Techniques *magazine's web site, sings the praises of 6 x 6-cm photography.*

Large format cameras

THE SIGHT OF A PHOTOGRAPHER *half-hidden by a big black cloth and gazing through a bulky, ancient-looking camera sounds like an historical flashback (or an hysterical flashback), but that's not the case. Large format cameras shooting 4 x 5- or 8 x 10-inch film are still used today. Many of the top advertising photographers use large format (often with colour transparency film) as their main tool of the trade.*

Many of the greatest landscape pictures that are fixed in our memories were shot on 8 x 10 cameras. Large format cameras are heavy and almost always need to be supported on a tripod, but photographers lugged these great loads up mountains and down the other side. The rewards were prints of magnificent quality due to the huge negatives they shot. Many landscape specialists still use large format, but usually the less bulky 4 x 5.

I started off by shooting press-type photography on a 4 x 5 press camera, but because shooting was slow, I had to plan my pictures carefully, which was good training.

A 50mm lens is considered normal on a 35mm camera, and a 150mm is normal for a 4 x 5. Because 4 x 5 cameras require longer lenses, they also require more light to achieve a depth of focus equal to a 35mm camera.

Take your time

Shooting large format has a much different philosophy to shooting on either medium or 35mm formats. A slower, more contemplative attitude is needed. These cameras are slow to operate but, with the large, ground-glass viewing screen, you can compose your shots carefully and see the image loud and clear.

Large format photography has another control advantage appreciated by many pros. Each exposure is on a separate sheet of film; this means that each one can be given individual processing attention, which is very difficult on a roll of 120mm or 35mm film.

Trivia...

When I was a young photographer in Melbourne, Australia, the quality of the printing in magazines was so poor that clients often demanded 8 x 10-inch transparencies to reproduce from. I can tell you from my own experience that trying to photograph hyperactive kids on 8 x 10 was an absolute nightmare!

The themes that best suit large format photography are still life, architecture and industrial shots, and landscapes.

Large format types

There are basically three types of large format camera: the monorail (or view camera), the flatbed (or field camera), and the press camera.

Monorail (view camera)

This is the most simple of all camera constructions. At the base of the camera is, as its name suggests, a single rail. At the front and back are two either L-shaped or, more usually, U-shaped brackets that support the lens (at the front) in addition to the ground-glass viewing screen and film holder. Between the lens and the viewing screen is a light-tight bellows. The brackets can slide up and down and across the rail in order to focus the camera, and they can also be swung in a circular motion. These up, down, and swivel actions are called camera movements. The camera movements are used to control perspective and depth of focus.

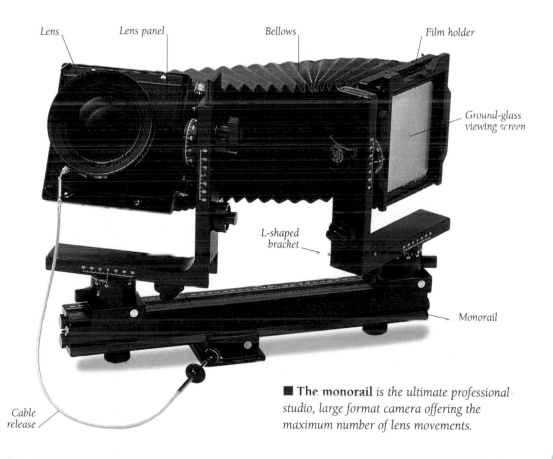

Lens Lens panel Bellows Film holder

Ground-glass viewing screen

L-shaped bracket

Monorail

Cable release

■ **The monorail** *is the ultimate professional studio, large format camera offering the maximum number of lens movements.*

Flatbed (field cameras)

Flatbed cameras do the same job as monorails but are more compact and lighter, making them a better choice for location work. The disadvantage is that they don't offer the same amount of movement control as the monorail.

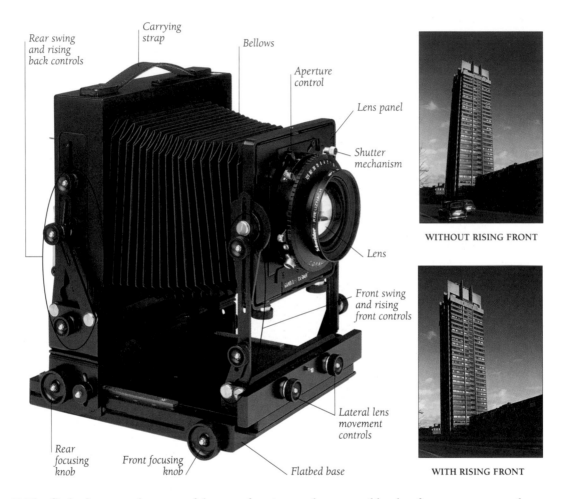

Rear swing and rising back controls

Carrying strap

Bellows

Aperture control

Lens panel

Shutter mechanism

Lens

Front swing and rising front controls

Lateral lens movement controls

Rear focusing knob

Front focusing knob

Flatbed base

WITHOUT RISING FRONT

WITH RISING FRONT

■ **The flatbed camera** *has most of the same functions as the monorail but has fewer movement and lens-extension possibilities. It is also lighter and more portable, making it a popular choice for location work, especially for architecture and garden photography.*

Deardorf (US) and Gandolfi (UK) still make beautiful field cameras from wood and brass. You can choose your own woodgrain and fittings, and many pros have them made to order.

Press camera

This is the sort of camera you'll see in old black-and-white movies, with a flash and photographer attached. It was the original press photographer's camera. Some have a rising front and limited movements built in. If you are interested in 4 x 5 large format photography, look for one of these in secondhand shops: They are a very inexpensive way of entering the large format world. With the great choice of lenses available you can produce images of incredible quality for a very small investment.

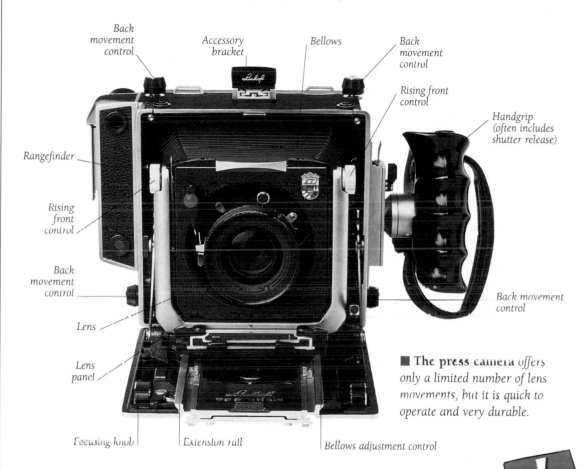

Back movement control · Accessory bracket · Bellows · Back movement control · Rising front control · Handgrip (often includes shutter release) · Rangefinder · Rising front control · Back movement control · Back movement control · Lens · Lens panel · Focusing knob · Extension rail · Bellows adjustment control

■ **The press camera** offers only a limited number of lens movements, but it is quick to operate and very durable.

Nearly all large format cameras have the lenses mounted on detachable lens boards that clip on and off the front of the camera.

Whether you use large format or not depends a lot on your temperament. If you prefer the more contemplative approach of a painter, then 4 x 5 or 8 x 10 cameras may be for you. If, on the other hand, you want to capture life's hustle and bustle, forget large format. Life will have hustled and bustled past you before you even have the camera properly attached to the tripod.

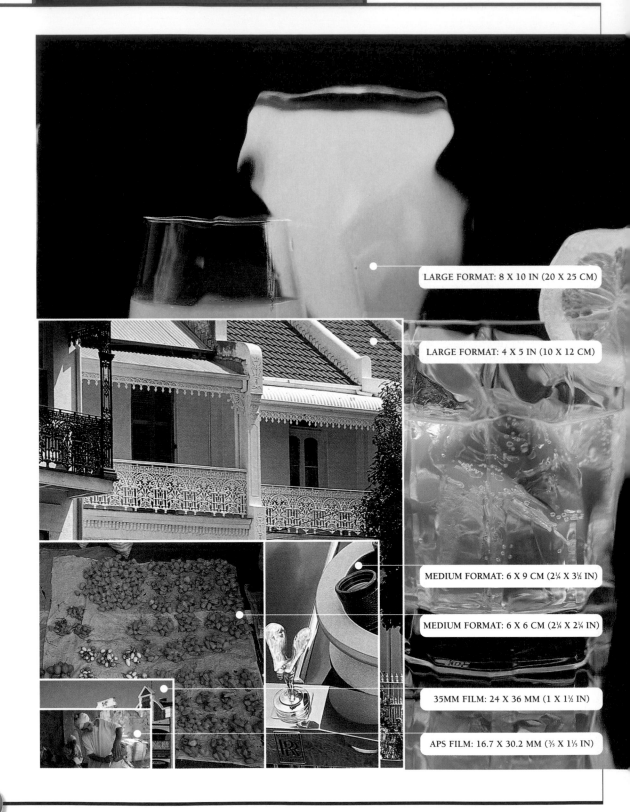

LARGE FORMAT: 8 X 10 IN (20 X 25 CM)

LARGE FORMAT: 4 X 5 IN (10 X 12 CM)

MEDIUM FORMAT: 6 X 9 CM (2¼ X 3½ IN)

MEDIUM FORMAT: 6 X 6 CM (2¼ X 2¼ IN)

35MM FILM: 24 X 36 MM (1 X 1½ IN)

APS FILM: 16.7 X 30.2 MM (⅔ X 1⅕ IN)

Comparative image sizes

TO EXPLAIN the differences between the formats available, I think it helps to show you the actual size of the negative or transparency that each one produces. More importantly, you can see the relative sizes.

Check out the size difference between an APS negative and that of an 8 x 10. The quality difference is relative to the size difference, so size does matter! It makes sense: You can't expect a tiny APS neg to produce an 11 x 14-inch (28 x 35-cm) print as sharp and fine-grained as an 8 x 10 neg will.

A simple summary

✓ The increased size of negatives and transparencies produced by medium and large format cameras means better quality images.

✓ The medium format camera is the choice of professionals.

✓ Medium format cameras come in various sizes from several different manufacturers, but all use 120mm film.

✓ Large format cameras are heavy and almost always need a tripod.

✓ Large format cameras use longer lenses than 35mm cameras and need more light to achieve a comparable depth of focus.

Chapter 22

Seeing in Black and White

I N ONE CHAPTER, I CAN'T ATTEMPT to teach you about black-and-white photography in any great depth: that requires another book devoted to the subject. This chapter is a taster – I'm going to point you in the direction of the possibilities and hopefully inspire you to take the subject further. Fifty percent of the quality of a black-and-white image is achieved in the darkroom. If you are going to get into black-and-white photography, you should also get into developing and printing your own black-and-white film. (Or you can make black-and-white prints on your computer.) To start with, though, you can get your photolab to print your black-and-white efforts and see how you like them.

In this chapter...

✓ Two-tone visualization

✓ Black-and-white technique

✓ The darkroom

BLACK-AND-WHITE PHOTOGRAPHY CAN MAKE SOME SUBJECTS LOOK EERIE

Two-tone visualization

WE LIVE IN A COLORFUL WORLD. *Our reality is color, so the moment we load a black-and-white film into our camera we are taking a step away from reality. We don't naturally see the world in monochromatic tones, so black-and-white photography is, in a sense, an abstraction.*

Oddly enough, black-and-white photojournalism pictures have always had the reputation of being the real thing, the most powerful interpretation of events.

Even though many newspapers now print color photographs, most of the definitive images from recent history have been black and white, so I suppose black and white is buried in our mind as the medium of news and current affairs. Black and white is also popular in fashionable art photography, and you see even more black-and-white images in trendy magazines than you did a few years ago.

To work well in black and white you have to develop a new way of seeing. You need to learn to visualize your colorful world in shades of gray. To get an idea of how colors convert to black and white, try fiddling with the controls on your TV. Change the picture from color to black and white. After a while you will recognize what density of gray various colors convert to.

<div style="float:right">

DEFINITION

*The term **tonal management** describes a photographer's ability to compose a picture to achieve a pleasing arrangement of tones.*

</div>

Where the success or failure of a color picture is dependent on color management, in black-and-white work it depends on *tonal management*.

■ **I first envisaged** *this Stockholm scene as a color picture (right), and it wasn't until later, when I walked by again, that I decided to take a black-and-white picture of it, too (opposite).*

■ **I think this has made** *a stronger image in black and white than in color. The light had moved slightly and the window was now more obviously highlighted. My composition is stronger in this picture also. The window makes a fine focal point, and the monochromatic tones lend themselves well to black and white.*

Black-and-white technique

THE TECHNIQUE OF BLACK-AND-WHITE *photography is based on a knowledge of how to manipulate the tonal contrast of the subject that you frame in the viewfinder. There are several variables that influence contrast, and we will look at them here.*

Light

The quality of light and the angle at which it falls on the subject are the first and most important elements in changing or controlling the tonal contrasts in a picture. (For more information, see chapters 10 and 11.)

Choice of film

The slower the film, the higher its inherent contrast, and the faster the film, the lower its inherent contrast. So if you want to take a very "contrasty" shot of, say, a beach scene, you would choose a 50–100 ISO film. Or if you need a soft, moody picture of a foggy morning, you would go for a fast 1000–3200 ISO film.

■ **The cross light** *has brought out the character lines in this artist's face, helping me capture the intensity of the man. The shadow adds some mystery.*

Development

Some developers give a more contrasty finish than others. A general rule is that if you want to increase the contrast, you underexpose the film and compensate by increasing the development time. So you could rate a 400 ISO film at 1200 ISO and increase the development time according to the manufacturer's instructions. You will then have pushed the film 1½ stops and, in doing so, created a *hard neg*. Conversely, if you exposed a 400 ISO film at 200 ISO and decreased the development time accordingly, you will have pulled the film 1 stop and softened the contrast of the neg.

Remember to mark the film immediately whenever you push or pull it. You might forget later and develop it incorrectly or give the lab the wrong instructions.

Filtration

This can have a dramatic effect on contrast. In black-and-white photography, a filter lightens the tonal reproduction of colors at its own end of the spectrum and darkens the tones of colors at the opposite end. Take, for example, a redbrick house in a green field where the sky above is a perfect blue. A red filter will lighten the house and darken the sky and field when shot on black-and-white film. The increase in contrast will be immense. The effect will be less marked if we were to use an orange filter. With the red filter the house will be almost white and the sky almost black, whereas the orange filter will convert the tones to light gray and dark gray. If we use a blue or green filter, the opposite effect would be apparent: an almost white sky, a pale gray field, and a dark gray house. The densities of gray will depend on how strong the green and blue filters are.

■ **These two pictures** *demonstrate the dramatic effect that filtration can have on black-and-white photography. This top picture was shot using a light orange filter. There is some separation in the tones.*

■ **After taking** *the picture above, I quickly changed to a deep red filter. The contrast has increased considerably, resulting in the more dramatic print seen here.*

Paper

In the darkroom we have another chance to alter the contrast of the picture. The contrast of multigrade or variable-contrast papers can be altered by using a series of filters over the lens that go from 0, which is very soft, to 6, which is very hard.

■ **I have chosen these three pictures** *to show how you can alter the contrast of pictures at the printing stage by changing the contrast of your multigrade filter. Left to right: grade 1, grade 3, grade 5.*

You can buy multigrade heads for your enlarger. These allow you to adjust the contrast filtration.

Aperture

Your choice of aperture can have a great effect on the tonal makeup of the picture. If you stop down and keep the image sharp for both foreground and background, the tonal effect will be to keep the tones sharp and more separated than if you open the aperture to wide open. The narrow depth of focus means that the out-of-focus foreground and/or background will produce the effect of the tonal separation to be softened. Therefore, the tones will tend to merge together.

Shutter speed

Your choice of shutter speed will have a similar effect on tonal separation as aperture. If you use a fast shutter speed, the tones of the moving subject will be crisp and sharply defined. However, on a slow shutter speed the subject will be blurry, and so will the tones: they will merge together.

INTERNET

www.photogs.com/ bwworld

The Black-and-White World web site describes itself as "a celebration of photography." There are informative articles, some great black-and-white pictures, and tips to help you improve your own work.

■ **I have used depth of focus here** *because it was important to the picture that all the background signs were sharp. I took this photograph on a Hasselblad 6 x 6 with a 50mm lens; I added a red filter to increase the contrast and, therefore, the drama.*

The darkroom

I HAVE BEEN DEVELOPING and printing my own black-and-white photography for about 40 years, and I am even more enthusiastic about printing now than I was when I first started It makes sense, then, that I really encourage you to try it yourself. If you are a computer enthusiast, you will probably opt for learning to print on your PC or Mac, but I don't believe you can match the quality of a fine, traditional bromide print. Also, I think the peace you find when you are locked away in the darkroom, undisturbed, is simply heaven!

Recent technology has dramatically simplified the making of prints. Traditional printing paper was made by coating a silver bromide photographic emulsion onto paper. The print required 45 minutes of washing in running water and needed to be placed in a print dryer to ensure that it ended up flat. Now we have *RC paper*, which has a plastic base. RC paper requires just 2 minutes of washing and you can dry it by just hanging it on a line. This means that, although still very convenient, running water is no longer absolutely essential in printing. You can wash by just changing the water several times.

> **DEFINITION**
>
> *The RC in RC paper stands for resin coated. Most printmakers still use a paper-based material called fiber-based, or FB, paper.*

One size fits all!

The traditional papers were graded, so you had to buy a whole packet or box of paper for each degree of contrast running from grade 1 (soft) up to grade 5 (hard). This made printing expensive. Now, with multigrade, or variable contrast, papers, you only need to buy one box and you can change the contrast by using filters.

Getting it together

To create a darkroom is not very expensive; you can even convert your bathroom into a temporary darkroom. However, that can cause problems with the rest of the family. An unused room or area is better. You'll find that you use your darkroom much more if you have a permanent setup. The most important thing is that the room is lightproof and, even more importantly, dustproof. Dust is Public Enemy No. 1.

Never clean your darkroom with a broom or a duster. You will lift the dust into the air. Just wipe it slowly with a damp cloth.

WHAT YOU NEED

Printing your own black and whites isn't expensive, but these are the essential items:

- A safe light
- A film-development tank and spirals
- Darkroom trays (at least three) to process and wash prints
- A thermometer
- An enlarger
- A masking board
- A measuring cup

Your major investment out of all of these is the enlarger, which can cost anything from $60 to $1200 – but they never go out of date. I still use an enlarger that I bought 30 years ago. The only addition I've made is the multigrade head, which is not essential. Most of the money for the enlarger goes on the quality of the lens. I recommend you buy a well-built enlarger with a good lens. Once you've got your enlarger you can get all the rest for about $100 or so. I don't have the space in this book to teach you darkroom technique, but there are lots of part-time courses you can attend to learn the basics, and I urge you to take them!

A simple summary

✔ We see the world in color so, for black-and-white photography, we must learn how colors translate into shades of gray.

✔ Black-and-white technique is based on manipulating tones.

✔ Tonal contrast is influenced by light, film, development, filtration, printing paper, aperture, and shutter.

✔ To appreciate black-and-white photography to its fullest, you should print your own pictures.

✔ The cost of printing yourself is lower than it used to be, so there's no excuse not to try it!

Working with Your Photofinisher

THE PHOTOFINISHER is the descriptive title given to the outfit that develops and prints your films. Other names are laboratory (or lab), process house, photolab, and D&P (developing and printing) house. The photofinishing business has become competitive in recent years and that has meant an improvement in service and print quality. Before we get into detail, I want to stress that, no matter how in control you are of your camera, it's the photofinisher's work that you're presented with at the end of the day. So take the time to find the best photofinisher in your area and build up a good relationship with the staff.

In this chapter...

✓ It's a photofinish!

✓ Choosing a lab

✓ The photolab

✓ The custom lab

✓ An alternative?

WORK HAND IN HAND WITH YOUR PHOTOLAB TO GET THE BEST RESULTS

It's a photofinish!

YOU'VE FINISHED YOUR ROLL OF FILM, *rewound it (or the camera's automatically done it for you), and removed it. The next step, unless you're developing your own black and whites, is to take it to the photolab for developing and processing. But what goes on in there?*

What you take to be developed is film with a *latent image* on it. The lab develops the film from the visible negative, or neg.

It's important to understand that a negative can be printed in a multitude of ways: light or dark; with or without color casts; it can have different contrasts; and it can be printed on different surfaces – glossy, matt, semimatt – and at various sizes. This all makes a difference. The negative is only a starting point, and it can be interpreted however you like.

Never get fingerprints on your negatives; when handling negs hold them by the edges.

NEGATIVES SHOULD BE PROTECTED

Choosing a lab

THESE DAYS YOU HAVE AN ENORMOUS CHOICE *of places where you can take your film to be developed. You can go to your local pharmacy, you can send the film in the mail and get your prints sent back a few days later, or you can take it to a photography store nearby.*

Mass-production labs – like the ones that your supermarket and pharmacy send your films to – have their machines set to automatically produce an average, standard, "okay" print. The best of these labs do a good job and, because they handle thousands of rolls of film every day, often they are cheaper than a photography store or photolab.

The photolab

I PREFER TO ENTRUST MY FILM to a local photolab. A photolab has its own developing machine in the store. You can find them all over. The advantage of the photolab is that you can discuss your processing and prints with the technician who operates the machine. He or she can override the machine's automatic settings to produce a more individual print to your own specifications.

I did a test with three rolls of 12-exposure film. On each film, I shot the same subjects in the same conditions, and I sent each roll to a different lab. One lab was definitely the best, so I stuck with it.

Communicating with your lab's staff

Getting the best results from your photolab often comes down to your relationship with the technician. Try to find a lab that you can communicate with and where the staff really care about producing good prints.

If the lab staff don't want to spend time discussing your work, find a different lab.

Photolabs are usually more expensive but worth it if you can find a good one. A good photolab will have a large selection of film, and the staff should be able to advise you not only on which film to choose but on other photographic topics too.

If the lab claims it's impossible to make a good print from your neg, ask the technician to point out the problem on the neg. If he's right, you'll get a useful tip . . . and if he doesn't know what he's talking about, consider changing labs.

If you have been shooting color in florescent or tungsten light, tell the lab and they can adjust the machine to compensate for the color cast. However, photolabs cannot change the balance of contrast in a print. If the sky has printed too light but the countryside is perfect, the photolab cannot change that. To get that degree of individual attention, you'll need to use a custom lab, or professional lab.

Printing, whether in color or black and white, is a great skill. There are some printers who are as famous in their field as photographers.

TAKING CONTROL

Your lab, or photofinisher, can do a lot more for you than just a straight print. However, you need to be able to tell the staff what you want. Apart from having an unsatisfactory print redone, what little tweaks would make your shot more pleasing? If you don't have a relationship with your photolab where you can discuss your prints, consider finding another one.

Changing color tones

Your photolab can dramatically change the color tones of your print, but only at one end of the spectrum per print. The machine can be programmed to make a print bluer or redder, for example, but it can't do both on the same print.

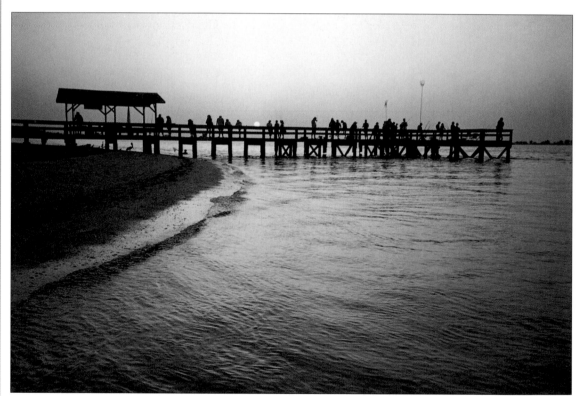

■ **This is the pier** *on Sanibel Island, Florida. The print above is what I originally received back from the lab. I asked the technician to add a bit more red, since I felt that the scene was more red when I shot it (although it probably wasn't, in fact). The result is the print opposite, which I like much more.*

Black-and-white tones

Now that it's had such a revival, most labs develop black-and-white film, but we don't have to end up with straight black-and-white prints. The machine can be programmed to produce beautifully toned prints that are comparable in color to darkroom-produced, traditional toning – without the effort! Don't go crazy though, keep the tones subtle: in other words, retain the black-and-white quality.

■ **These four prints** *were all made by an automatic photolab machine from a black-and-white neg. Explain to the technician that you want tones, not solid colors.*

The custom lab

CUSTOM, OR PROFESSIONAL, LABS *are only found in towns and cities large enough to have a community of professional photographers. Here you can get your prints made individually by hand. The printer at a custom lab can change the contrast by adding more exposure to small areas of the print or by shading small areas of the print to make it lighter – for example, if you have a face that's in the shade.*

Of course, all this extra time and attention costs money. The custom lab is more expensive but for that special picture or for a beautiful enlargement of your favorite person, pet, or scene, why not try the choice of professionals?

Before you order an enlargement, make sure the neg is really sharp – the printer or photolab technician will help you check. In a big print, lack of focus will show up . . . big time.

■ **The swan picture** *above is the original print I received from the photolab. The machine made an average exposure, but the tonal range was too great for it to cope, so I had it reprinted at a custom lab. They were able to add more exposure to the swans in the foreground. The result was the print on the right.*

An alternative?

THERE IS ANOTHER ALTERNATIVE to the photolab and the pro lab, and that's the photo kiosk. Although not so commonplace in the US as in some other countries, you may find one of these in a supermarket or even inside your local photolab.

Here you can crop your images and play with color and tone. The resulting prints have a different feel and quality to photographic prints, but they can be interesting and are definitely worth a try.

INTERNET

www.libraryof
photography.com/

This site is a great resource for photographers. It's packed with information on all aspects of the art, links to other sites, and great pictures.

A simple summary

✔ The negative that your camera produces can be printed in many ways by varying the contrast, color cast, size, and even printing surface.

✔ These days there are many places where you can have your pictures developed and printed.

✔ There are plenty of photolabs and printing stores that have their own machine and experienced technicians.

✔ Often you will get the best results from your lab by communicating your needs to the technicians

✔ Don't stick with a photolab if you aren't happy with the service – there are plenty more that would love your business.

✔ Custom, or professional, labs, often only found in large towns, are the most expensive option, but they are worth considering if you want a special print made.

Chapter 24

Digital Photography

DO YOU KNOW YOUR PIXELS from your RAMs? Your CD-ROMs from your hard drives? Well, if you do – if you are a 21st-century, computer-literate person to whom the mobile phone and the PC are vital, life-sustaining pieces of equipment – then you already have a great start when it comes to digital photography. I must confess that I'm a student myself in this technology and have had to study and practice in order to pass on some sound advice to you.

In this chapter...

✓ What exactly is digital photography?

✓ The cameras

✓ Let's talk about pixels

✓ What do I do with my images?

✓ How does the quality compare?

GET TO KNOW THE TOOLS OF THE TRADE

What exactly is digital photography?

AT ITS MOST BASIC LEVEL, digital photography is the same as conventional photography – that is, they both make an image by drawing light through a lens into a light-tight box.

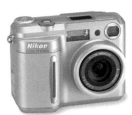

■ **The basic function** *of a digital camera is the same as that of a 19th-century daguerreotype camera – to record the world around you as a photograph.*

The big difference is that, instead of capturing the image on film, a digital camera uses electronic sensors. The sensors convert the light into various electronic charges that are converted into computer language or code and recorded onto a microchip.

Digital cameras are more fragile than analogue ones. Extreme heat, humidity, or even just a bump can cause serious damage.

Mass production

Loaded with the electronic code of a digital photograph, you can produce an image that (with the help of the right software) you can manipulate to your heart's content, without getting your hands wet or turning off the lights. You can also reproduce the image identically as many times as you want to from the digital file.

Even though some people – and it's probably a generational thing – are nervous about technology and therefore don't want to get involved in digital, there are many others whose interest in photography has been sparked by the computer – and that's good news. Also good news is that, generally speaking, shooting digital is the same as shooting film. If you can shoot beautiful pictures on a conventional camera, you can also do it on a digital camera. The working techniques feel pretty much the same.

All the major news agencies use digital cameras now. It means that a news picture taken in New Zealand can be up on a newspaper editor's computer monitor in London just seconds later.

The cameras

AS WITH TRADITIONAL CAMERAS, *in the digital world you get what you pay for. The decision you make on price, therefore, determines the quality of image you will produce. What you want to produce depends on what you intend to do with the images once you have recorded them.*

If you only want to view your pictures on your computer screen, e-mail them to friends or business associates, or use them on your web site, then you don't need a high-resolution camera. A camera with 640 x 480 *pixels* would suffice.

DEFINITION

The easiest way to define a **pixel** *is to think of it as one tile of a Roman wall mosaic, where each tile has only one color, but when all the tiles are creatively arranged, it makes a complete picture.*

Even at the cheaper end of the digital market you get an LCD screen to play back your images. You also have a viewfinder, like that on a point-and-shoot camera, a fixed memory (or storage capacity), and a fixed-focal-length lens.

I would advise you to go for a digital camera with a removable memory card; this may cost more but it adds flexibility.

If your budget is a little bigger and you think you will want to move onto producing some reasonable-quality prints later, then you need to buy more pixels, a zoom lens of better quality, and an LCD screen to guide your playback facility. Make sure you get a good, clear LCD, because the quality does vary between the various makes and models.

Increasing quality

If you really want high-quality large prints, you will need to go straight to the top of the line – and you're looking at more than just more pixels. In money terms, that will mean a price comparable to a top-of-the-line conventional SLR. One of the best cameras currently available in this price range will enable you to shoot 21 consecutive shots at 4½ frames per second and has shutter speeds from 30 seconds to $\frac{1}{1600}$ of a second. It has fast autofocus, and the flash synchronizes at $\frac{1}{500}$ of a second.

■ **The LCD screen** *on a digital camera is enormously useful, but you should use your regular viewfinder as much as possible to save draining your batteries unnecessarily.*

What do digital cameras do better?

There are several great things about digital cameras, and these include their compatibility with the computer. The computer enables you to e-mail pictures around the world in seconds, print instant postcards (if you have a printer, of course), and show the images on your TV or monitor. Also, digital cameras can record up to 500 images on a memory card (I'll discuss this further later), which is like having a 500-exposure film in your camera. And, of course, digital cameras let you manipulate your pictures to produce an infinite number of visually differing versions of your original.

Remember that although initial expenditure on a digital camera is more than in conventional photography, you have no more film costs or lab costs to pay for.

■ **One of the great things** *about digital images is that you don't have to look at them as prints. You can view them on your TV or computer monitor, for example.*

What are digital cameras not so good at?

The main problem with digital cameras is the delay between pushing the button and the camera writing the image to memory. For my kind of photography, which is mostly photojournalistic and relies on catching a "magic moment," digital is just not fast enough yet. Plus the start-up time delay between switching the camera on and being ready to record images is also a big problem.

Some of the more recent top-of-the-line cameras have shortened both the image-capture delay and the start-up time, closing the gap between digital and analogue, but these delays are still a factor.

The print quality is still not as good from a high-priced digital camera as it is from a low-priced point-and-shoot camera. Also, producing a black-and-white exhibition-quality print that approaches the quality of a fine bromide print requires a huge investment in equipment. One final point is that you don't have the control over depth of focus that you do with conventional cameras.

Let's talk about pixels

TRADITIONAL PHOTOGRAPHIC IMAGES *are recorded on light-sensitive photographic film, and digital images are recorded on a sensor made up of pixels. The quality of image that a digital camera is capable of depends on the number of pixels it incorporates.*

Most 35mm cameras record on 24 x 36-mm (1 x 1½-inch) film, and digital cameras record on sensors measured in pixels. An example might be a rectangular 2,048 x 1,536 pixels, giving a total of 3.34 million pixels, or 3.34 *megapixels*, or MPs.

> **DEFINITION**
>
> *A megapixel, or MP, is one million pixels.*

More pixels = better quality

If you just intend to use your images for publishing on the Internet or viewing on your monitor, you can make do with a camera with a 640 x 480 pixel resolution, which will cost about the same as a midpriced compact camera. However, if you want to produce good-quality prints, you really need 1,600 x 1,200 pixels of resolution (around 2 MPs). The top-of-the-line digital cameras are currently boasting 4 MPs and rising all the time. To get high-quality prints, look for a camera with a lot of pixels.

However, pixels are not the only consideration when it comes to image quality. The quality of the lens is vitally important, and, at the other end, the quality of the printer is just as important. So if you are looking to produce digitally created prints that compare with traditionally created prints, you need to make a serious investment.

■ **One of the most** *important considerations when buying a digital camera is the quality of the lens. Go for the best you can afford.*

What do I do with my images?

THE LOWEST-PRICED DIGITAL CAMERAS have a fixed memory built into the camera. The problem with that is that when you have filled the memory with pictures you have to download the images.

You can take up to 60 photographs on a fixed-memory camera before downloading for storage on your computer hard drive, Zip disk, or CD. You should also make backup copies of all your work.

ZIP DRIVE

The limitations of a fixed storage capacity are obvious. You need your computer handy at all times and that means there's a big time gap before you can start shooting again.

The midpriced and expensive models have memory cards that store images and can be replaced when full, just like a film. Therefore, if you are on vacation or want to take lots of shots, you just buy a few memory cards and keep shooting.

Storage capacity on memory cards can vary dramatically. Some hold more than 300 images. Make sure you know which card is compatible with your camera and what its capacity is.

318

Alternatively, if you are happy enough to put your faith in e-mail, you can send the images to your computer at home, where they'll be waiting for your return, wipe your memory card clean, and start shooting again.

You can even bypass the computer altogether and plug your camera directly into the printer.

Another way to save digital images is to plug your camera into your VCR and record the pictures onto videotape.

DIGITAL MEMORY SYSTEMS

There are two systems to record, and temporarily store, your pictures in the camera. The cheapest is a built-in memory that can't be expanded. A more flexible alternative is a removable memory card: Once a card is full you can either download it right away and reuse the card, or you can replace it with another card and download later.

The names of the removable memory cards vary between manufacturers and include Compact Flash and Memory Stick. When buying extra cards make sure you get the correct type for your camera.

■ **Compact Flash** *is the memory card used by the largest number of manufacturers.*

■ **Memory Stick** *is the name Sony gives to its own digital camera memory cards.*

How does the quality compare?

ONE OF THE BIGGEST PROBLEMS *with digital cameras has been that their sensitivity to light has only been about the equivalent of that of a 100 ISO film. This has meant that you could only produce good-quality images in bright light without using flash.*

Some of the latest top-of-the-line cameras, however, offer the equivalent of 200, 400, 800, and even 1600 ISO. There's a falloff in quality and increase in *noise* as the light sensitivity increases, but it's an improvement on previous cameras.

As we move forward, other big technological advances are the reduced start-up and shutter-delay times. Digital cameras are closing the gap on traditional cameras in regards to their ease of use and quality of image.

> **DEFINITION**
>
> *Noise is digital jargon meaning a breakup of the image, similar to grain on film or interference on your TV screen.*

Scanning prints

Despite all this, as I write, I feel that if you already own a good-quality 35mm camera, why not originate your pictures on film and scan the negs or prints? I'll tell you more about this in the next chapter.

■ **I shot this picture** *with a digital camera. I set the aperture to f6.3 and the shutter speed to 1/320 of a second. I was only 8 inches (20 cm) from the poppy, so I used the macro mode to ensure it was in focus.*

INTERNET

www.dpreview.com

This is a great web site for those of you thinking about buying a digital camera. Unbiased, in-depth reviews of most of the current models can be found here.

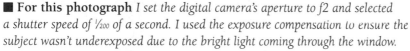

■ **For this photograph** *I set the digital camera's aperture to f2 and selected a shutter speed of ¹⁄₂₀₀ of a second. I used the exposure compensation to ensure the subject wasn't underexposed due to the bright light coming through the window.*

A simple summary

✓ The purposes of digital and conventional photography are the same – to record the world around us. Essentially, the way they work is the same too.

✓ Conventional photography records images on to film; digital records to a microchip.

✓ With the right software, digital photographs can be manipulated on a computer and exact copies of your final image can be made time and time again.

✓ As always – in terms of number of pixels, LCD screens, and lenses – you get what you pay for.

✓ Cameras that use removable memory cards cost more than those with a fixed memory but are far more convenient.

✓ You should always back up your images onto a storage medium.

✓ The quality of digital is not as good as conventional, but it's getting there.

Chapter 25

The Digital Darkroom

THESE DAYS WE USE COMPUTERS to do a great many things for us, or rather the computer is the tool that seems to be increasingly indispensable for performing our daily tasks. It's only natural that we extend this list of tasks to our photography . . . I guess! In this last chapter we'll look at the computer's role in 21st-century photography and what equipment you need in order to buy into this revolution. I'll also show you some digital work created by a couple of friends of mine.

In this chapter...

✓ *Photography and your computer*

✓ *Which computer to choose?*

✓ *Peripherals*

✓ *Case study: Graeme Harris*

✓ *Case study: Maud Larsson*

PHOTOGRAPHY DOESN'T HAVE TO REFLECT ACCURATELY WHAT YOU SEE

Photography and your computer

SOME PEOPLE FEEL THREATENED *by the computer as a producer of photographic images, and some see it as a sacred gift that will set us free. I see it as a fantastic new tool that can offer more creative possibilities to photographers.*

The computer can certainly set you free from chemicals and darkrooms. It allows you to manipulate and print in minutes an image that could take hours in the darkroom. Also, once your file is stored, you can reproduce your print at the press of a button to make an identical copy.

For me, the point of a digital print is that it isn't the same as a bromide print. They don't need to be constantly compared. They are what they are.

In fact, you don't even need a digital camera to be able to digitally manipulate your work. Where digital printing can set you free is when you start considering the original photograph – whether it's digital or analogue – as just a starting point. You can do almost anything to and with this image with the help of imaging software. However, I feel obligated to pass on a warning at this stage.

As you become more competent with computer software, you feel very powerful and think that you can make any old image look good – and that will make your photography sloppy.

■ **Whether you have** *a digital camera or a conventional film camera, you can use your computer, along with the relevant software, to manipulate your images.*

Nothing you can do on your computer will transform a bad picture into a good one, but if you shoot a great image, the computer can make it fly!

As a digital photographer, your ultimate goal is to be able to see in your mind how you want the print to look *after* it's been through graphic manipulation. That way, you'll know what sort of original image you need in order to create the final image. If you don't know what you want the final image to be, how will you know what to shoot?

Which computer to choose?

IF YOU DON'T HAVE A COMPUTER, or can't upgrade your present PC enough to accommodate your digital photography needs, you will have to buy one. That means you'll have to decide whether you want a PC or a Mac.

There is no doubt that some 90 percent of photographers, designers, artists, and publishers use Macs. It is generally accepted that Macs are easier to work with. On the newer models it's also easier to upgrade the amount of *RAM* on a Mac, which means you can increase your memory as you become more involved. In my opinion, controlling color is also easier on a Mac. However, if you already own a PC and are computer literate, you'll manage beautifully with the addition of photography software.

> **DEFINITION**
>
> RAM *stands for random access memory and is the memory-storage component of your computer. It is measured in* **megabytes**, *which you may also see or hear referred to as MB or megs.*

Because photographic files are larger than text files, your main concern will be having enough RAM. To do anything serious you will need at least **64 *megabytes*** available for use.

■ **Your choice of PC or Mac** *might be dictated by what your friends and relatives use, but do some research; you may find that one system is better for the work you intend to do. If you travel a lot, for example, it may be worth investing in a laptop computer.*

Peripherals

AS WITH SO MUCH IN LIFE, it doesn't end there. Having a computer is not enough: you need some other gear before you can start.

Graphics-manipulation packages

There is a handful of packages (also called applications or programs) available for your computer that you can use to manipulate your photographs. Perhaps the most well known of these is Adobe Photoshop. You can use these packages regardless of whether the pictures were shot on a conventional or digital camera. The only thing to remember is that before you can manipulate the image, the image must be digital.

a If you shot the picture on a digital camera, you just need to connect your camera to your computer with the relevant lead (this probably came with the camera when you bought it) and follow the instructions in your camera's manual.

b If you shot the original image on a film camera, then you will have to digitize it first. You do this by scanning the picture. (I will explain scanners in a minute.)

Whichever route you have taken or will take, you will end up with a computer file, or electronic file, that contains your image.

Playing with the image

Once your image is an electronic file, you can import it into your manipulation program and the world is your oyster!

It's impossible for me to teach you how to use your chosen application but I can give you a list of some effects you can achieve. The most basic manipulations you will make probably fall into one of the following categories:

1 Compensation for over- or underexposure on the original shot; this can also be thought of as adjusting the overall brightness of the image

2 Sharpness of the image

You can also consider making the following types of changes (among others), but you will then start to move away more dramatically from the look you originally wanted to capture:

(1) Contrast (that is, the degree of difference between the bright and dark areas of the original image)

(2) Color saturation (the overall richness or strength of the color in the picture)

Color variation

On the subject of color, be aware that the colors you see on your monitor will be different to the colors you'll get on the printout. You need to check out your computer manual and set up your monitor colors as closely as possible to the colors of your printer. Even then you will still need to experiment to get the best results.

Graphic tablets

If you start getting really involved with your photographic software, and money is no object, a graphic tablet is a great tool to use instead of the mouse. It has a *pressure-sensitive* stylus that you use like a pen to draw on the tablet. It gives you easier control since you can draw around areas with great accuracy. A graphic tablet isn't essential, but if you are seriously into retouching and manipulation it'll make life much easier.

> ### DEFINITION
>
> *With items like graphic tablets, the term* **pressure sensitive** *means pretty much what it says. Specifically, it means that you can create different effects by varying the pressure, just like you can with a pencil or paintbrush.*

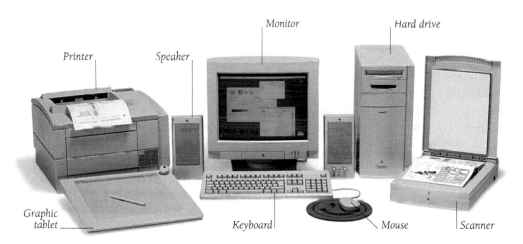

Printer Speaker Monitor Hard drive

Graphic tablet Keyboard Mouse Scanner

■ **Once you've got your computer** *you'll need other equipment too! Along with a graphics-manipulation package, a scanner, printer, and graphic tablet will be of great benefit to you.*

Scanners

Some computer deals include a basic scanner and printer, and these are adequate to get you started. Most scanners are flatbed scanners, much like a photocopier. The scanner turns the print or document into digital language that can be used by your computer and printer to turn out digital prints. I would advise you to buy one with a transparency adapter so that you can scan transparencies or negatives.

Resolution for scans

How much resolution do you need when scanning a print or transparency? This is a much-debated point. The important questions to ask yourself are:

1 What is the size of the original source image?

2 What will the output size be? (This will probably be determined by how you want to use the image. For example, is it 8½ x 11-inch paper for your home printer, or will it be sent in an e-mail to a friend? Or are you going to make a large print that you want to exhibit?)

3 What will the output device be?

If you are producing a small postcard-size print or using the image on the Web, you only need a low-resolution scanner. There is no point in scanning at a higher resolution because you will produce a larger file than you need, and that will be harder and slower to work with. On the other hand, an exhibition print will require a higher resolution, which in turn will produce a larger file.

You will rarely need more than 25 MB for a photographic file.

■ **The capabilities** *of a scanner can vary greatly, depending largely on price. However, if you're concentrating mainly on small work, an inexpensive one can still produce great results.*

Also, the amount of *PPI*s you need depends on the size of the original images you are scanning. An APS neg requires more resolution to produce a good-quality 4 x 6-inch (10 x 15-cm) print than a 8 x 10-inch (20 x 25-cm) color print. However, let's slip some common sense into this discussion. When brochures and magazines talk about high-quality prints, they are comparing digital prints to bromide prints. And if you want bromide-quality digital prints, you are going to have to spend serious money on a top-of-the-line computer, scanner, and printer . . . and you still won't even get close. So forget all about that and you will find that you can produce really good-quality prints using basic scanners and printers. They will probably make you happy, and that's what it's all about. So don't be intimidated by having too few PPIs and *DPI*s, just get on with the job at hand.

> **DEFINITION**
>
> *On screen, resolution is measured in **PPI** – pixels per inch. Printer resolution however, is measured in dots per inch, or **DPI**.*

If you are doing lots of scanning of negatives or transparencies I would advise a self-contained film scanner that produces consistently high-quality results.

The hardware and software that you end up buying should reflect where you want to go with your images, creatively speaking. Don't buy equipment that you don't need or can't afford just to have as some sort of status symbol.

It's very important that you set up a sensible filing system for your images so that you can access them easily. I would suggest you name your files after how they look (for example, "boat by shore").

Printers

The standard printer – the sort of thing you'll get as part of your computer package, for example – is an ink-jet printer. These printers produce printouts by squirting (this isn't the technical term!) dots of color and tone. The resolution is therefore measured by how many DPIs the printer can reproduce. The latest printers are very good value for money. Even an inexpensive one can produce surprisingly good prints. However, to create a huge poster of one of your favorite images, use a professional printing house.

It's important to point out that, like traditional photography, it's not the equipment that takes photographs – it comes down to the talent of the photographer using the equipment. Digital imaging is the same. Sure, the resolution and equipment are important, but more important is your ability and your personal creative input. The more effort you put into getting to know your equipment and the more you experiment with it, the better your digital photography will become.

The paper you use in your printer is very important to the quality of your end print, and there is an enormous variety of surfaces available now. If you want the ultimate in definition, use a glossy photographic-style paper. If, on the other hand, you want a soft, romantic feel, use an uncoated watercolor paper.

Always check out the deals being offered by your computer stores. It's very competitive out there and there are some great bargains to be had.

■ **As with scanners,** *you get what you pay for with a printer. However, these days, the technology is so good that not much money can get you pretty impressive results.*

You may be able to get a program like Adobe Photoshop with your printer as part of the deal. Most likely it will be a pared-down version of the latest one available, but it will serve you well at little or no extra cost.

CD burner

It's essential that you make backup copies of your photographic files. The best way to do this is by *writing*, or *burning*, them onto a CD. This makes more sense than putting them onto any other backup medium because CDs have a greater storage capacity and are less expensive to buy.

A CD burner is also an essential purchase if you are going to be sending work to clients or potential clients.

DEFINITION

The act of making copies of your work on to a CD is known as **writing,** *or* **burning.** *It's not as scary as it sounds – in fact it's not that dissimilar to copying onto floppy disks in the old days!*

■ **The best way to back up:** *Your computer may come with a CD burner built in, but if it doesn't you should buy one, because it's an essential item.*

Case study: Graeme Harris

MY FRIEND AND PHOTOGRAPHIC COLLEAGUE *Graeme Harris is a distinguished photographer and printmaker who has recently been printing on his computer instead of in the darkroom. He still prints traditionally, too, but is experimenting with his computer to produce a different look or style to his work.*

I twisted Graeme's arm to let you see the step-by-step process behind one of his new images. Here's what he had to say.

1 This original picture of whitebait fish was shot on HP5+ film using a 55mm macro lens on a 35mm camera. I lit the fish with window light and put a white reflector opposite the window. This produced the highlight along the bellies of the fish. To give a suggestion of a golden-brownish color I slightly sepia-toned the print. This has created enough color to warrant me scanning it in color. I could have opted to scan it as a straight black-and-white print and later color it in Photoshop.

The original print measured 5 x 7½ inches (12.63 x 19.3 cm). I scanned it using a flatbed scanner, creating a 5.6 MB file, then adjusted the brightness and contrast of the image. This is something that can only be done to suit your personal taste.

THE ORIGINAL WHITEBAIT PICTURE

2 The next thing I did was crop the top and bottom of the image slightly – once again to personal taste. Resized in Photoshop, the picture size is now 6¼ x 5 inches (15.82 x 12.63 cm), and the file size is 4.61 MB.

3 Using Photoshop, I lightened up each eye, adding a highlight to make the eyes (and the fish) look more alive. I also removed some dust spots. I played around with the color curves to dramatically change the color. I wanted to produce a more abstract image than the original, something looking like a silkscreen print.

CROPPED AND RESIZED

THE FINISHED ARTWORK

This process can take many or few steps, depending on what sort of effect you are trying to achieve. I adjusted each of the primary red, blue, green colors separately. First was blue (input 43, output 164), then green (input 145, output 255), and finally red (input 107, output 8).

The number of possible combinations – and overall potential – is overwhelming, and once you start adding the overlay and filter possibilities it can become mind-blowing. The bottom line is personal taste. What I might find to be a neat image, you may not, and vice versa. You have to create work that, first and foremost, will be pleasing to you.

If you are just getting started, don't be put off by curves and inputs and outputs. It will make more sense once you start.

Case study: Maud Larsson

MAUD LARSSON *is a young freelance photographer who has been my
brave assistant on this book. She has worked as a traditional printer (in both
color and black and white) for a number of years, but she is definitely part
of the new generation. She has moved her work further into digital printmaking
in order to increase the creative scope of her pictures, which, at the moment,
are made mostly for the creatively demanding music industry.*

Maud has contributed some of her images and I thought it best to let her describe her
approach in her own words.

Not better, just different

Photoshop is a terrific imaging software package. It does all your usual darkroom work
and more. For me the benefit of digital printmaking is that it takes you
further, and without chemicals. It's more flexible, mobile, and easier to use.

*I've never understood why people compare the quality or outcome of
digital with analogue photographic printmaking. They are both forms
of expression, which is why arguing that one is "more real" or "worth
more" is a waste of energy.*

What we today call "alternative processes," like all the old-school and not-so-
straightforward ways of working (cyanotype, lith printing, salt printing, Van Dyke
prints, and bromoil printing, for example), never had to fight any battles with whatever
processes preceded them.

Printmaking in the darkroom is still something else entirely. Here the magic is a more
physical kind. If you're after a traditional photographic image, use your traditional
darkroom. If you're interested in old, alternative printmaking, where you print images
using sunlight or liquid photographic emulsion, then do it. However, if you want a new
and interesting way of working with imagery, there's Photoshop.

There are important issues to be aware of with regards to retouching, manipulation,
and digital enhancement, and there's also your responsibility as a photographer.
However, photographs were always a construction of one person's reality (whatever
that reality is) seen through a camera. Add to that the choice of printing method,
context, and the viewer's response

There's far more to be gained by avoiding labels like "traditional quality" and "real photography" than there is by adhering to them.

Generally I like to just twist and turn the imagery I've got to work with. I like to see where it takes me. The original medium may be photographic, artwork, scanned media, or various combinations of all these (this brings copyright into focus!). Then . . . well, it turns into something else – something that reflects how I feel. Usually it comes out looking like a fine-art relation.

I don't always know what effect a particular filter is going to have on an image. It's never a case of "I'll apply this because then X will follow"; more like, "Maybe this will take me somewhere interesting." When I start off, I may have a vague idea of where I want the image to go, but that can change completely while I'm working, usually due to happy accidents.

Photoshop is truly fantastic – an advanced and creative toy. Go play!

■ **Yannis Viglis:** *This image originated from a transparency that I printed onto negative paper (C-type paper), but it was put through a transparency process – that is, it was turned into a negative image and then back into a positive one. This shouldn't really be taken to extremes since it messes up the chemistry. I've used it here simply for the sheer intensity of effect. It turned the print into a blue-toned image. I scanned the picture, sharpened my dear cousin Yannis, and used the "diffuse glow" filter. Then I faded it until I was happy with the look.*

■ **The Sad Man:** *I wanted to illustrate what sadness can do to someone, or what someone can turn sadness into. Many people, for their own reasons, feel more comfortable being unhappy than not. This picture was originally a straight, but very dark, photograph, looking nothing like this final print. I lightened it, stretched the guy's body, and made his eyes larger.*

■ **Benjamin Waiting for the Bus:** *This was originally a black-and-white photograph. I worked with Photoshop's "pinch" and "glass" filters, together with various levels of fading of both.*

■ **The Latecomers:** *This is Brian Quinn, songwriter and main vocalist of The Latecomers. To increase the amount of blue in this picture, I used curves and the channel mixer, fading where appropriate.*

INTERNET

www.atsf.co.uk/ilight/ tech/colmap2.html

This web page shows some of the effects you can create by playing with the color channels in Adobe Photoshop.

■ **Maja in Winter:** *Taken on the Greek island of Crete at the turn of the 21st century, this was originally a black-and-white photograph of my younger sister Maja. I used Photoshop's "diffuse glow" filter, and I worked a lot with curves and fading back and forth.*

A simple summary

✔ The computer is simply another means of expanding your levels of creativity. It's not intended to replace the old methods – it just offers an alternative.

✔ The two types of computer to choose from are PCs and Macs.

✔ You need some other hardware and software if you want to manipulate your pictures.

✔ A graphics-manipulation package like Photoshop is an essential

purchase. The effects you can achieve are almost limitless.

✔ If you intend to work with shots taken with a traditional (rather than digital) camera, you will need to scan them first.

✔ A printer is vital if you want a physical version of your finished image.

✔ Burning your work onto a CD is the best way to back it up. Blank CDs are usually inexpensive.

Photography on the Web

THERE IS A HUGE AMOUNT of information about photography on the Internet. The following list contains some of the sites that I think are most useful. Please note, though, that due to the fast-changing nature of the Net, some of these sites may be out of date by the time you read this. Happy hunting!

www.a1.nl/phomepag/markerink/af_expla.htm
This link takes you to an explanation of how autofocus works.

www.amateurphoto.about.com/hobbies/amateurphoto/library/bllenses.htm?terms=lenses
This page has some good information on lenses in addition to some tips on filters.

www.amateurphoto.about.com/hobbies/amateurphoto/library/weekly/aa030498.htm
Check out this web page for some great still-life tips.

www.amphot.co.uk/content/creatmono/cm2.htm
You can subscribe to *Photo Art International* and *Digital Photo Art* magazines at this web site.

www.aophoto.co.uk
This is the web site of The Association of Photographers. Among other things, it contains a huge selection of work by its members that may inspire your own creativity.

www.apogeephoto.com/apr2001/ratty042001.shtml
This page of Apogee Photo's web site is entitled "Seven Steps For Better Point-and-Shoot Pictures" and offers you just what it says.

www.apogeephoto.com/buyguide/index1.htm
Click on "Film" in the category list for a selection of film manufacturers. There's a detailed product guide for each company.

www.apogeephoto.com/PFYP.shtml
This web page is called "Photography for Young People," but it's great for beginners of all ages. The topics covered change from time to time, so take a look.

www.artisdead.net
This site contains not just photography, but a range of work from several fields of the arts. There are often some very interesting photographs here, so check it out!

www.artzone.gr
The Black-and-White ArtZone web site is dedicated to black-and-white photography.

www.atsf.co.uk/ilight/tech/colmap2.html
This web page shows some of the effects you can create by playing around with the color channels in photography software.

www.azuswebworks.com/photography/
Go to this web site and click on "Camera Basics" in the left-hand column. Scroll down for a look at how the camera's aperture and shutter work.

www.betterphoto.com/exploring/groenhoutExposure.asp
This web page is well worth visiting: It contains an interesting article called "Obtaining Correct Exposure."

www.camerareview.com
This is a great place to start if you're not sure which SLR camera to buy. You can even type in which features you're looking for, and the site will come back with a list of cameras that fit the bill.

www.capa-acap.ca
The Canadian Association for Photographic Art is a nonprofit organization helping people improve their photography. It offers a forum for both amateur and professional photographers to share views with others.

www.corbijn.co.uk
This is the official Anton Corbijn web site. It contains a good selection of his work, with each picture annotated by Corbijn himself.

www.dpict.org
DPICT (incorporating *Creative Camera*) is "the new magazine of camera culture" and this is its home page. See what's in the latest magazine, subscribe, or buy back issues.

www.dpreview.com
This great web site contains unbiased reviews of most current digital cameras.

www.explorephotography.com/
This site has tips on photography techniques and buying cameras and lenses, in addition to depth-of-field charts and articles on many photographic topics.

www.fodors.com/focus
This web page, "How to Take Travel Pictures Like a Pro," gives some great hints and tips for the travel photographer.

www.friendsofphotography.org
This is the web site of The Friends of Photography – a nonprofit, international visual-arts organization that operates the Ansel Adams Center for Photography in San Francisco.

www.geocities.com/clickbrah/surfphototips.htm
Check out this web page for tips on how to photograph surfing action. There are some great photographs too!

www.geocities.com/cokinfiltersystem
This is an unbiased, independent analysis of Cokin filters, the world's leading range of special-effects filters.

www.howstuffworks.com/digital-camera2htm
This web page contains an in-depth look at how digital cameras work and is recommended reading.

www.libraryofphotography.com/
This site is a great resource for photographers. It's packed with information on all aspects of the art, links to other sites, and great pictures.

www.masters-of-photography.com/
This web site boasts a small selection of works by some of the best photographers of all time. It includes pictures by Ansel Adams, Alfred Stieglitz, and Edward Weston, to name a few.

members.home.net/gillettm/DOF.html
This web page contains a depth-of-field calculator, which you can use "to find the near, far, and hyperfocal distance for a specific lens."

www.midland-7.org/moutray/photography.htm
Entitled "Photography: The Basics," this web page contains a history of photography, how to make a pinhole camera, black-and-white printing, and lots of other stuff.

www.nyip.com/tips/topic_art0700.html
This web page contains the New York Institute of Photography's "Tips for Better Photographs."

www.photography.about.com/arts/photography/library/weekly/aa071999.htm
"Who's Ansel Adams?" Well, this is a good place to find out.

www.photography.about.com/arts/photography/library/weekly/aa122099.htm?terms=Home+Lighting
This is a useful article on how to photograph celebrations, parties, and other events that take place indoors.

www.photographybygarrett.com
This is my own web site. Why not visit and see if there's anything you like?

www.photography.ca/otherartists/karsh.html
This web page has a handful of portraits by Yousuf Karsh in addition to a brief biography of this important portraitist.

www.photogs.com/bwworld
The Black-and-White World web site describes itself as "a celebration of photography." There are informative articles, some great black-and-white pictures, and tips to help you improve your work.

www.photo.net
Photography tips, equipment reviews, learning forums, photographers' portfolios, and chat rooms are among the services offered here.

www.photonorth.com
This is a great site with links to the best Canadian photography web sites, including coast-to-coast listings for national organizations and regional camera clubs.

www.photosecrets.com/tips.htm
PhotoSecrets is a series of travel guides aimed at photographers. This page of their web site contains a lot of useful tips.

www.phototechmag.com/previous-articles/2000/capinegro-mar/cappi1.htm
This sample article from *PHOTO Techniques* magazine is called "Re-orchestrating Light" and is in the series "The Art of Photoshop."

www.phototechmag.com/previous-articles/2000/lane-july/lane1.htm
This is a great article on photographing children. The author has even managed to build a stock photography business with her pictures.

www.phototechmag.com/previous-articles/sept99-kerr/kerr1.htm

This article, "Controlling Light for Photography," offers a great analysis of what can be achieved with just one studio light.

www.phototechmag.com/previous-articles/sept99-mort.htm

This great article, which is found on *PHOTO Techniques* magazine's web site, sings the praises of 6 x 6-cm medium format photography.

www.photoweb.ndirect.co.uk

Photoweb UK claims to be Britain's number one site for photographers. In its 80 pages are 300 pictures and over 300 links to other sites.

www.pinholevisions.org/

Pinhole Visions is a great resource for those who are interested in pinhole photography. There is a fantastic gallery of pictures by a number of artists.

www.psa-photo.org/gallery.htm

This is the gallery page of the Photographic Society of America.

www.rleggat.com/photohistory

If you want more information about some of photography's pioneers this is a great place to start. Not only is there a history of the art form up until the 1920s, but all the key names are cross-referenced: just click on a name in the text to jump to the relevant biography.

www.rps.org

This is the web site of England's Royal Photographic Society, which was formed 150 years ago with Queen Victoria and Prince Albert as patrons.

www.teleport.com/~pacrim/storys/milan/95-02x.htm

This is an interesting glossary: It contains words and phrases that you might hear from secondhand camera dealers . . . and what they really mean!

www.thirdeyephoto.com

The great Third Eye Photowork Collection web site exhibits many photographs taken from unusual points of view.

ubmail.ubalt.edu/~dhaynes/photo/depth.htm

This web page contains an article on depth of field from *Introduction to Photography* by David Barnes.

www.west-crete.com/photos.htm

This is something of a curio – a web site that only contains landscape photographs of the Greek island of Crete.

www2.southwind.net/~tkalp/pw2/Comp.htm

This page of Wichita South High School's web site contains some sound advice on photographic composition.

Further reading

THERE ARE SO MANY photography books and magazines on the market these days that it's almost impossible to select what to recommend. The choices that I have made here reflect my own personal interests to a great extent, but I really think that you should read as much as you can and look at as many photographers' pictures as possible.

Books

Ansel Adams
Any book by or about Ansel Adams is worth reading.

Tom Ang
Digital Photography (Mitchell Beazley)

Diane Arbus
An Aperture Monograph (Aperture)

Marc Atkins and Iain Sinclair
Liquid City (Reaktion Books)

Richard Avedon
Evidence (Eastman-Kodak)

John Berger and Jean Mohr
Another Way of Telling (Vintage Books)

Henri Cartier Bresson
The World of Cartier Bresson (Thames and Hudson)

Graham Clarke
The Photograph (Oxford Books)

Anton Corbijn
Famouz (Schirmer Mosel)
Star Trak (Schirmer Mosel)

Edward S. Curtis and Hans Christian Adams
Edward S. Curtis (Taschen)

Eddie Ephramus
What's Missing? Realising Our Photographic Potential (Argentum)

Elliott Erwitt
Photographs Antiphotographs (New York Graphic Society)

Max Ferguson
Max Ferguson's Digital Darkroom Masterclass (Focal Press)

John Garrett
John Garrett's Black-and-White Photography Masterclass (Collins & Brown)

Ralph Gibson
L'Histoire of France (Aperture)

Ernst Haas
In America (Thames and Hudson)

Andre Kertesz
60 Years of Photography (Thames and Hudson)

Ralph Eugene Meatyard
An American Visionary
(Akron Art Museum)
An Aperture Monograph
(Aperture)

Duane Michals
Duane Duck
(Museum of Modern Art Oxford)

Irving Penn
Passage (Stropf/Callaway)

W. Eugene Smith
The Camera as Conscience
(Thames and Hudson)

Chris Wainwright
The Creative Darkroom Handbook (Cassell)

Randall Webb and Martin Reed
Spirits of Salts (Argentum)

Donovan Wylie
Losing Ground (Fourth Estate)

Magazines

Amateur Photographer
This British magazine, launched over
115 years ago, claims to be "the world's
number one photo weekly magazine."

American Photo
Published six times a year and aimed at
professionals and advanced or aspiring
photographers.

Aperture
This slightly pricey quarterly magazine
has been described as "the most serious
and the most valuable periodical in the
photographic world." Need I say more?

Outdoor Photographer
Written by the world's leading landscape,
wildlife, sports, and travel photographers.
Published ten times a year.

PC Photo
Dedicated to computers and
photography. Includes advice on effects,
in addition to reviews and tips.

PHOTOgraphic
Monthly magazine for all camera
enthusiasts. Packed with tips, techniques,
and product reviews.

Photolife
Canada's national monthly magazine for
amateur and advanced amateurs includes
articles on equipment and techiques,
reader's pictures, and contests.

Popular Photography
This monthly is aimed at beginners and
professionals with tips to help you
improve your photographic prowess.

A simple glossary

Aperture The adjustable diameter of a lens, the size of which determines how much light is able to reach the film. Aperture size is measured in f-numbers, or f-stops. *See also* f-number.

Aperture priority A mode on a semiautomatic camera, where you select the setting for the aperture and the camera automatically sets the correct shutter speed to make the exposure.

APS Stands for Advanced Photo System, a type of camera launched in the mid-1990s.

ASA Stands for American Standards Association and was the measurement of film speed before ISO was adopted. *See also* ISO.

Available light This is a term used to describe photography utilizing existing light only. Often available-light photography refers to pictures taken in low light. Many of the most moving and powerful reportage photographs ever taken have been available-light pictures. Unfortunately, too many photographers seem to have lost the art of this type of photography and allowed the flash to take over. With the fast film available today there is virtually no situation that cannot be photographed without flash.

Backlight Light that comes from behind the subject in a photograph. Can sometimes cause problems with exposures leading to the need for a backlight compensation (BLC) function. *See also* Backlight compensation.

Backlight compensation A function available on many cameras these days, for use when the light from behind a subject is so bright that the subject would be underexposed.

Between-the-lens shutter *See* Leaf shutter.

Bracket To bracket exposures means to take a series of exposures both under and over the meter reading. With your SLR you will probably have an exposure-compensation facility that allows you to go up to +2 stops and down to -2 stops in ⅓-of-a-stop increments.

Burning *See* Writing.

Camera obscura This is a Latin term that literally means dark room, or dark chamber. It is also an early form of the camera as we know it today.

Chromogenic Means "as color," *chrom(os)* being Greek for color. These films are black and white but can be processed and printed as color film.

Clip test A test in which a short piece of film – about three frames – is cut off the start of the film and developed to test whether your exposures are perfect.

Color cast An unnatural color that affects a print. Often these are true reflections of the scene at the time of shooting, but the human eye and brain had compensated for the color discrepancy. The camera cannot do the same.

Color-correction filter A filter that is used to either add a little warmth to or cool down the overall feel of a scene.

Color negative Color negative film produces a negative, or reverse, image, from which your print is made. You will hear people refer to color negative film as print film.

Color temperature The color of light, or color temperature, is calculated in degrees Kelvin (° K). For example, midday is between 5200 and 5400° K. Color temperature readings are taken on a color temperature meter, and from this reading you can figure out what you need in terms of filters or camera/lens settings to get your desired color effect.

Compact camera The correct term for a point-and-shoot camera. Usually a small, automatic 35mm camera with a direct-vision viewfinder.

Dedicated flash This is a flashgun designed by camera manufacturers to work only with their own make of cameras.

Depth of focus The distance in front and behind your picture's point of focus that is kept sharp. It is also known as depth of field.

Development Converting of an exposed film's latent image into a visible image. *See also* Latent image.

Diffuser A material that is used to soften or spread the light from a light source.

Direct-vision viewfinder A viewfinder that allows the photographer a direct look at the scene, which is not exactly what the lens "sees."

Downrating *See* Pulling.

DPI Printer resolution is measured in dots per inch, or DPI.

80B filter This is a blue filter that restores the color temperature of tungsten light back to daylight.

Enlargement A term used to mean a large print.

Exposure The amount of light permitted onto the film. Also the length of time the light is allowed to act on the film.

Exposure latitude The amount a film can be under- or overexposed and still produce a satisfactory print.

Film speed A film's sensitivity to light, measured in ISO numbers. The higher the number, the faster the film, and the greater its sensitivity to light.

Filter A glass, plastic, or gelatine disk that is placed over a lens to alter the appearance of the scene being photographed.

Fixed-focal-length lens A lens that does not have zoom capabilities.

Flash throw Used to mean the distance from the camera that the flash will light adequately for a photograph.

f-number The measurement of a lens's aperture. The f-number is a fraction of the focal length of the lens, so f2 on a 50mm lens would mean that the aperture is 25 mm. f-numbers are also called f-stops.

Focal-plane shutter Almost universal in SLR cameras, the focal-plane shutter is basically a curtain with a slit that travels across the film plane exposing the film. Some designs use two curtains. The focal-plane shutter is positioned at the back of the camera, in front of the film.

Focal point The point in a picture to which you wish to bring the viewer's attention.

Frame Used to describe the area of the world that you see through your camera's viewfinder.

f-stop *See* f-number.

Hard neg This is the term given to a high-contrast negative. A low-contrast neg is called a soft neg.

Iris diaphragm Adjustable mechanism of metal blades that forms the aperture. Also called a diaphragm.

ISO Abbreviation for International Standards Organization and the unit of measurement of a film's sensitivity to light. Some of your old cameras and books will have an ASA rating. They are exactly the same as ISO ratings. *See also* Film speed.

Kelvin Unit of measurement used to describe the color temperature of light, degrees Kelvin (° K).

Kodak™ The trademark Kodak is a word George Eastman made up – he just liked the sound of it – he also thought the visual appearance of it would look good and be remembered. It doesn't mean anything!

Latent image The invisible image made by the chemical reaction of light on the film's emulsion.

LCD Stands for liquid crystal display.

Leaf shutter A shutter system built into a lens rather than into a camera body (as is the case with the focal-plane shutter), so called because of the series of overlapping leaves that allow it to expose the film.

Megabytes The unit of measurement for the memory of a computer. Also called MB or megs.

Megapixel One million pixels. Also known as MP.

Noise Digital jargon meaning a breakup of the image; similar to grain on film or interference on your TV.

Opening up Increasing the size of the aperture in order to allow more light to expose the film.

Overexpose To allow too much light to reach the film.

Pan A verb meaning to move the camera in the same direction as a moving subject, always keeping the subject in approximately the same position within the frame. Panning is also used in TV and the movies to follow the on-screen action, and in music meaning to move sound from one speaker to another.

Pinhole camera A light-tight box with a pinhole instead of a lens through which light is transmitted to a piece of film directly opposite.

Pixel The easiest way to define a pixel is to think of it as one tile of a Roman wall mosaic. Each tile has only one color, but when all the tiles are creatively arranged, you have a complete picture.

Point-and-shoot camera This is the name often given to compact cameras, simply because it more or less defines the actions needed to take a photograph with those machines. The trade and professional photographers tend to use the term compact camera instead.

PPI On a computer screen resolution is measured in PPI – pixels per inch.

Pulling This term means to expose a film to more light than its ISO rating dictates. Also called downrating.

Pushing This term means to expose a film to less light than its ISO rating dictates. You need to tell your lab if you do this because they will need to develop the film differently. Pushing is sometimes also known as uprating.

Pressure sensitive Means pretty much what it says. But specifically, with items like graphic tablets, it means that you can create different effects by varying the pressure, just as you can with a pencil or paintbrush.

Quality Photographers use this word as an all-embracing term that covers sharpness, grain size, color saturation, and contrast.

RAM (said "ram," rather than as initials) Stands for random access memory and is the memory-storage component of your computer.

RC paper The RC stands for resin coated. Most printmakers still use a paper-based material called fiber-based, or FB, paper.

Reflector Any material that reflects, or bounces, light. Reflectors are usually white or off-white to reduce the possibility of color casts.

Selective focus When you focus on one plane and throw the rest out of focus by using a large aperture this is known as selective focus.

Shutter The mechanism that you use to control when and for how long the film inside the camera is exposed to light. It is activated by pressing the button that "takes the picture." The button is correctly called the shutter button or shutter-release button.

Shutter priority A mode on a semiautomatic camera, where you select the shutter speed and the camera automatically sets the correct aperture to make the exposure.

SLR Stands for single lens reflex and is a camera design in which, through the use of an angled mirror and a series of silver surfaces, the scene in the viewfinder is exactly the same as that "seen" by the lens.

Soft focus Means out of focus, giving a soft edge to the subjects.

Soft neg The term given to a low-contrast negative. A high-contrast neg is called a hard neg.

Stopping down Term meaning to close down the aperture, minimizing the amount of light allowed to expose the film.

Surrealists The Surrealists created paintings, drawings, and photographs that were inspired by dreams. Salvador Dalí, Pablo Picasso, and Marcel Duchamp were the leaders of the movement. Man Ray was the most famous Surrealist photographer.

Telephoto lens A compact, long-focal-length lens.

Tonal management This term describes a photographer's ability to compose a picture that consists of a pleasing arrangement of tones.

Transparency The professional term for a slide.

TTL metering Through-the-lens light metering.

Uprating See Pushing.

Viewfinder A system through which the photographer is able to see what he or she is shooting.

Writing The act of making copies of your work onto a CD is known as writing, or burning.

Index

Acknowledgments

AUTHOR'S ACKNOWLEDGMENTS

I owe many thanks to the following people:
Michelle Garrett for supplying many of her images for this book and also for helping me with picture editing; Graeme Harris for sound advice and for supplying illustrations and copy on the Digital Darkroom chapter; Maud Larsson for all her patient work as my assistant on this project and for her prints and copy on the Digital Darkroom chapter; Mary Thompson at DK for commissioning this book and for general support; designer Simon Murrell and editor David Tombesi-Walton for their skill and humor throughout the process. A final thanks is due to my sons Nick and Matt who are the subjects of many of the pictures, plus all the brave souls who wittingly or unwittingly contributed to this book.

PACKAGER'S ACKNOWLEDGMENTS

Sands Publishing Solutions would like to thank the following people for their help in this project: Hilary Bird for compiling the index; Jessops of Maidstone for the loan of equipment for photography purposes; Barry Robson for the dog illustrations; Hayley Smith at Dorling Kindersley's picture library; Mariana Sonnenberg at ilumi for picture research; Frank Spence for the loan of his digital camera. A special thanks also to John Garrett for making this project such a pleasure.

PICTURE CREDITS

Apple Computer UK Ltd: 325.
Canon: 54, 58 br, 77, 80 cr, 82 cr, 85 bl, 315 ct.
Corbis UK: 96.
Dorling Kindersley: 20; Science Museum, London 24; Musée Gauguin, Tahiti 26; 27, 29, 30, 38, 146, 263, 267, 269, 286, 291, 327; Philip Gatward 55, 58; Steve Gorton 42, 218 cr; Dave King 314 tr; Stephen Oliver 218 br, 289. All © Dorling Kindersley. For further information see: www.dkimages.com
Fuji: 32, 80 br, 83, 84, 85 tr, 86, 282, 315, 324 bl.
Gandolfi Ltd: 290.
Michelle Garrett: 67, 78, 125, 140, 144, 159 bl & br, 168, 170, 174, 179 b, 180 b, 220, 223, 225, 227, 228–9, 230, 231, 281.

Graeme Harris: 74, 284, 331, 332.
Hasselblad: 287.
Hewlett Packard: 330 tr.
Hulton Getty: 22, 25, 28.
Iomega: 318, 330 br.
Maud Larsson: 322, 334, 335, 336, 337.
Janos Marffy: 31.
Simon Murrell: 36, 37, 43, 44 tr, 48, 56, 62, 64, 65, 71, 90, 93, 94, 306, 316.
Nikon: 33, 81, 324 br.
Sony: 317.
UMAX Systems: 328.

All other images © **John Garrett**.

Key:
t=top; b=bottom; l=left;
r=right; c=center